The Blue Room

The Blue Room

Eugene Richards

Where we were going there were no lit-up houses, only dying ones.

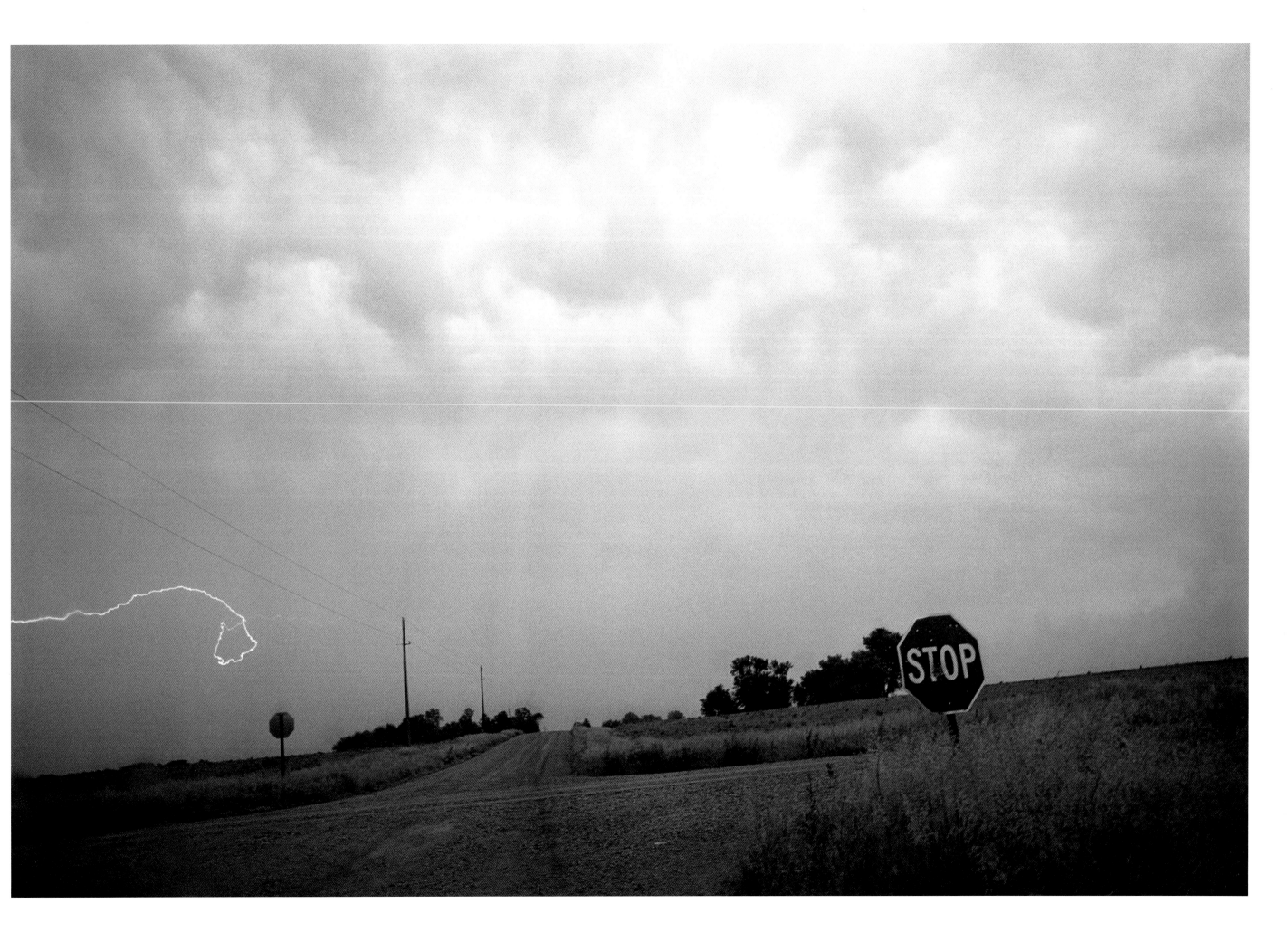

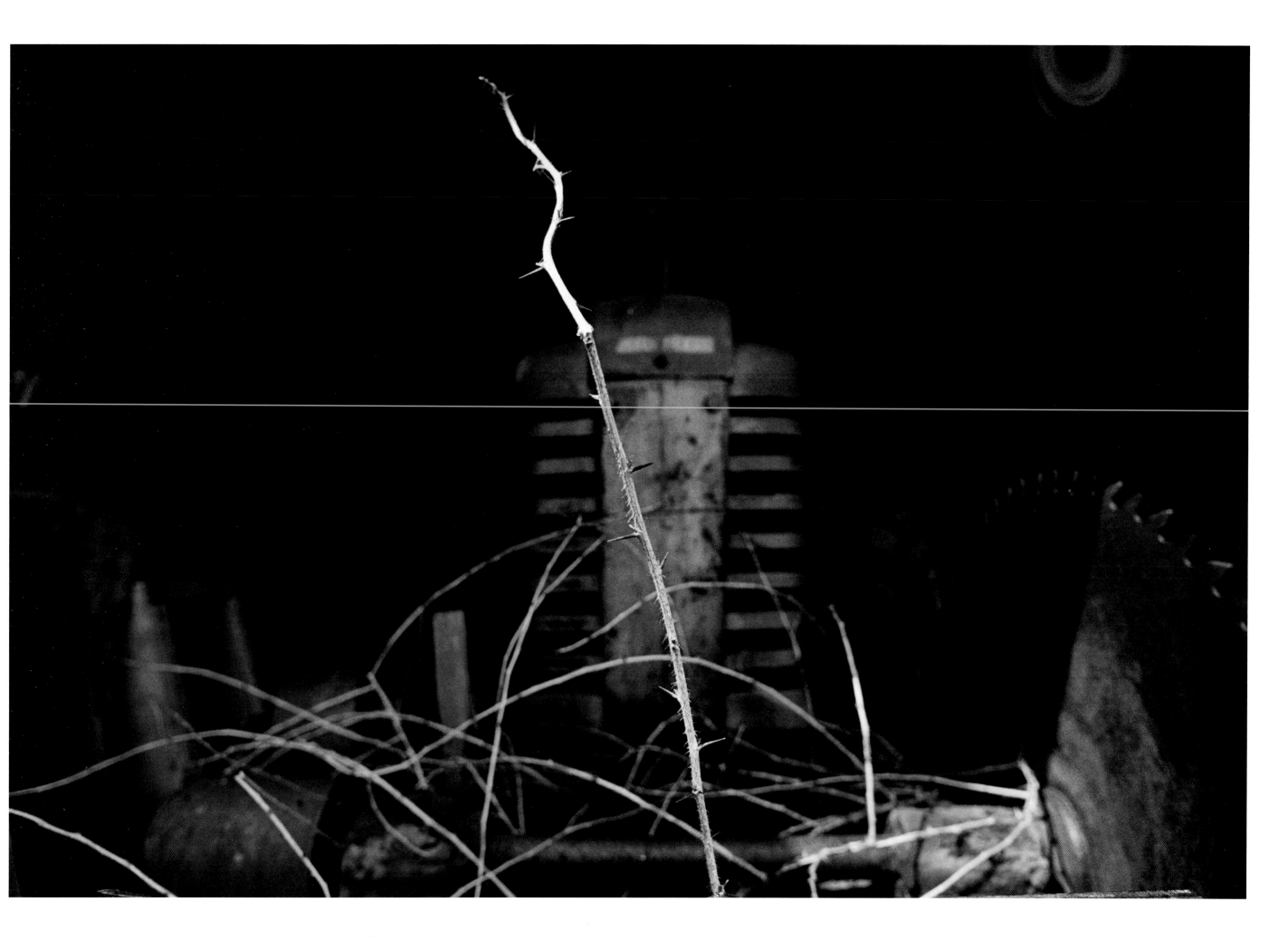

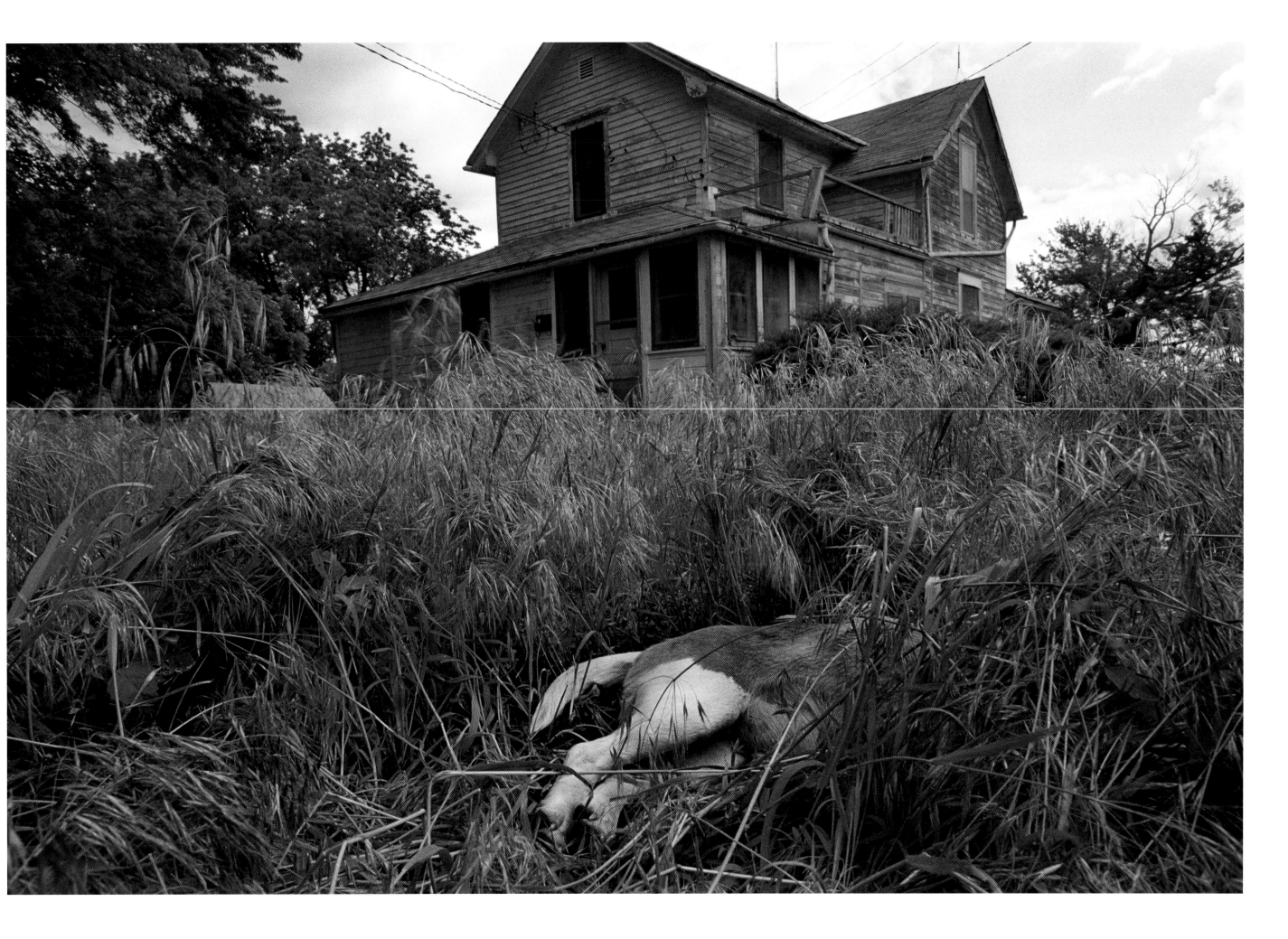

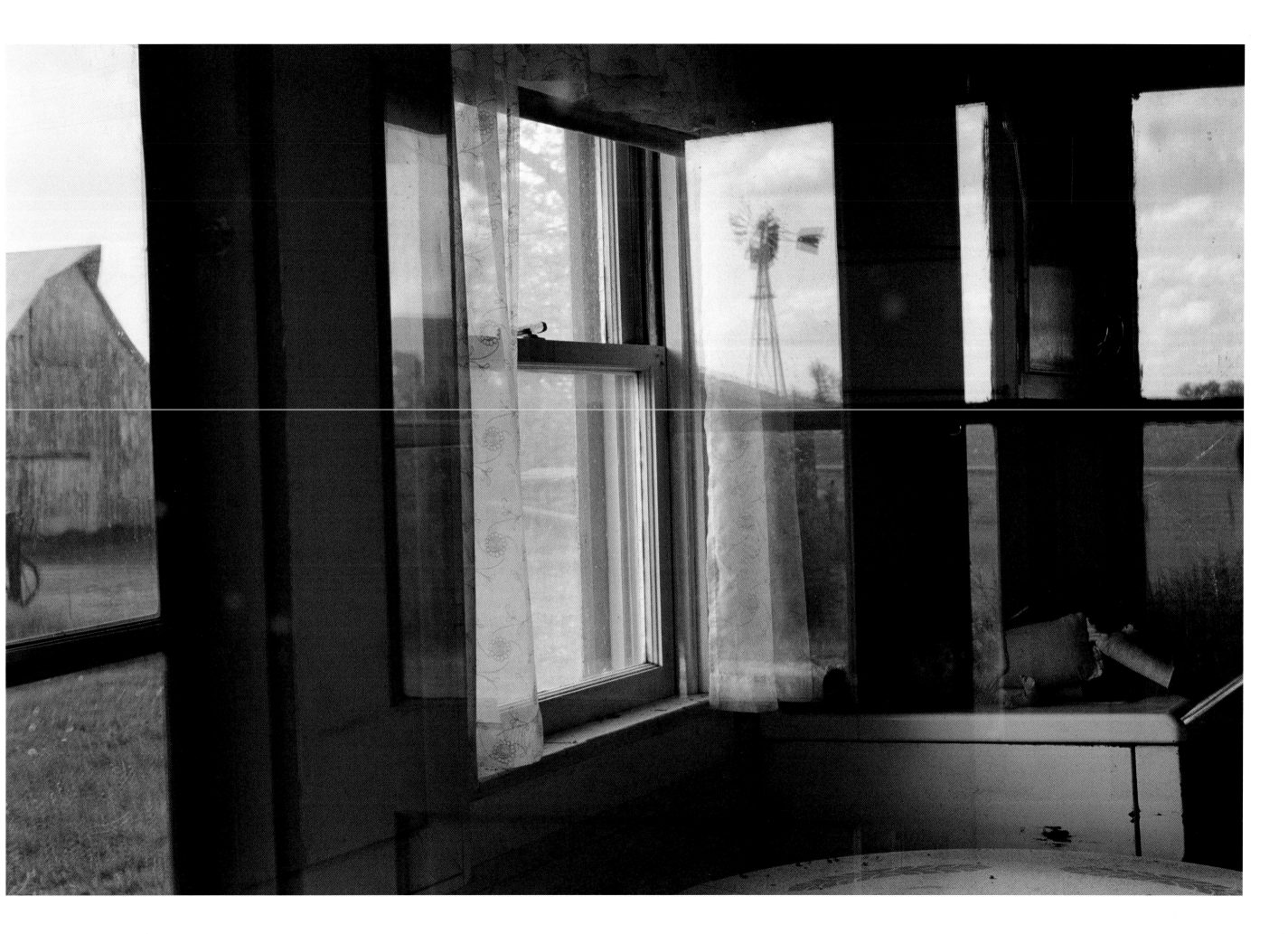

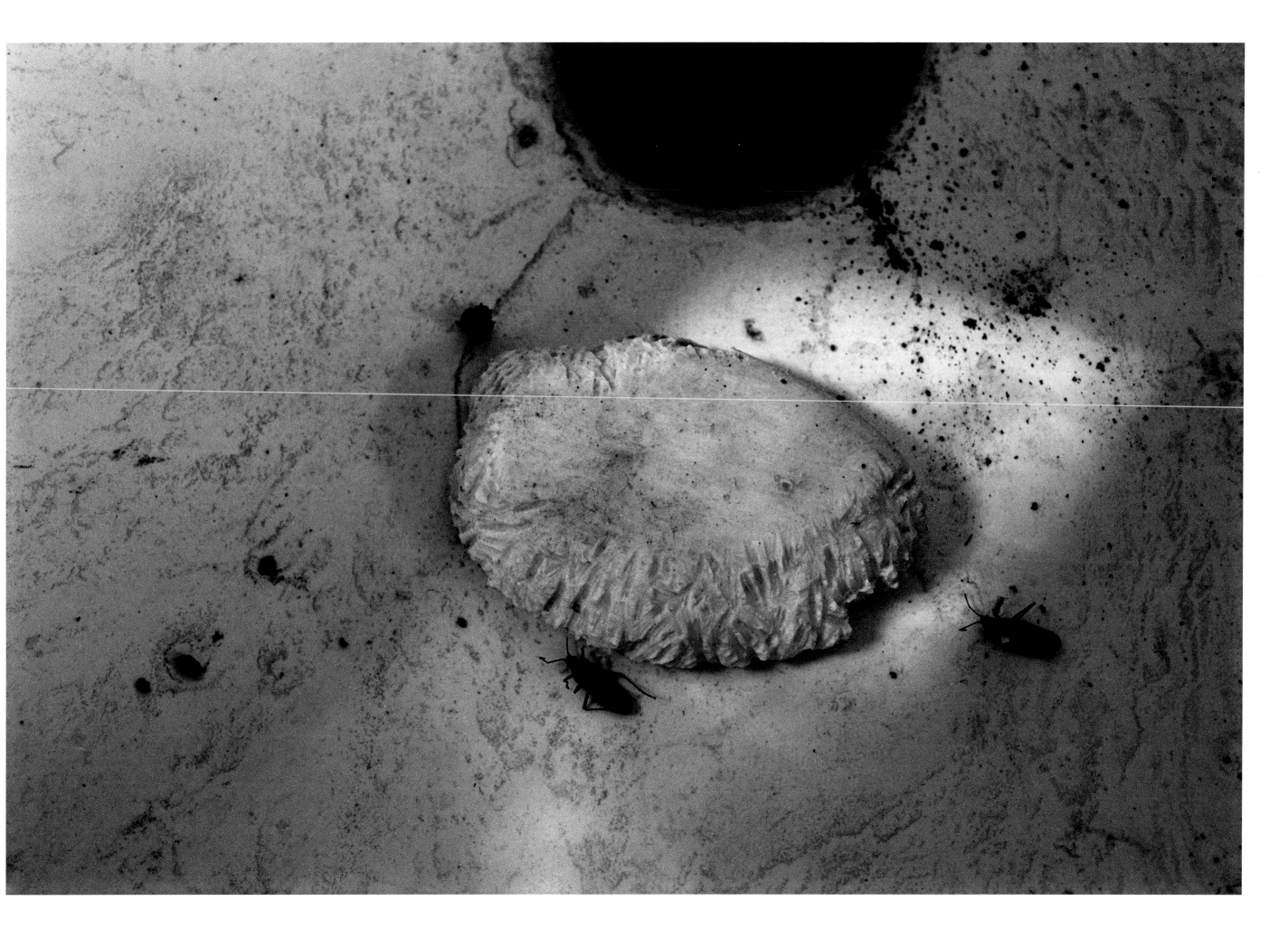

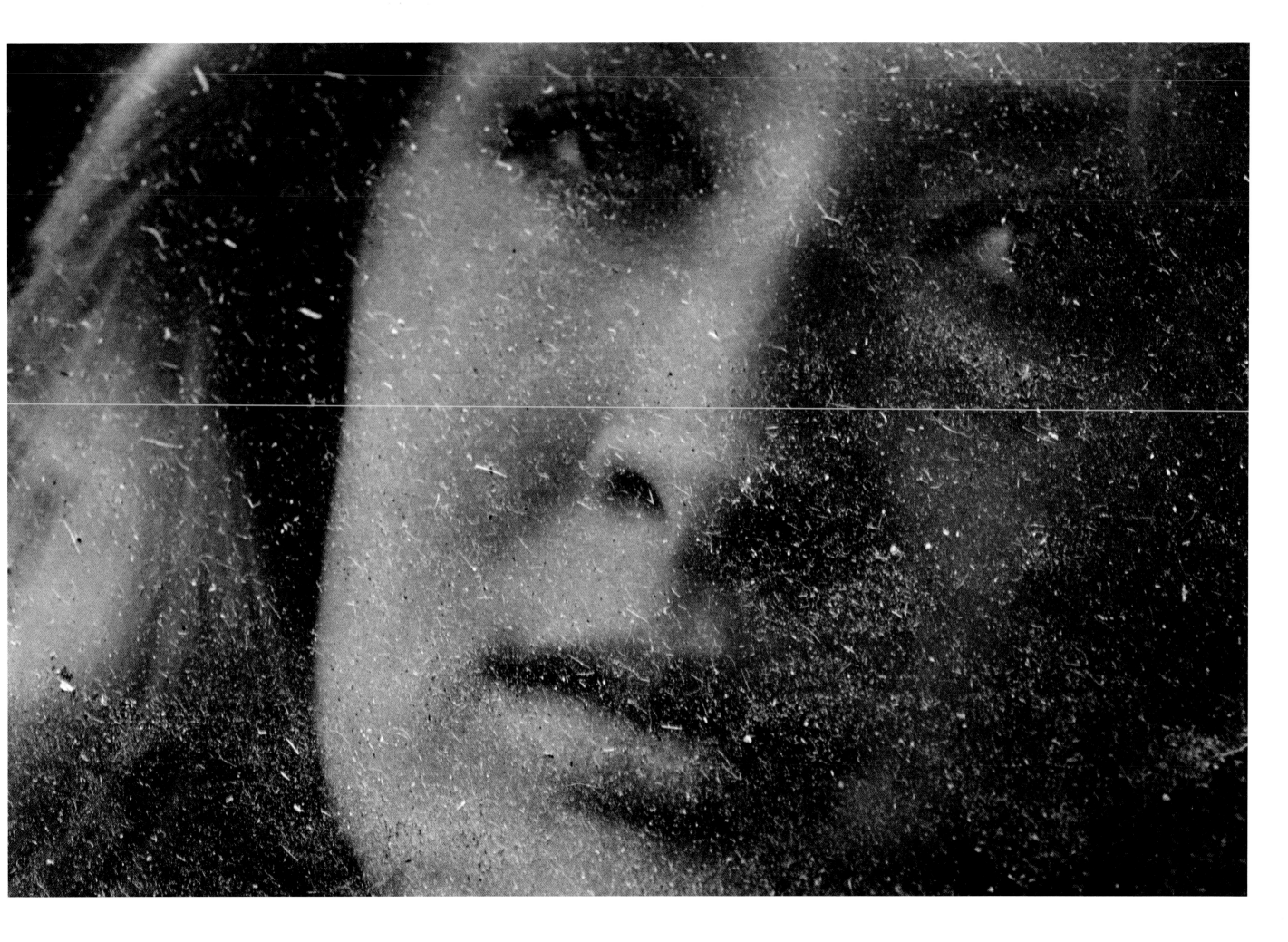

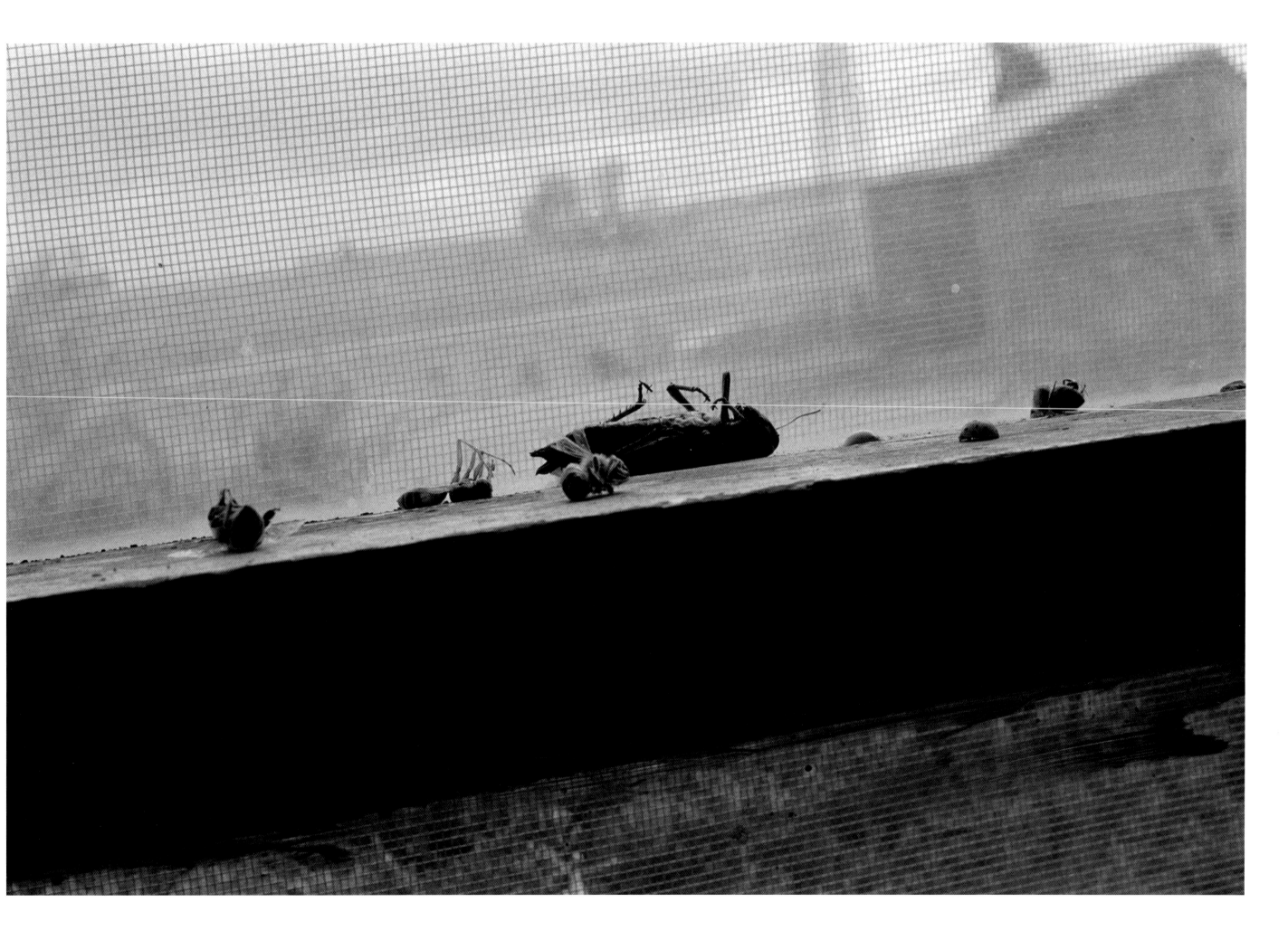

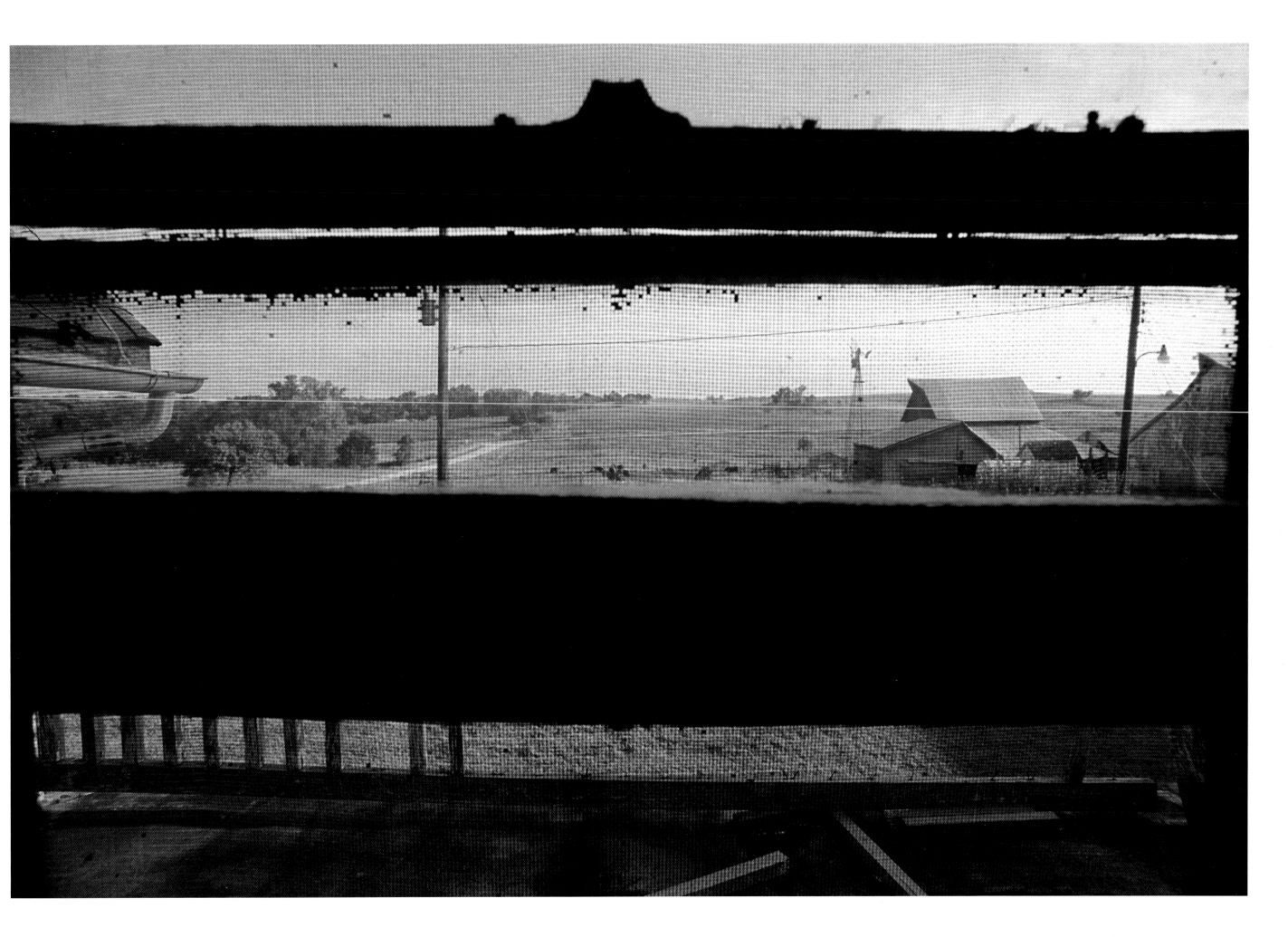

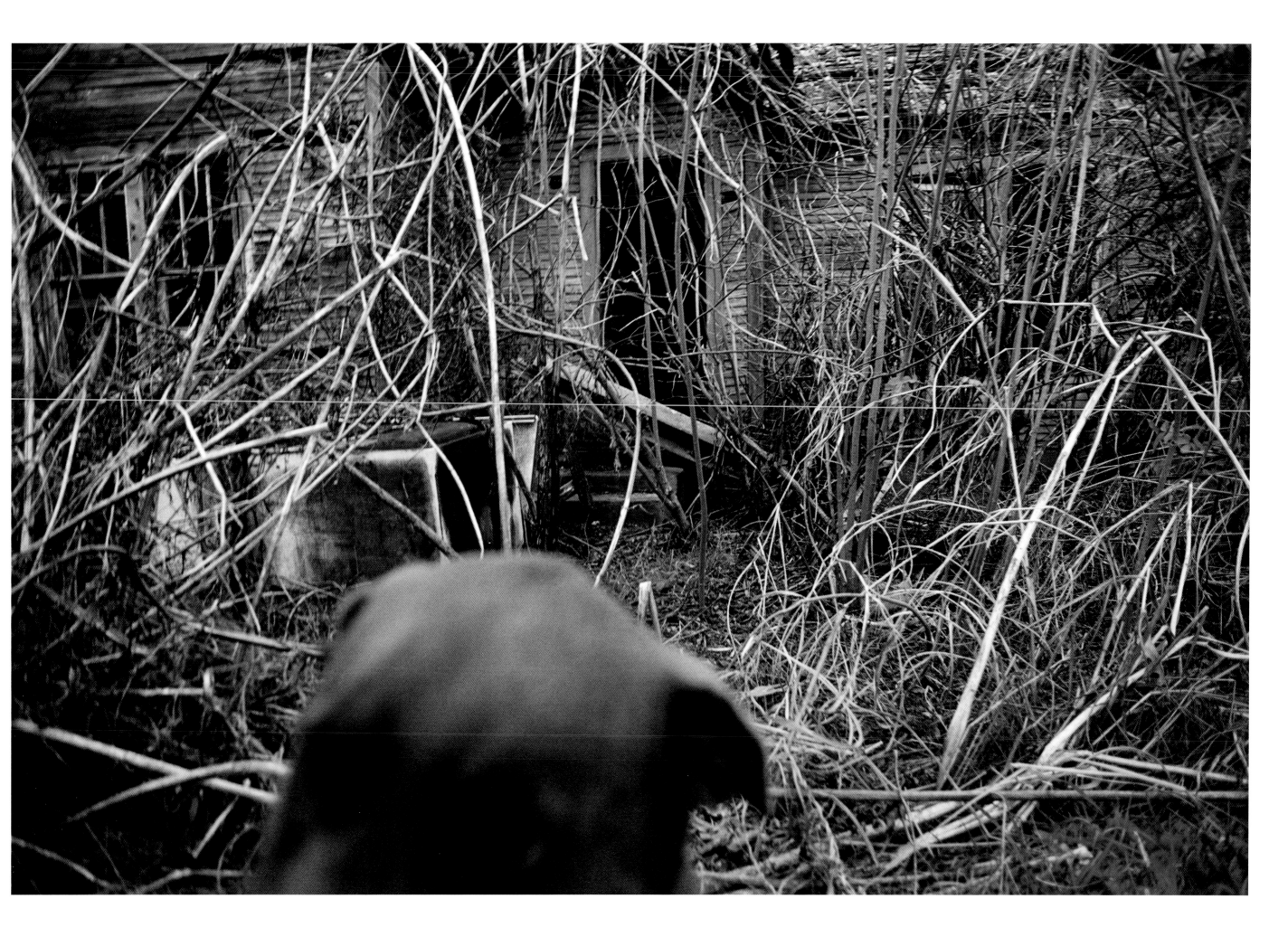

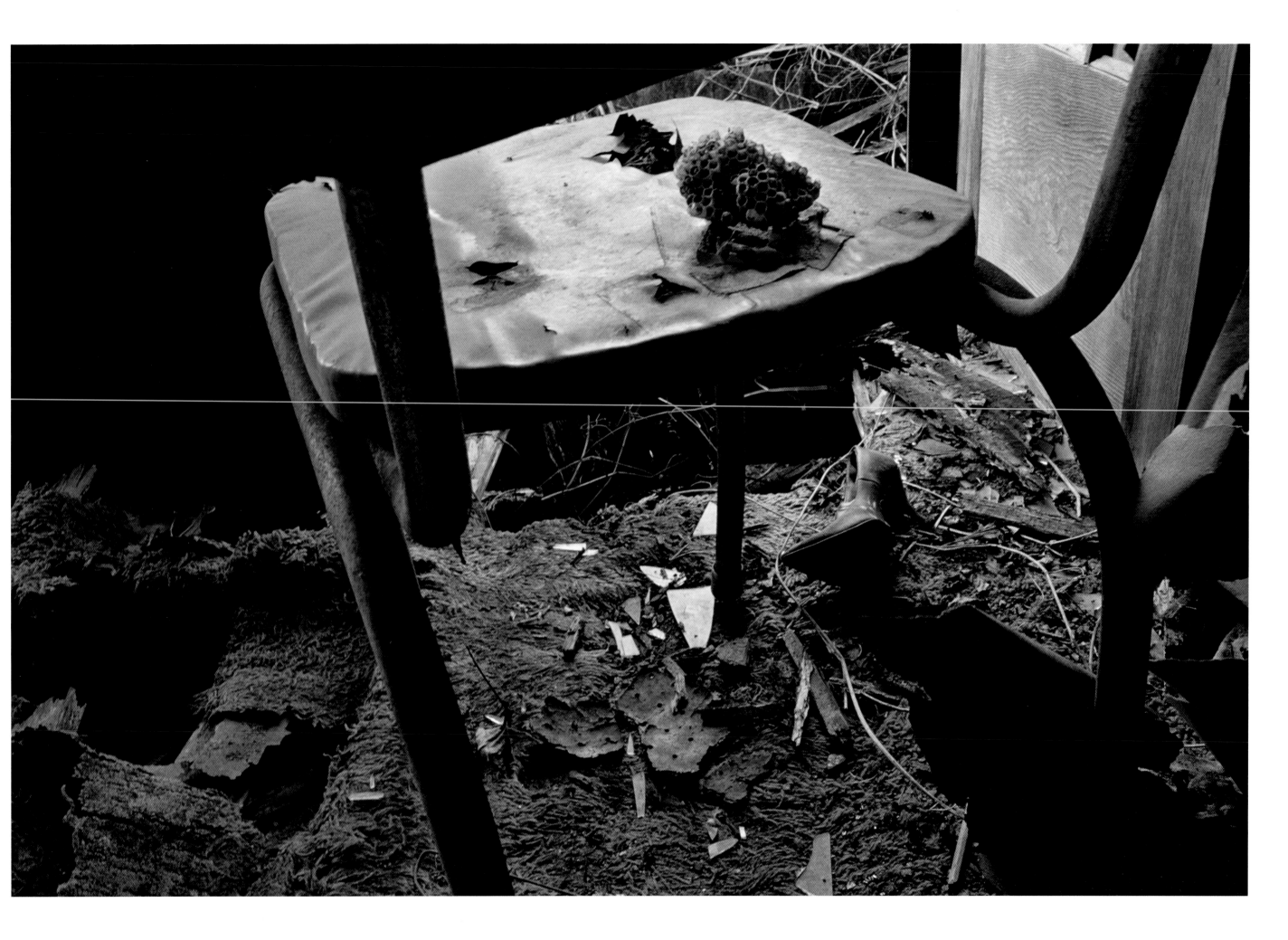

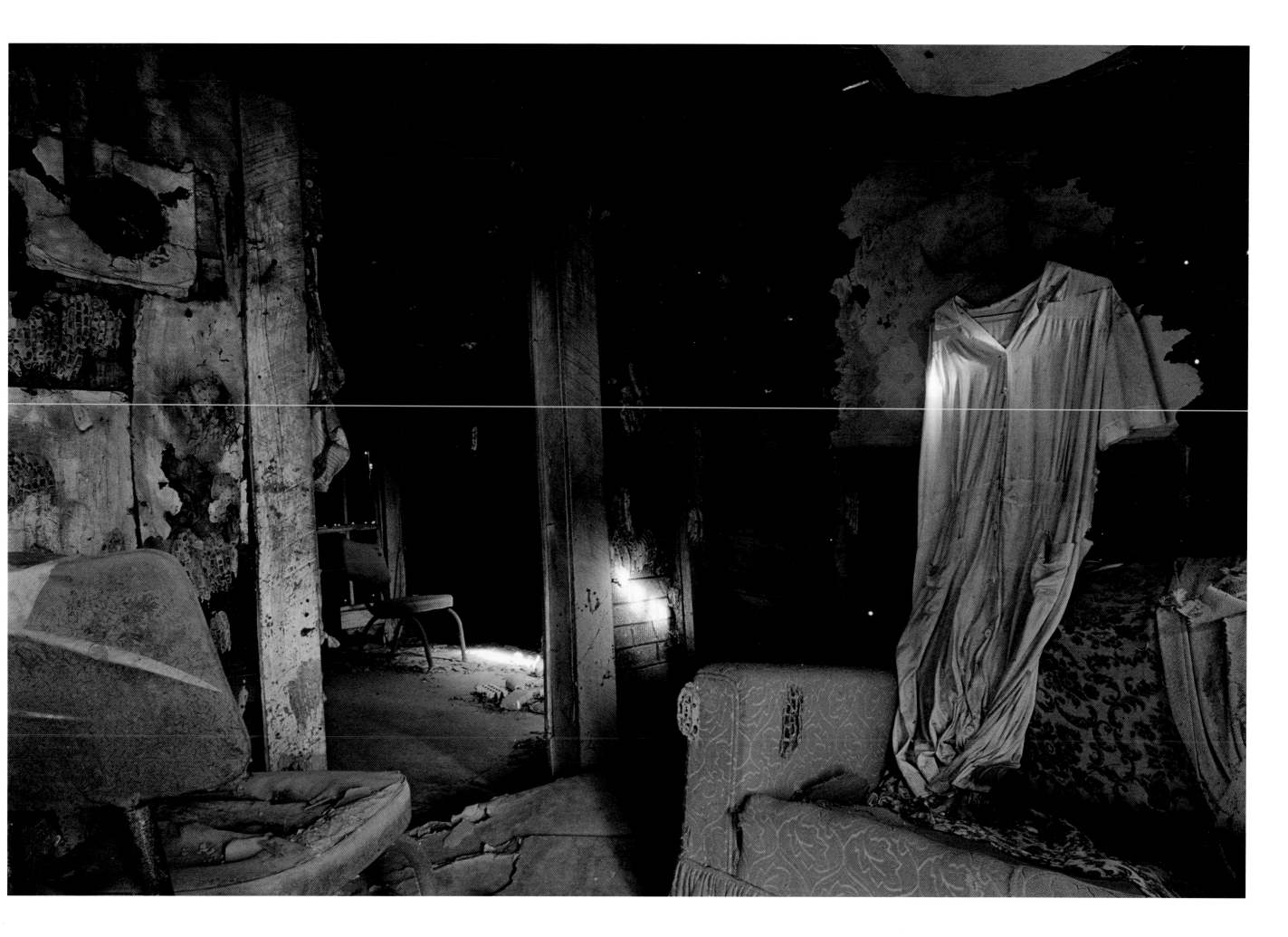

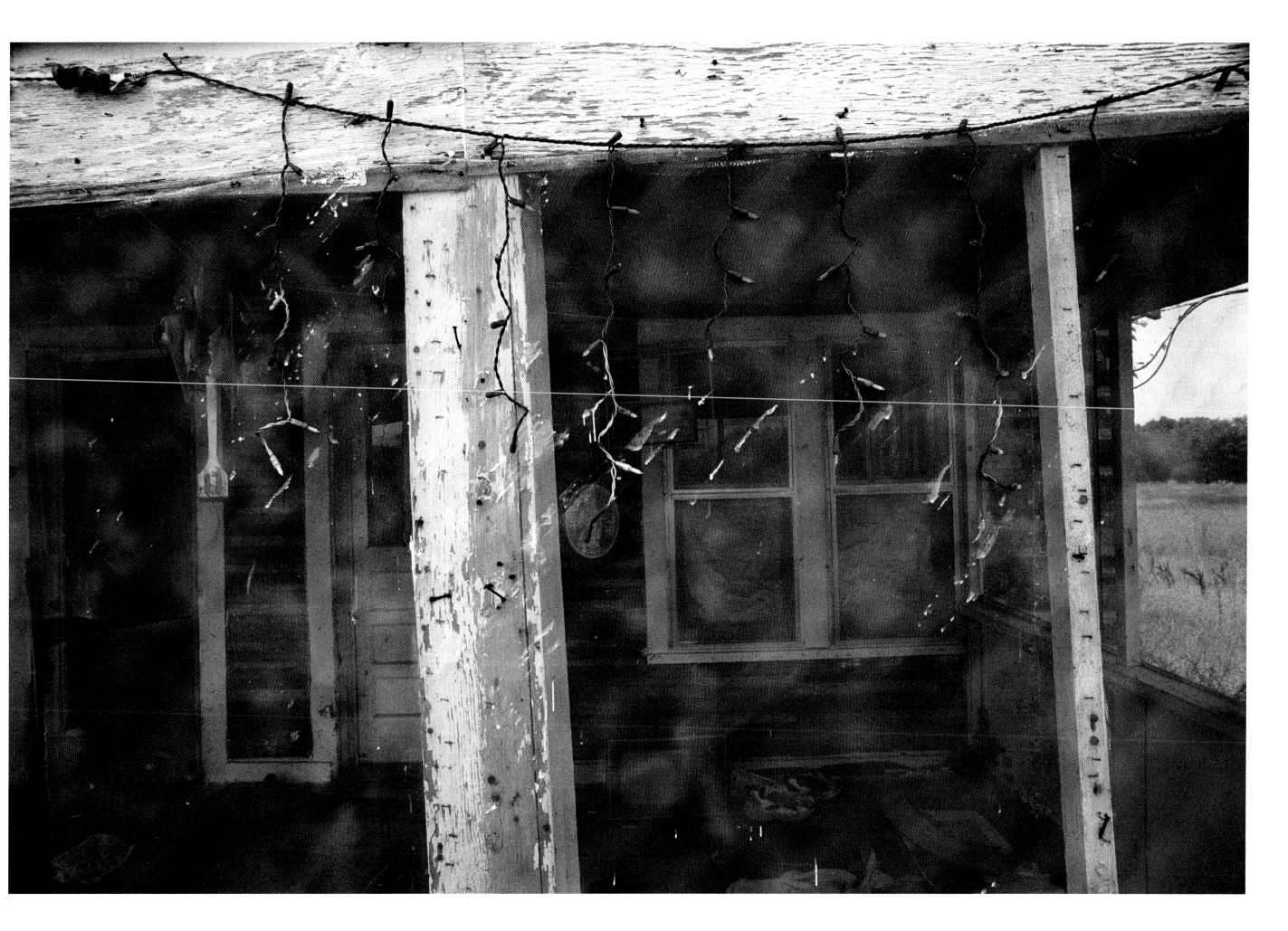

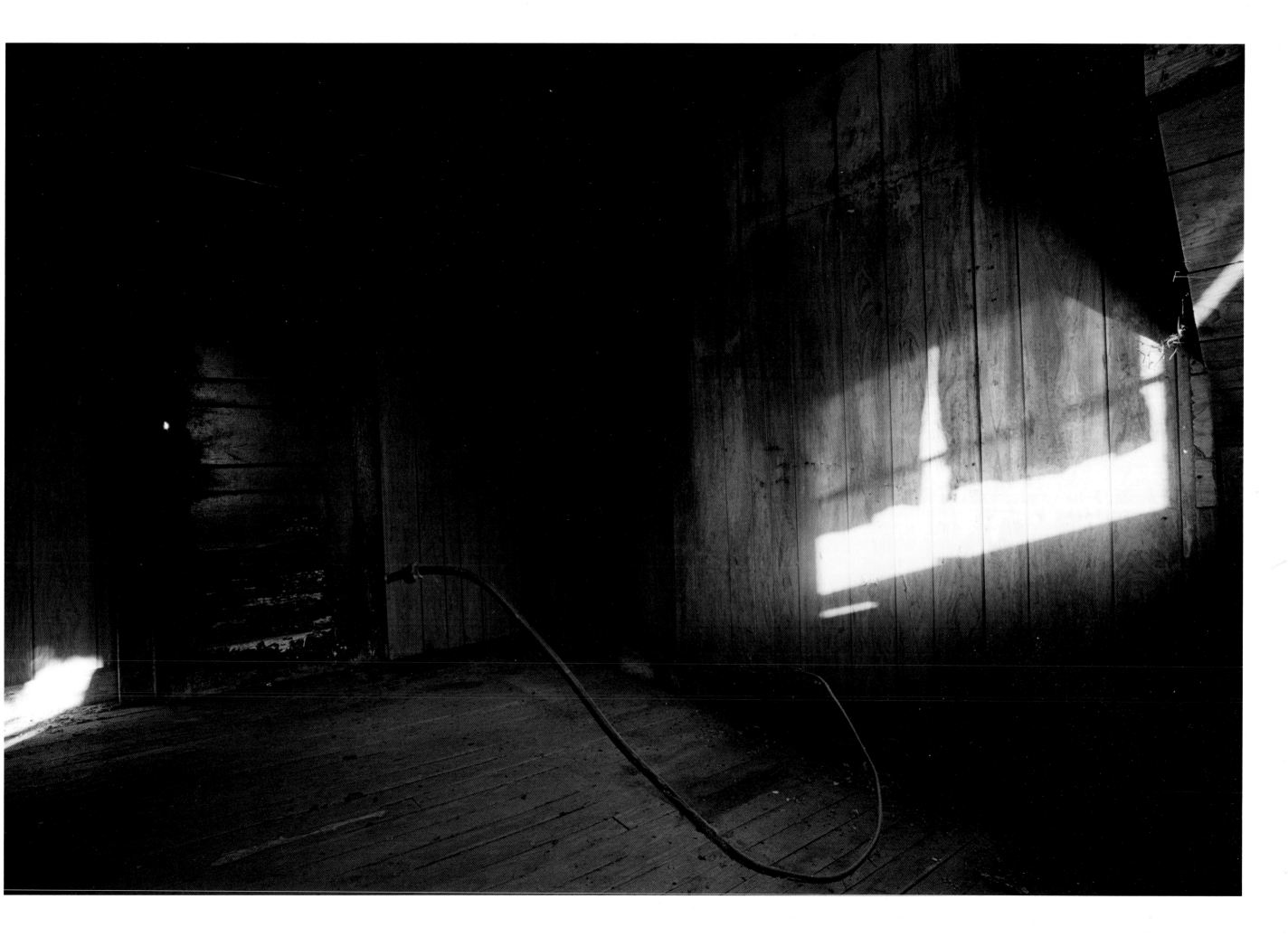

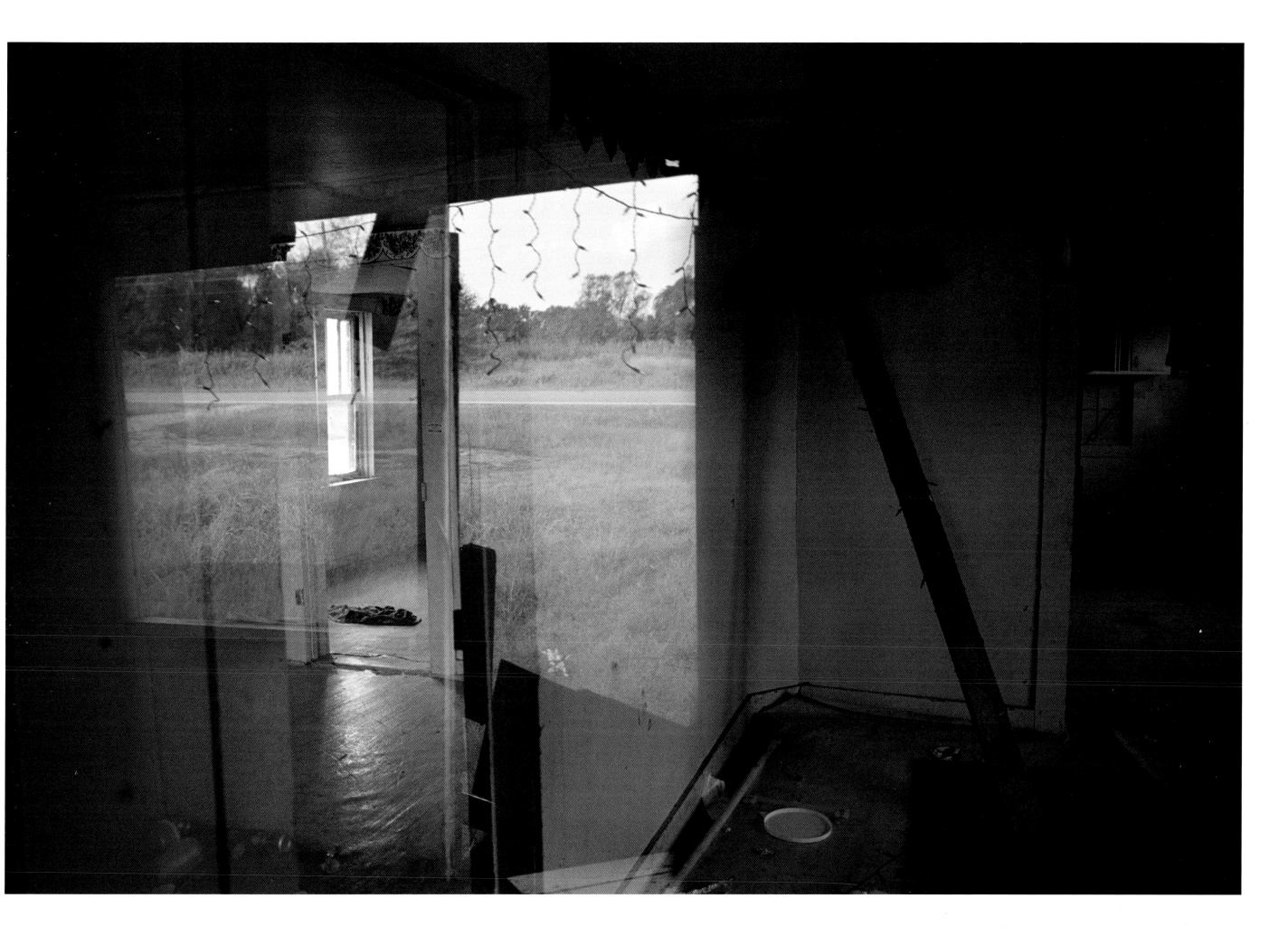

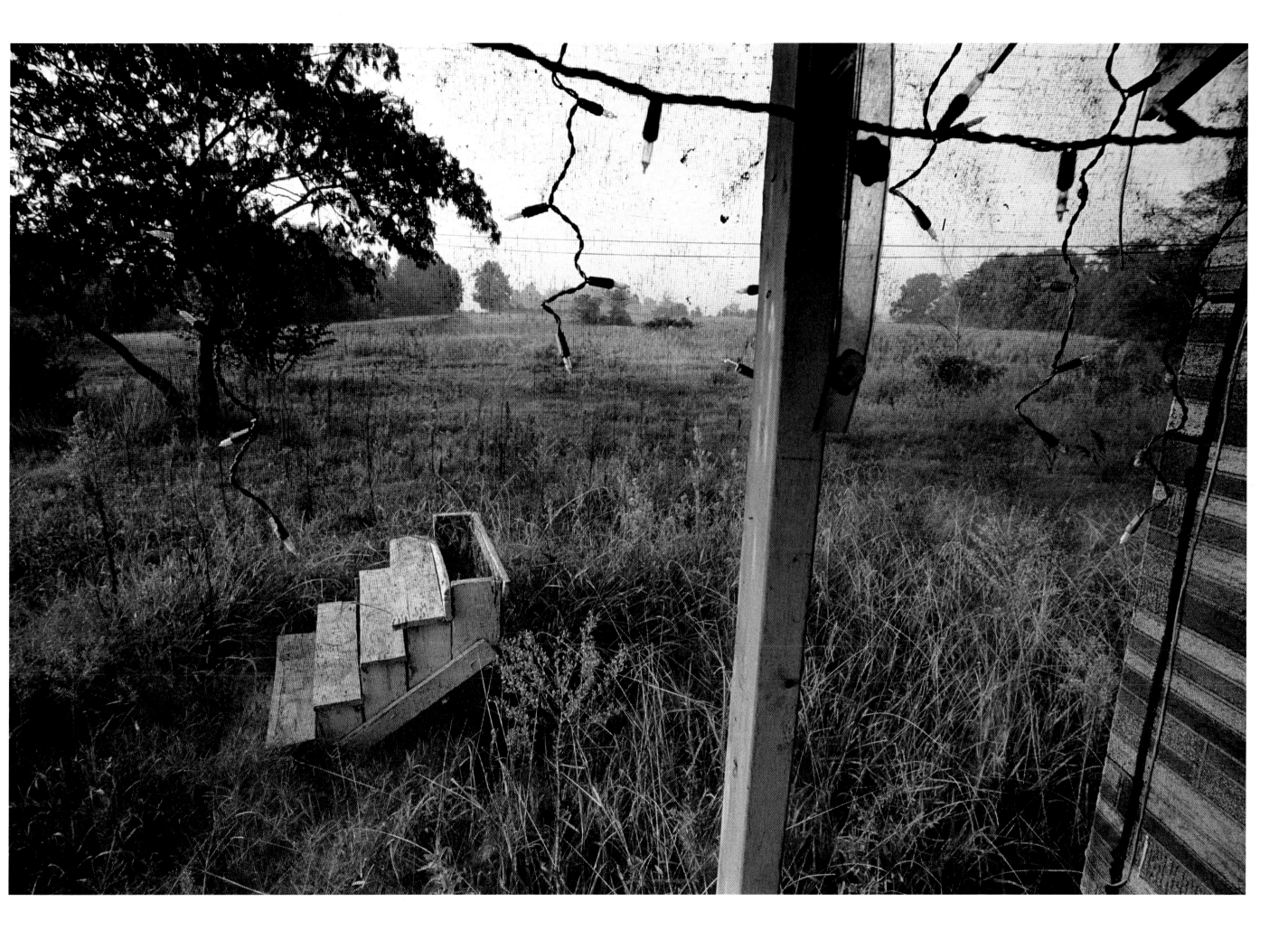

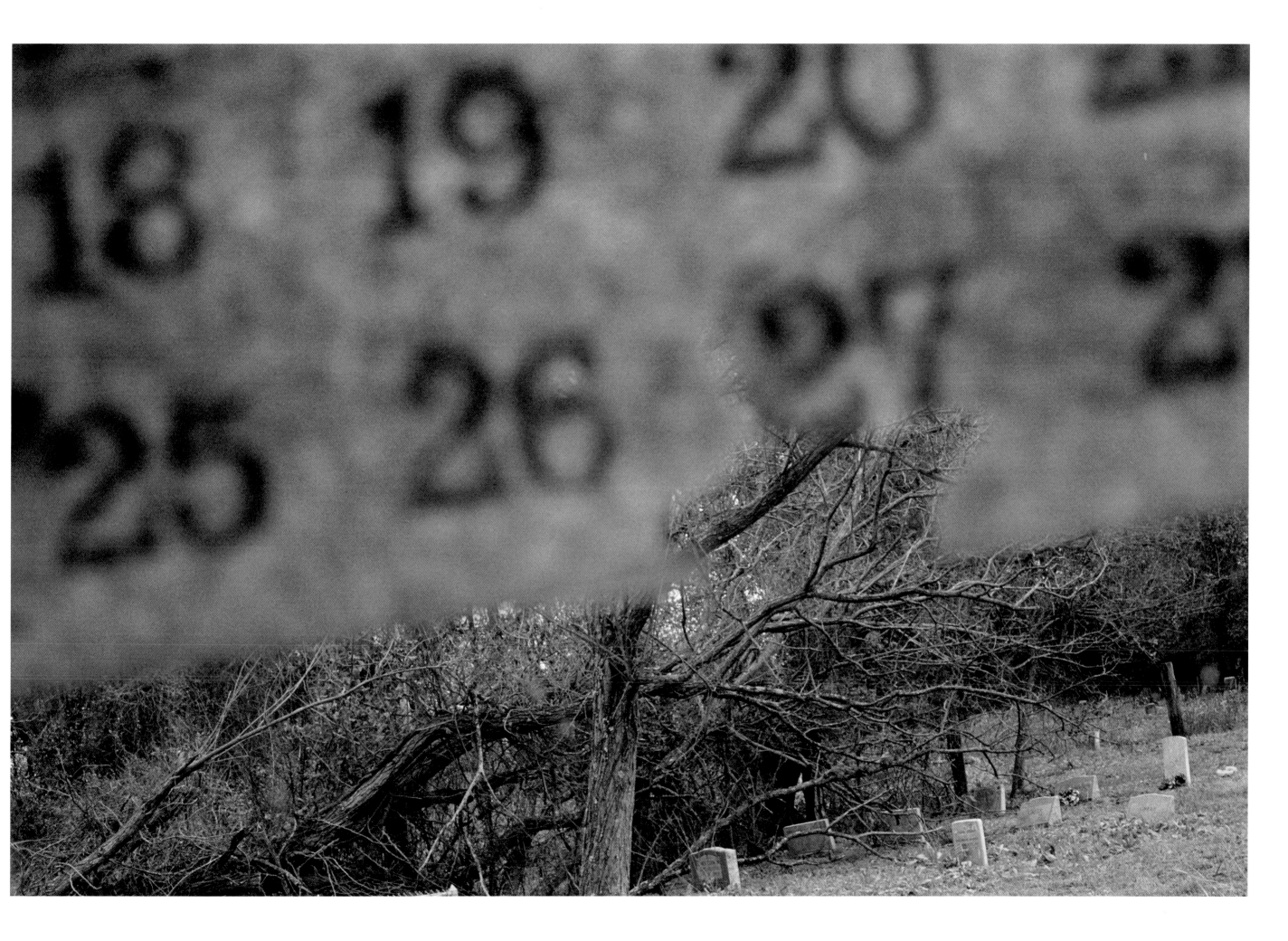

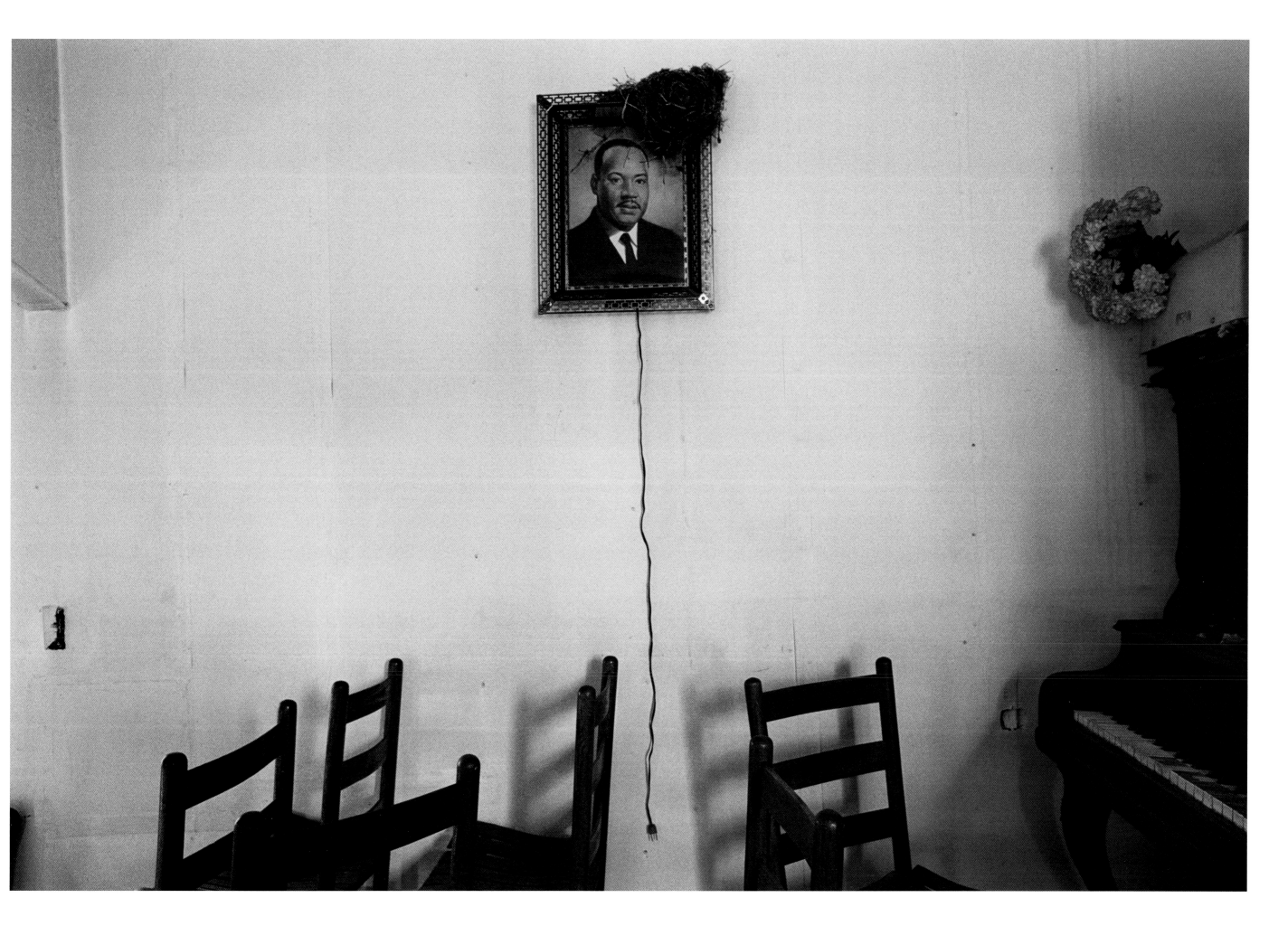

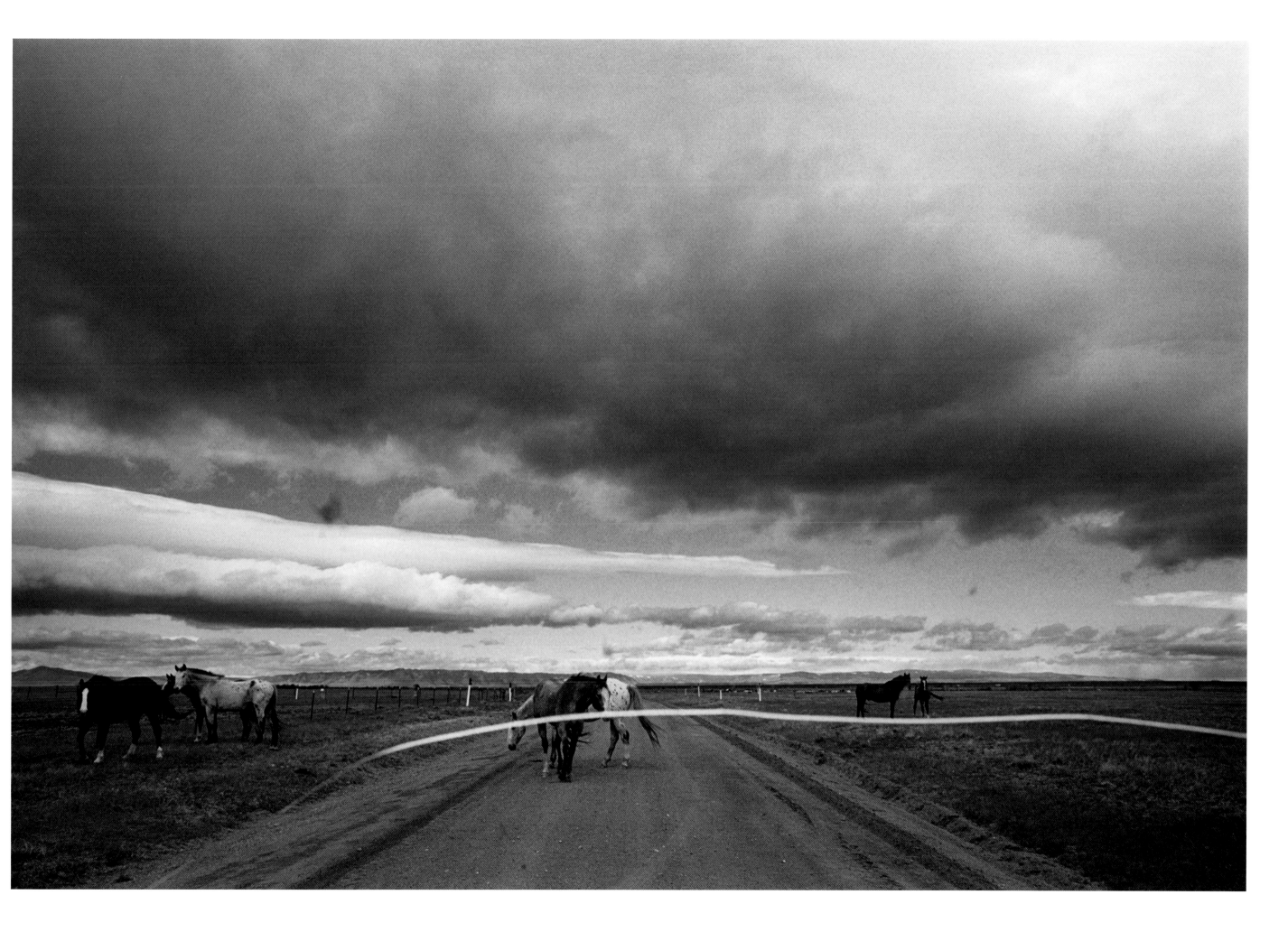

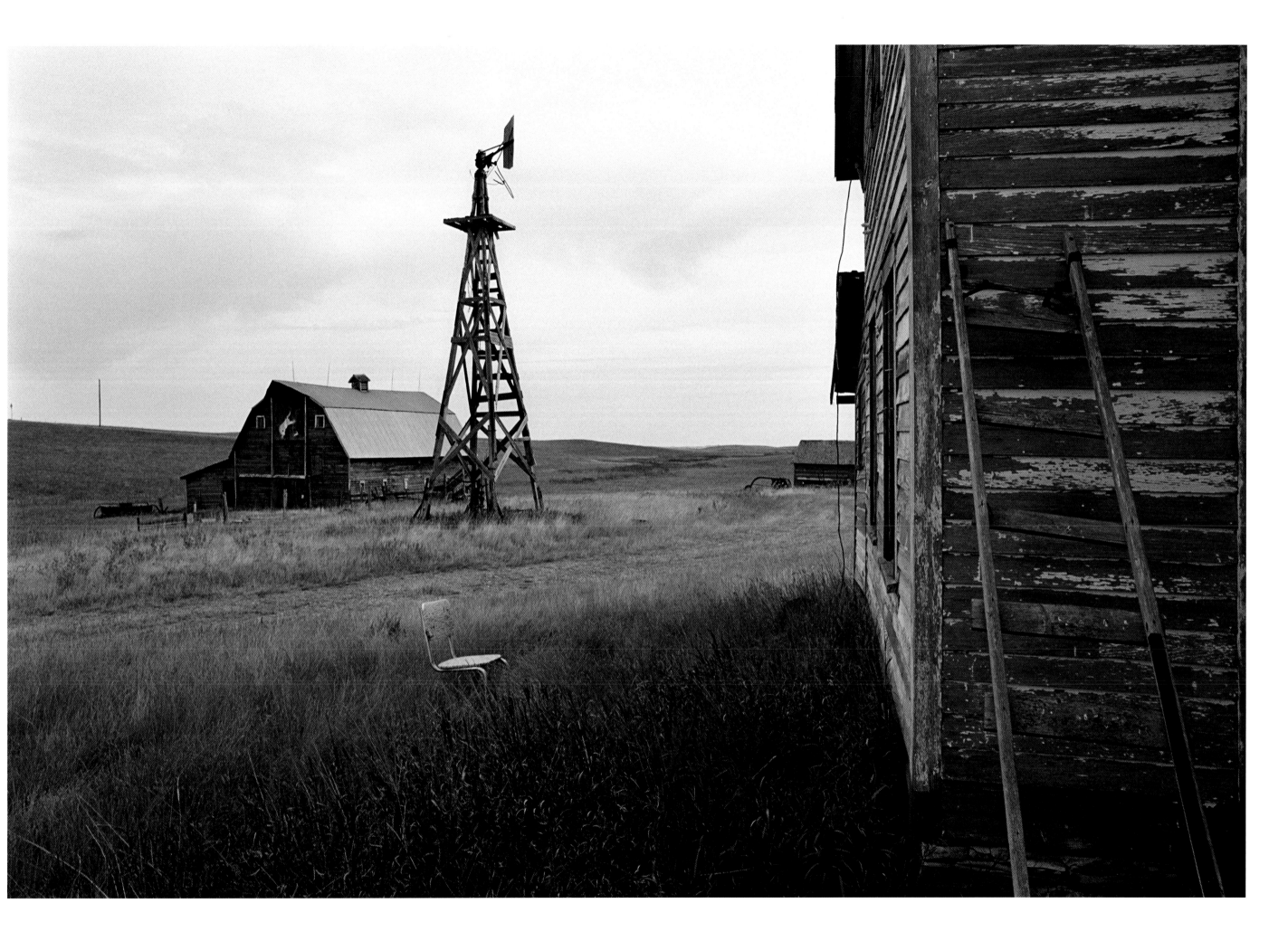

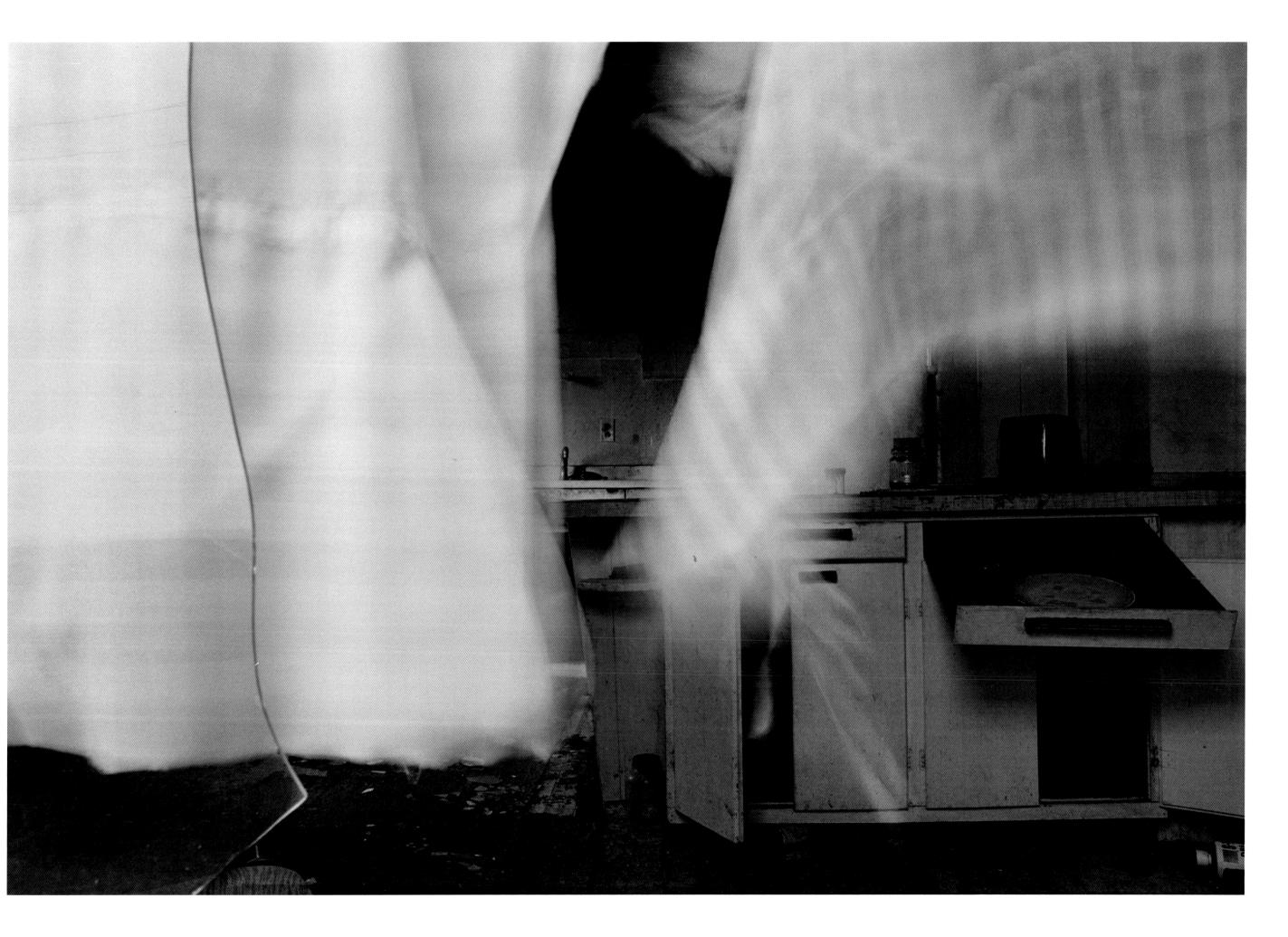

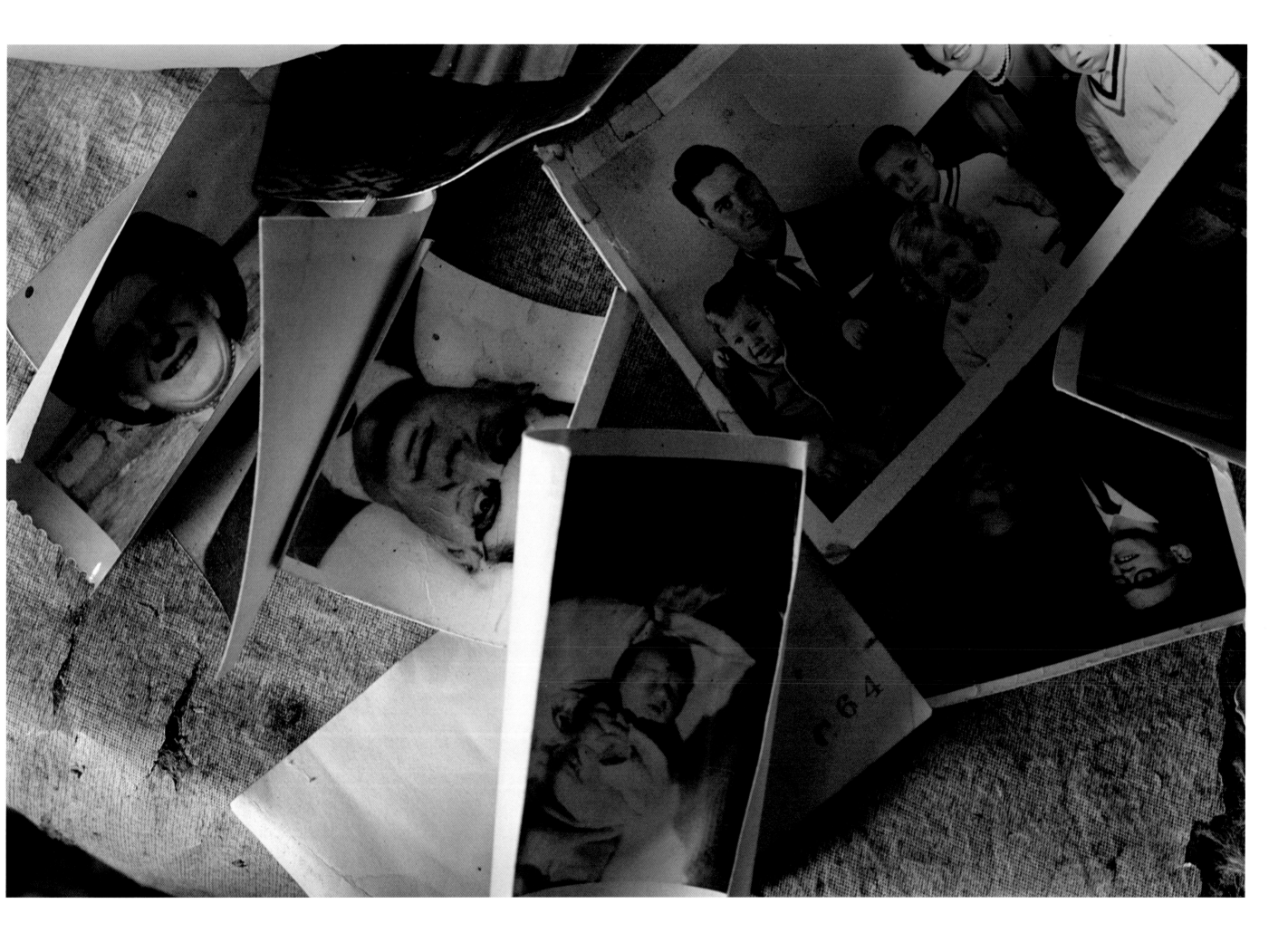

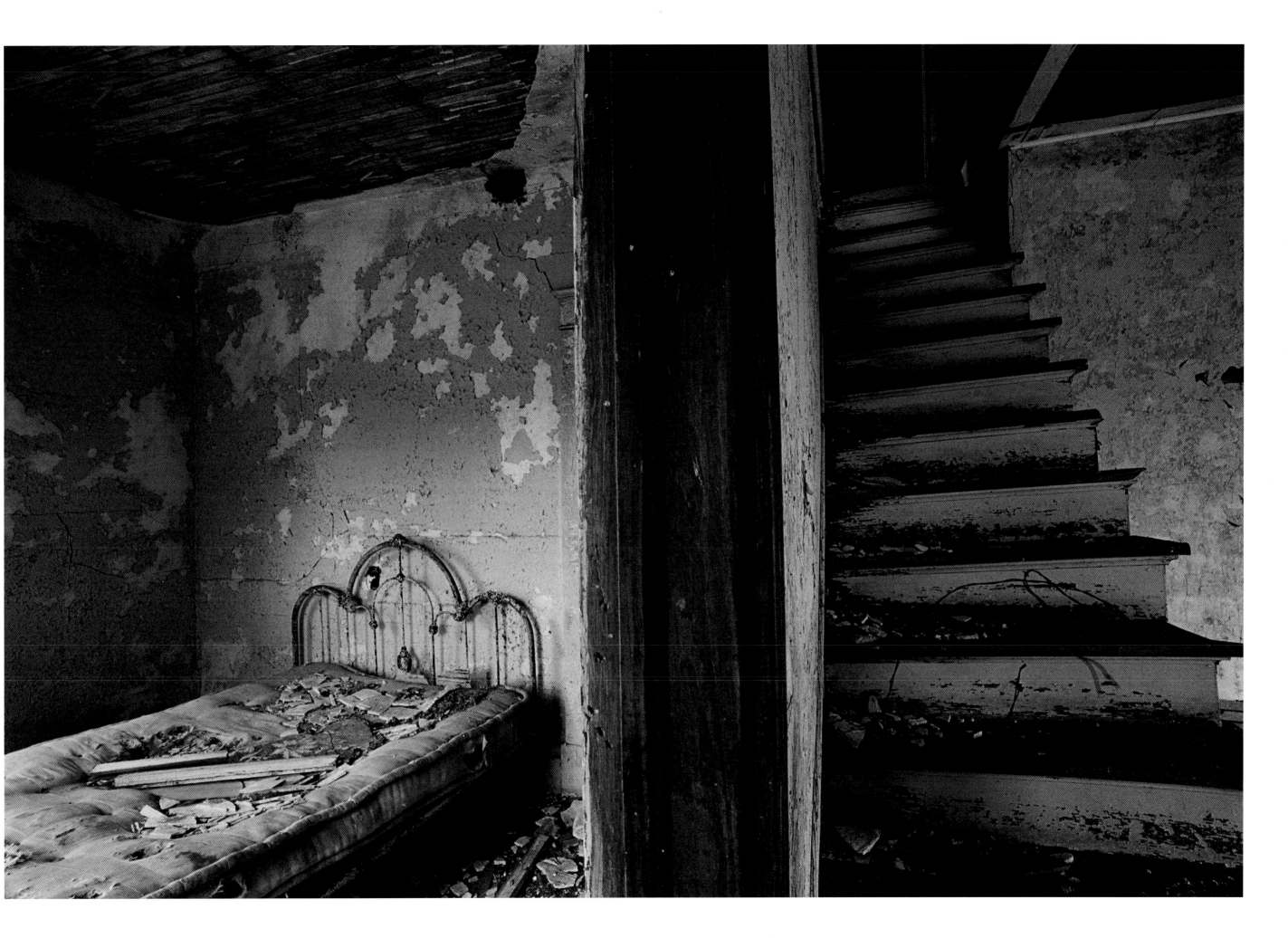

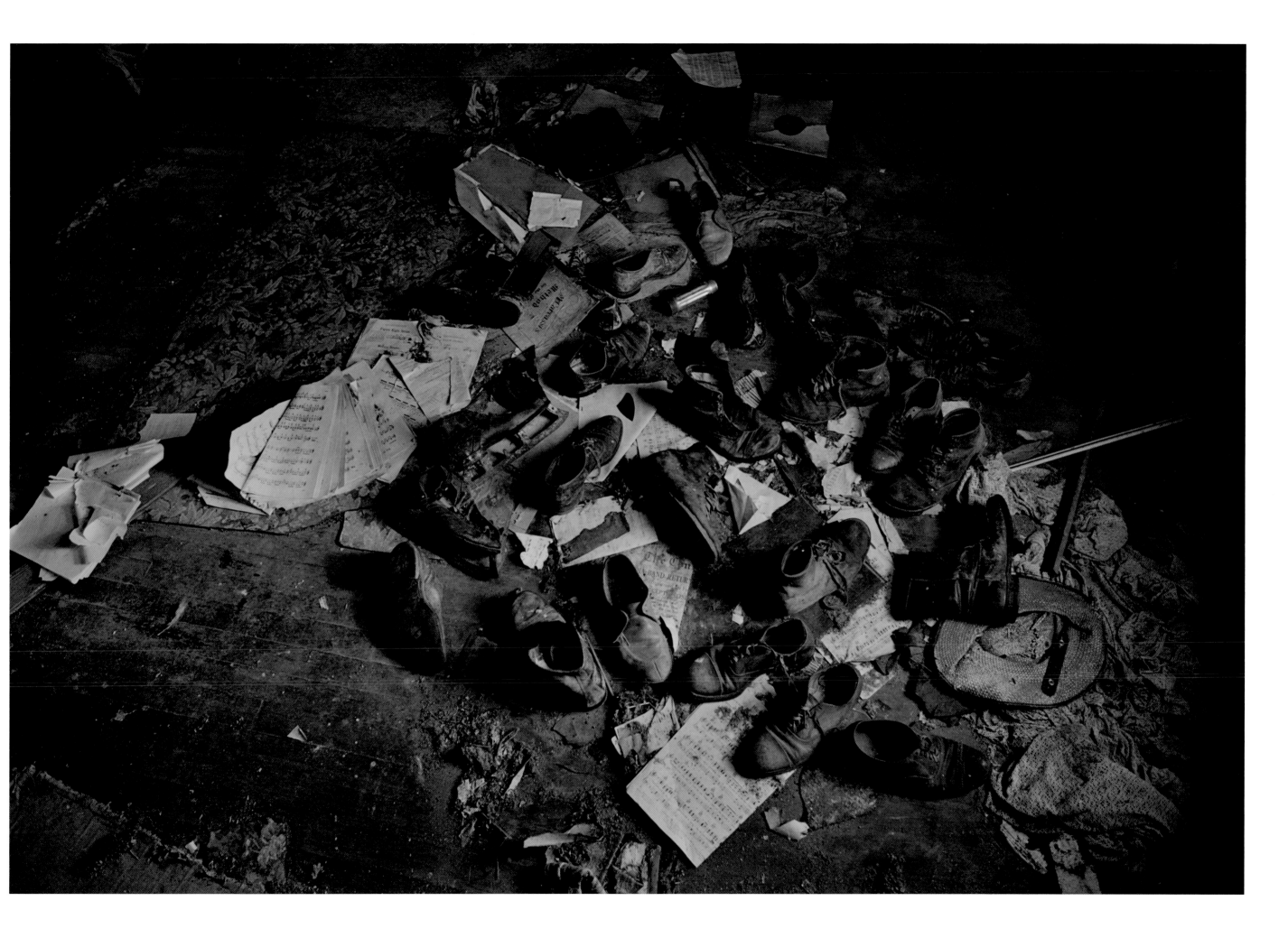

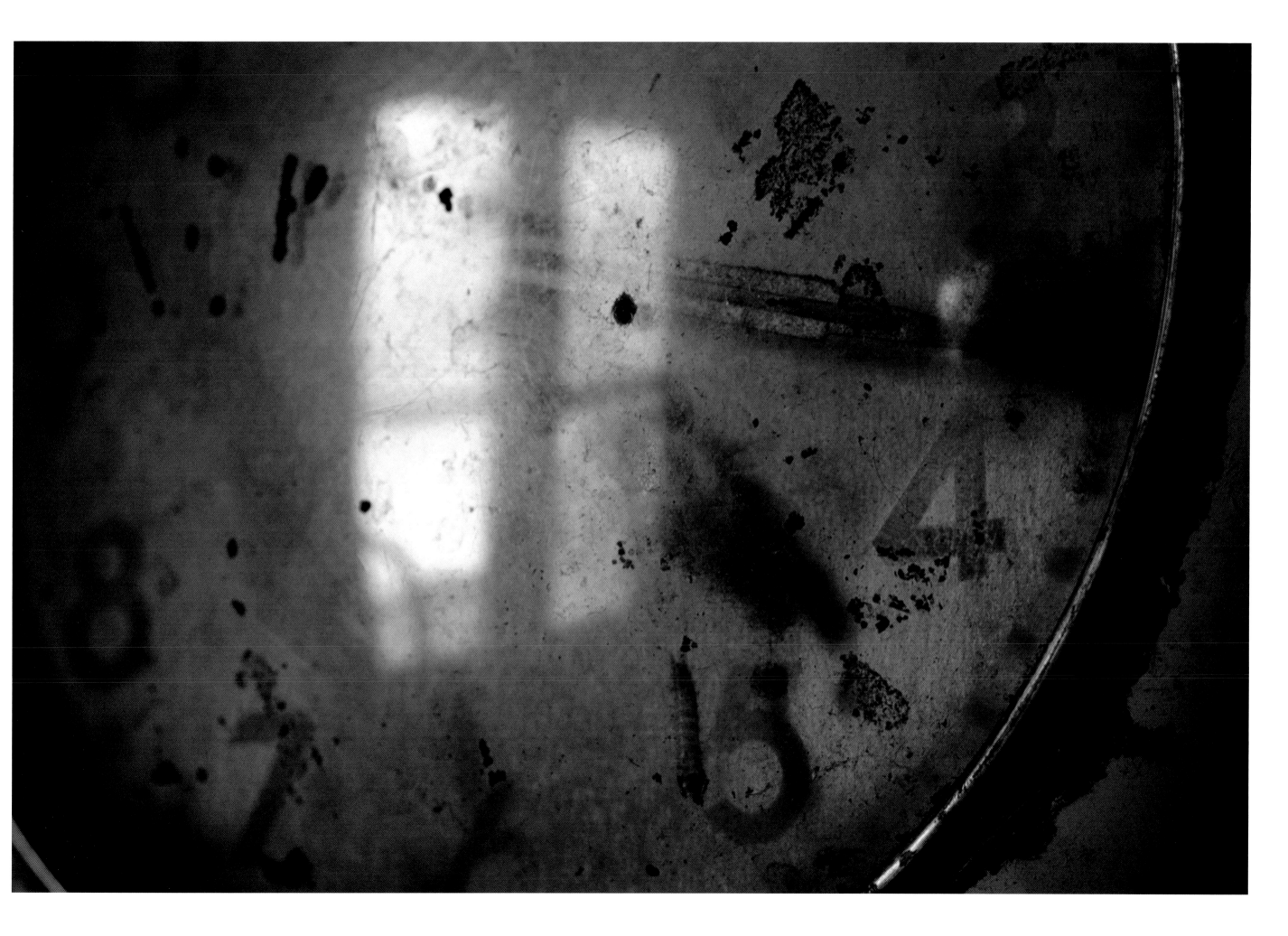

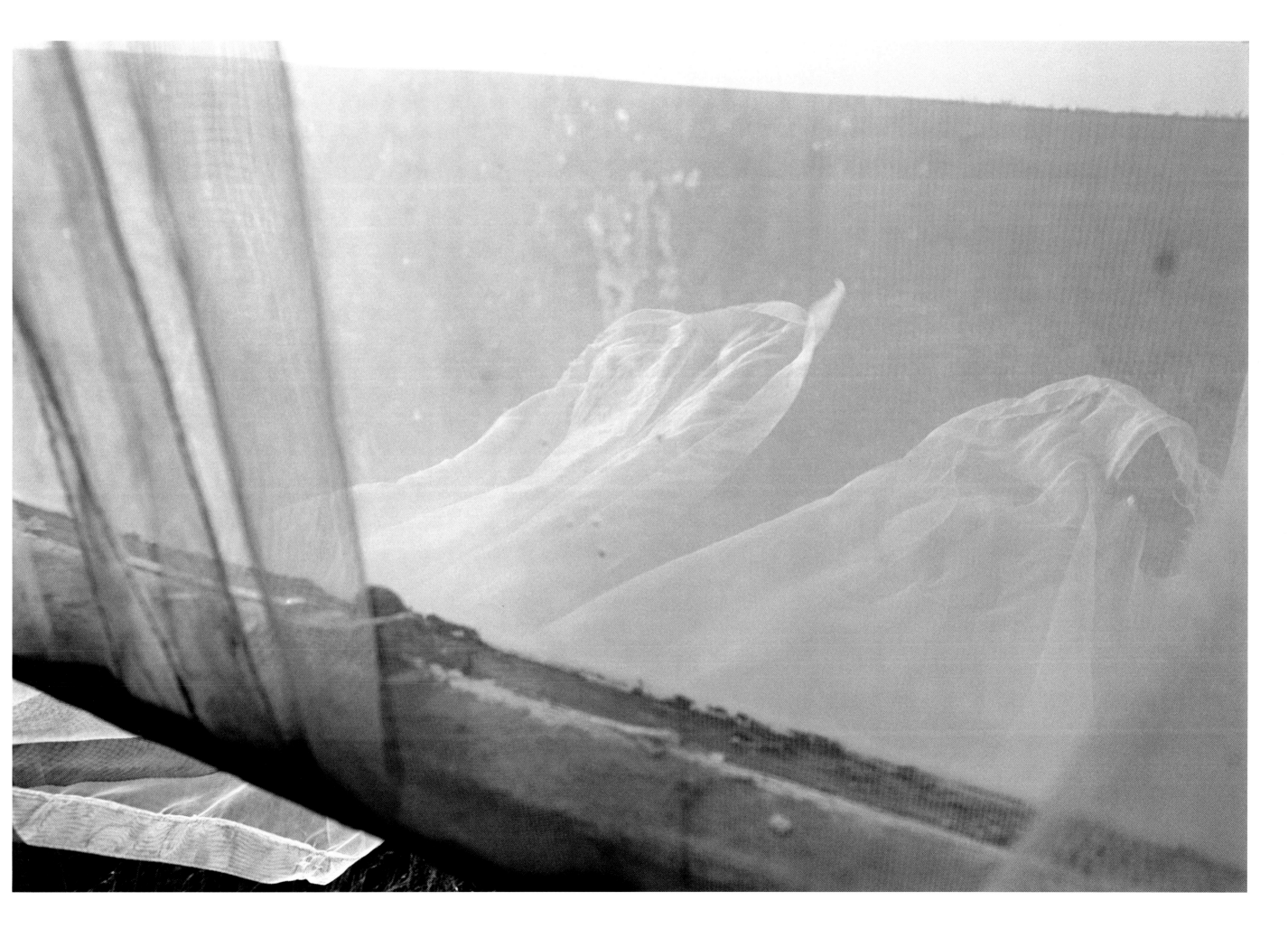

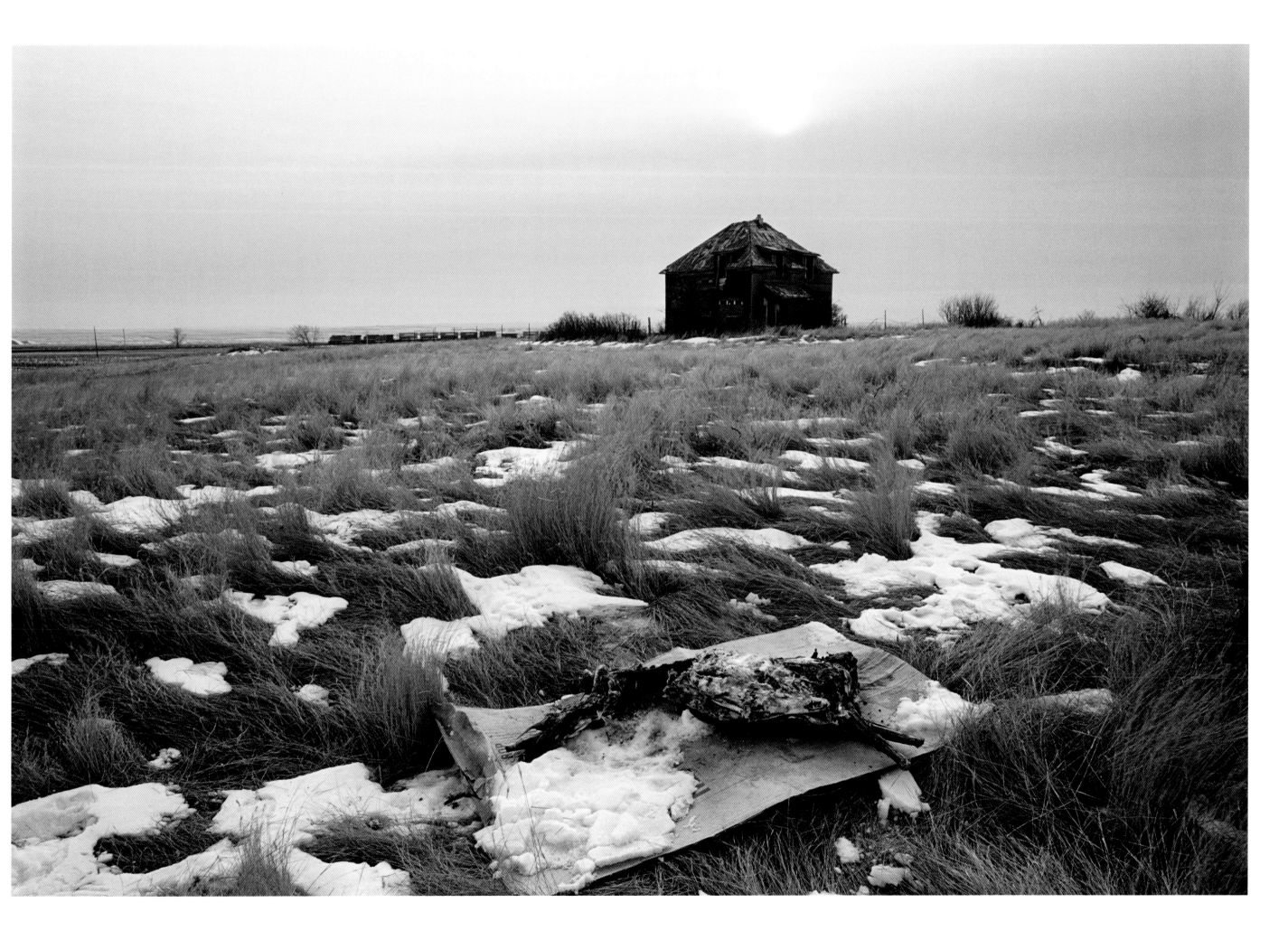

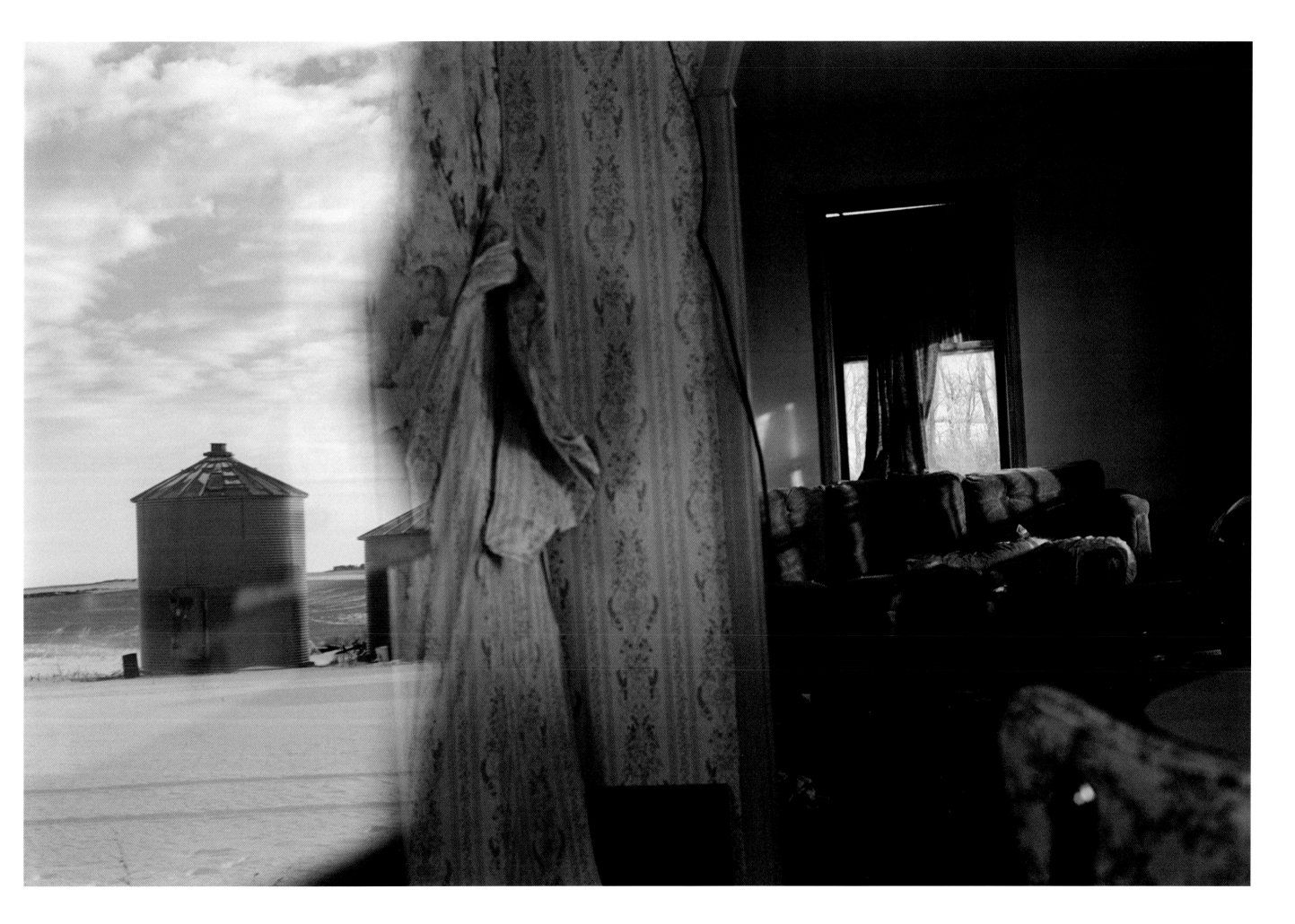

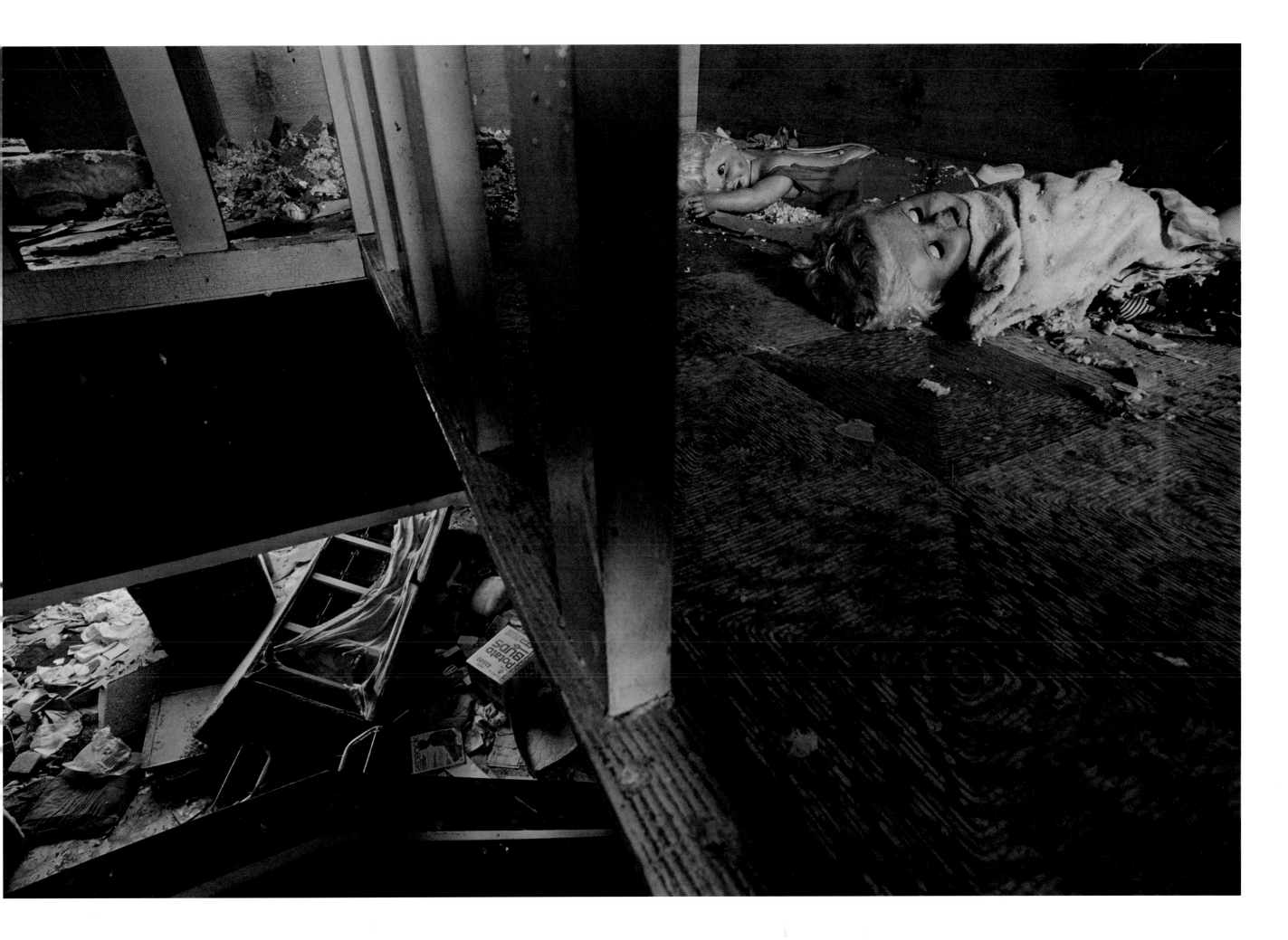

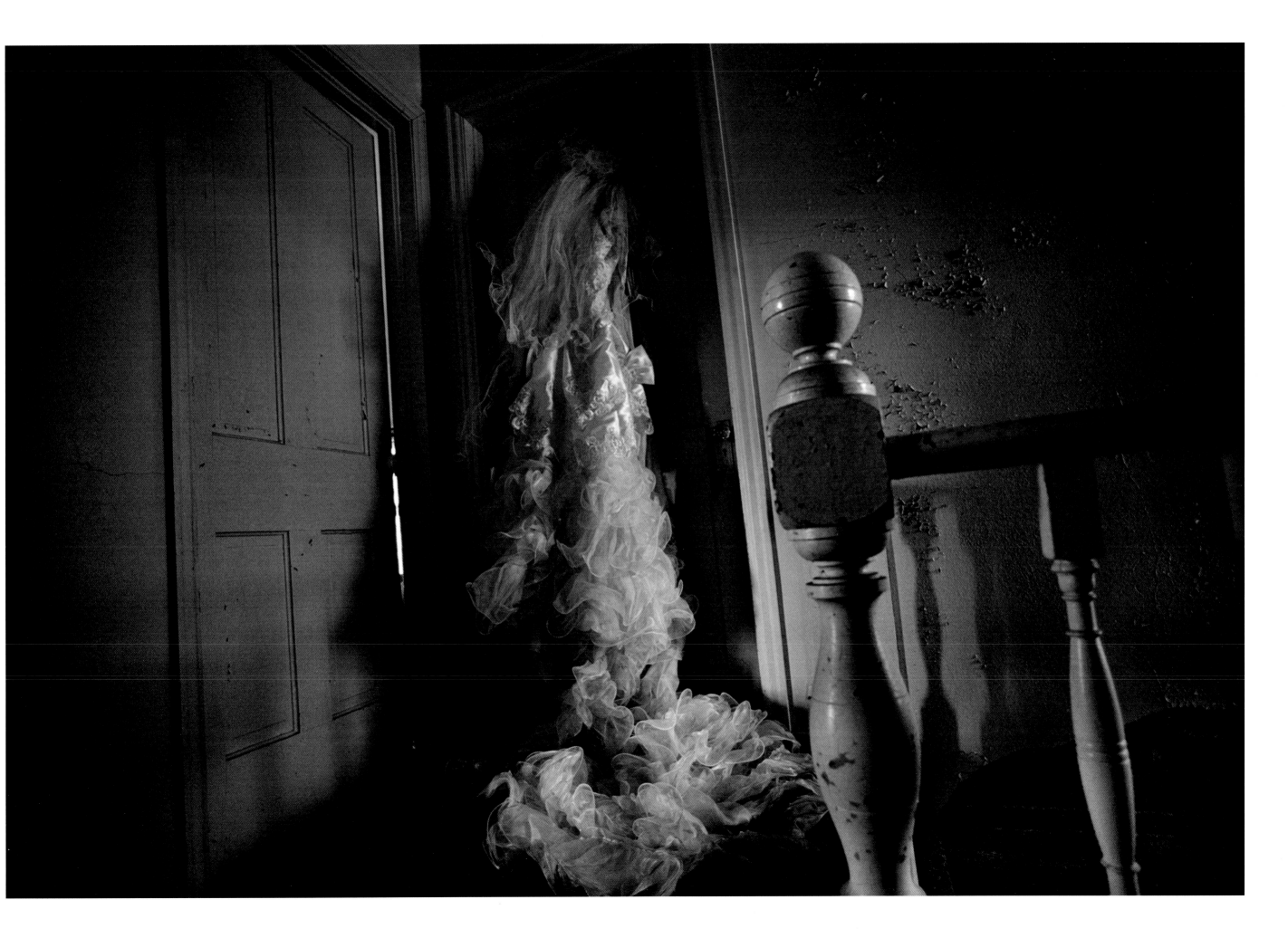

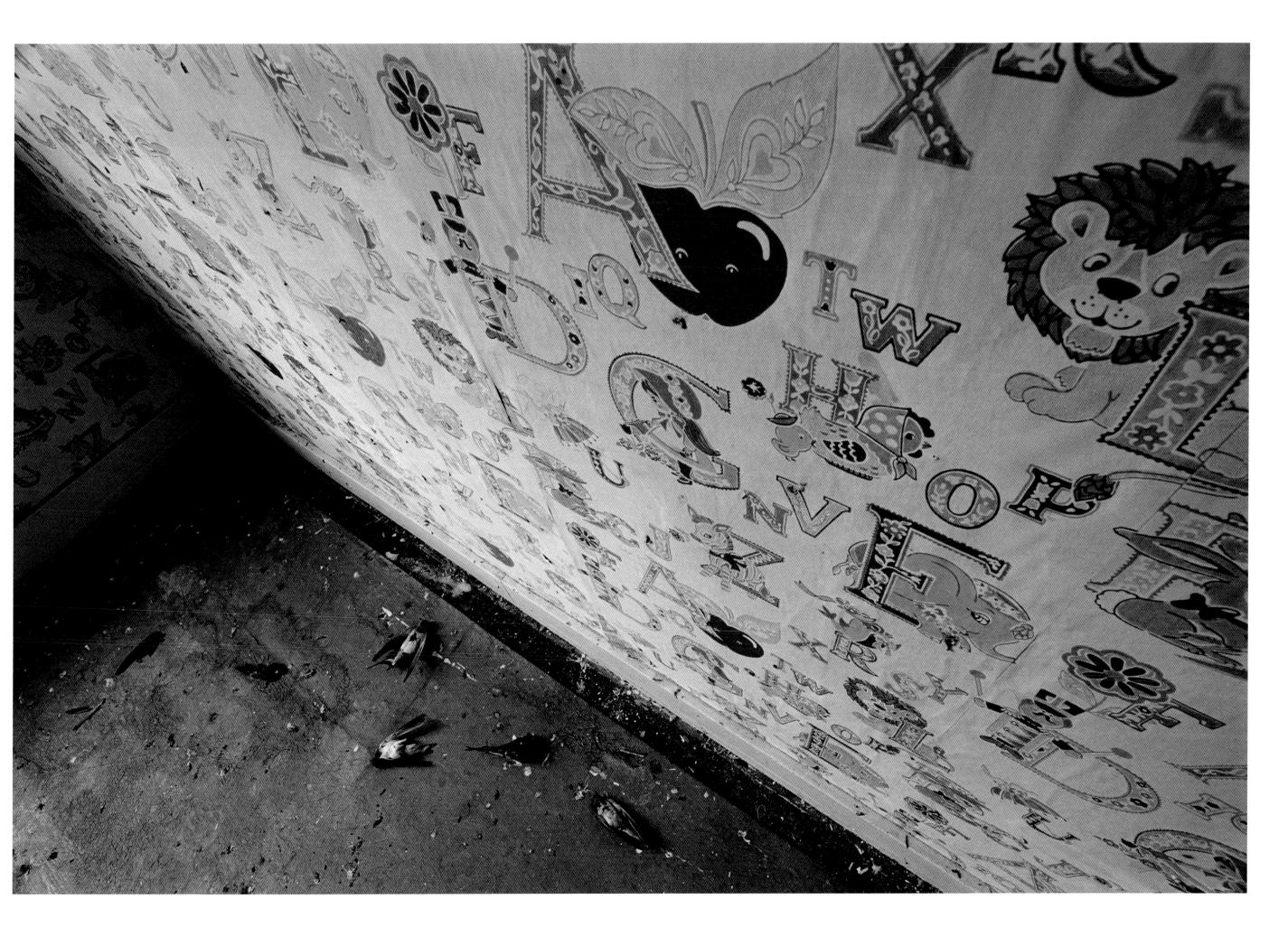

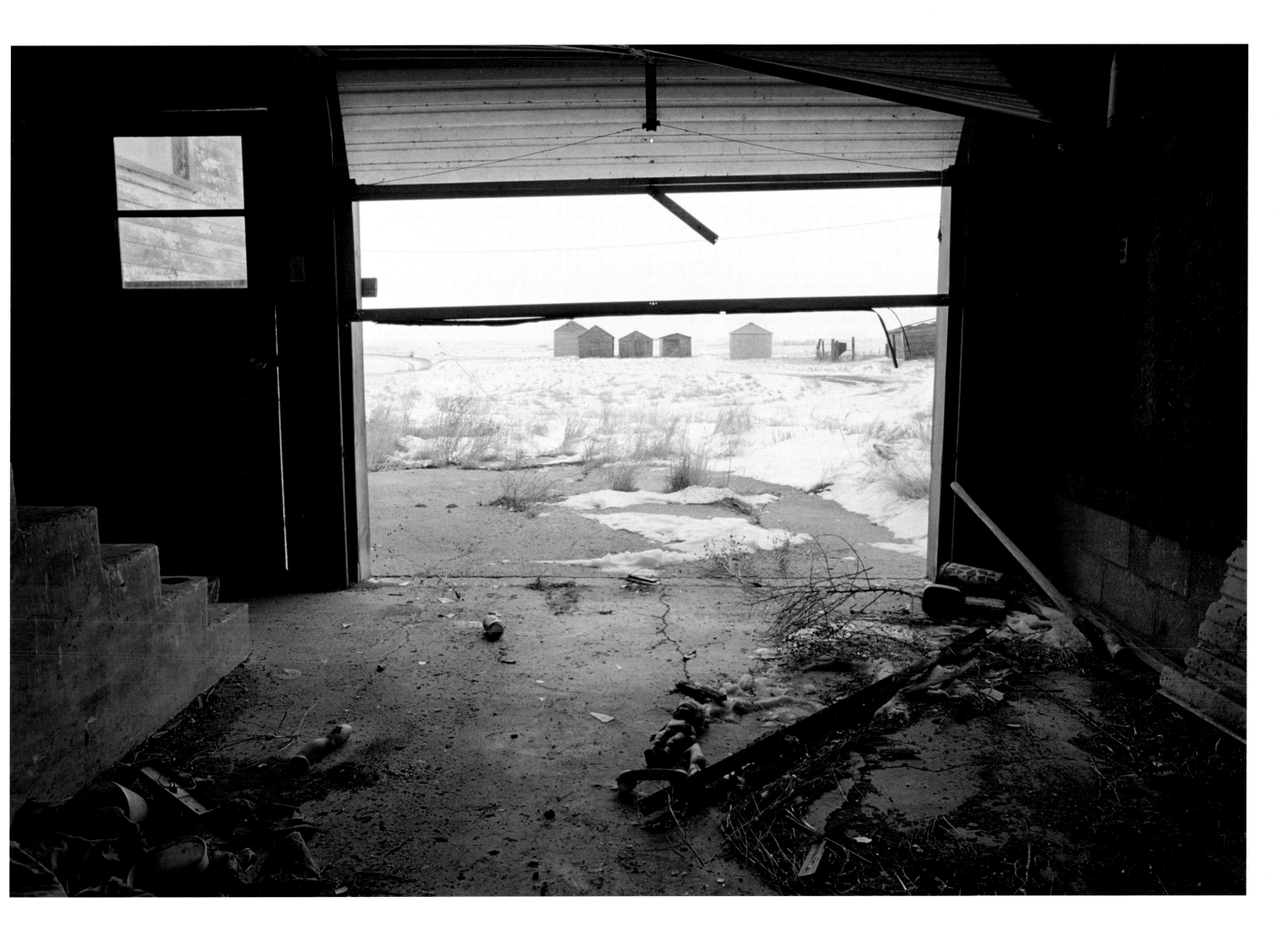

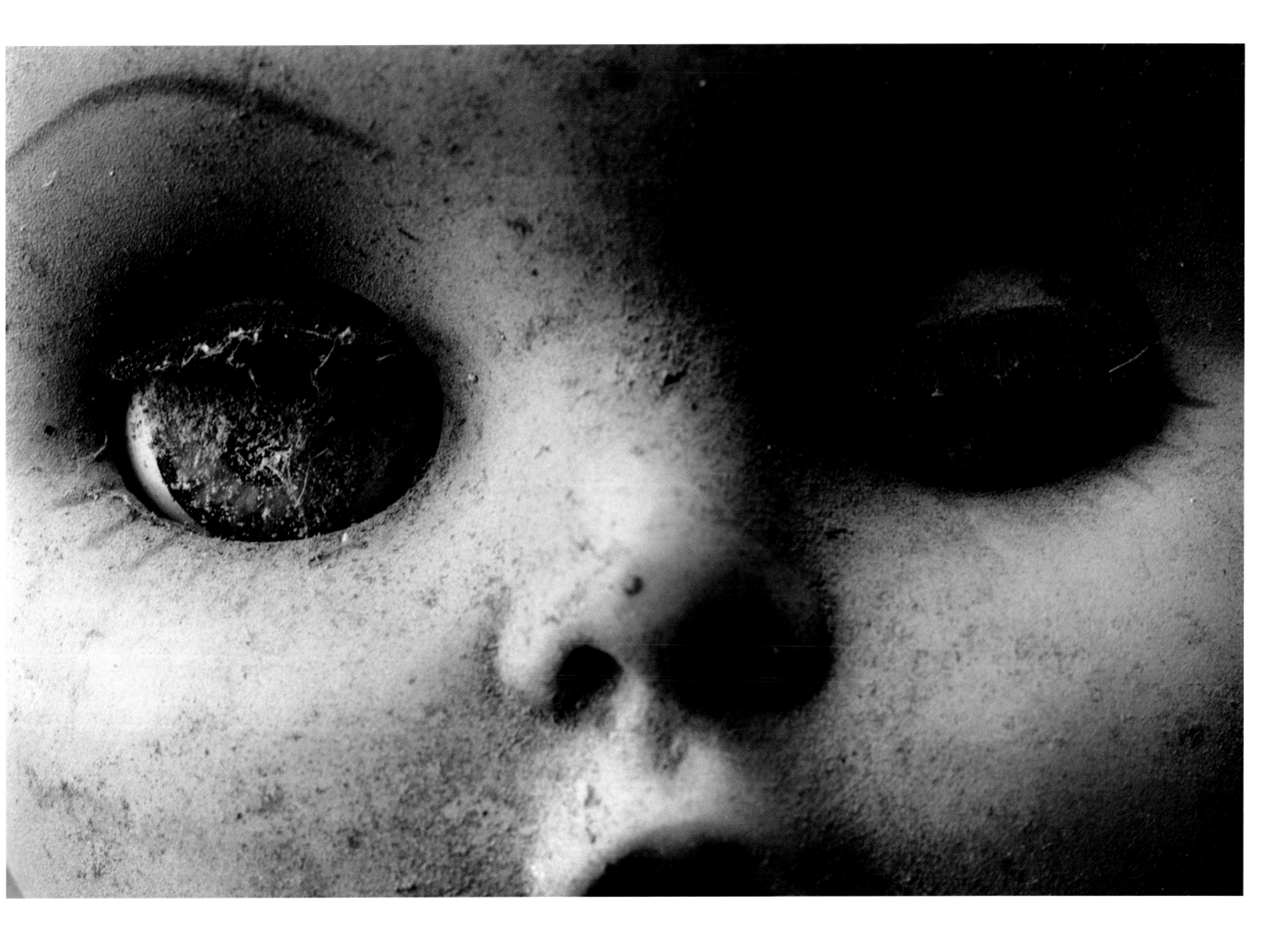

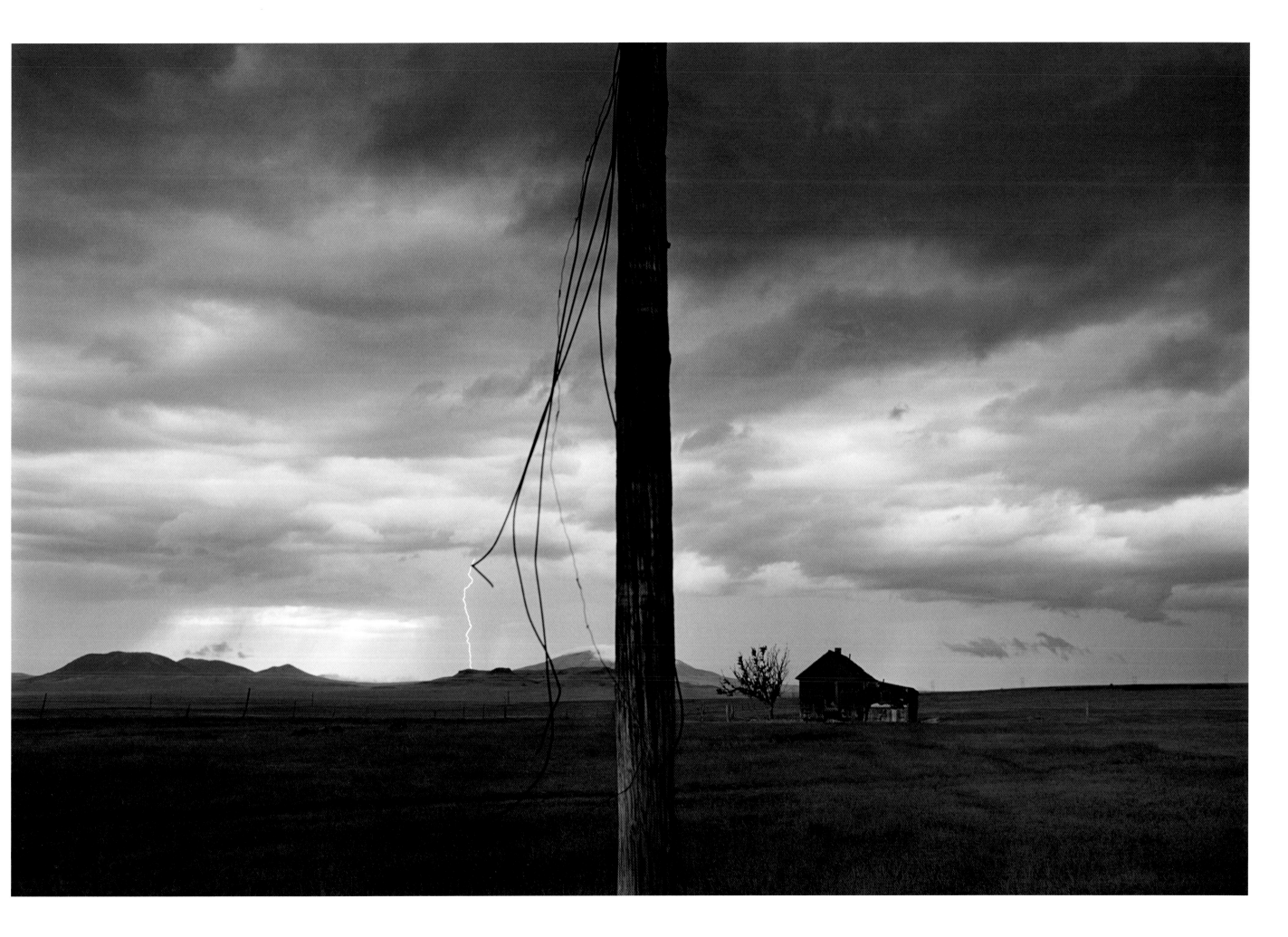

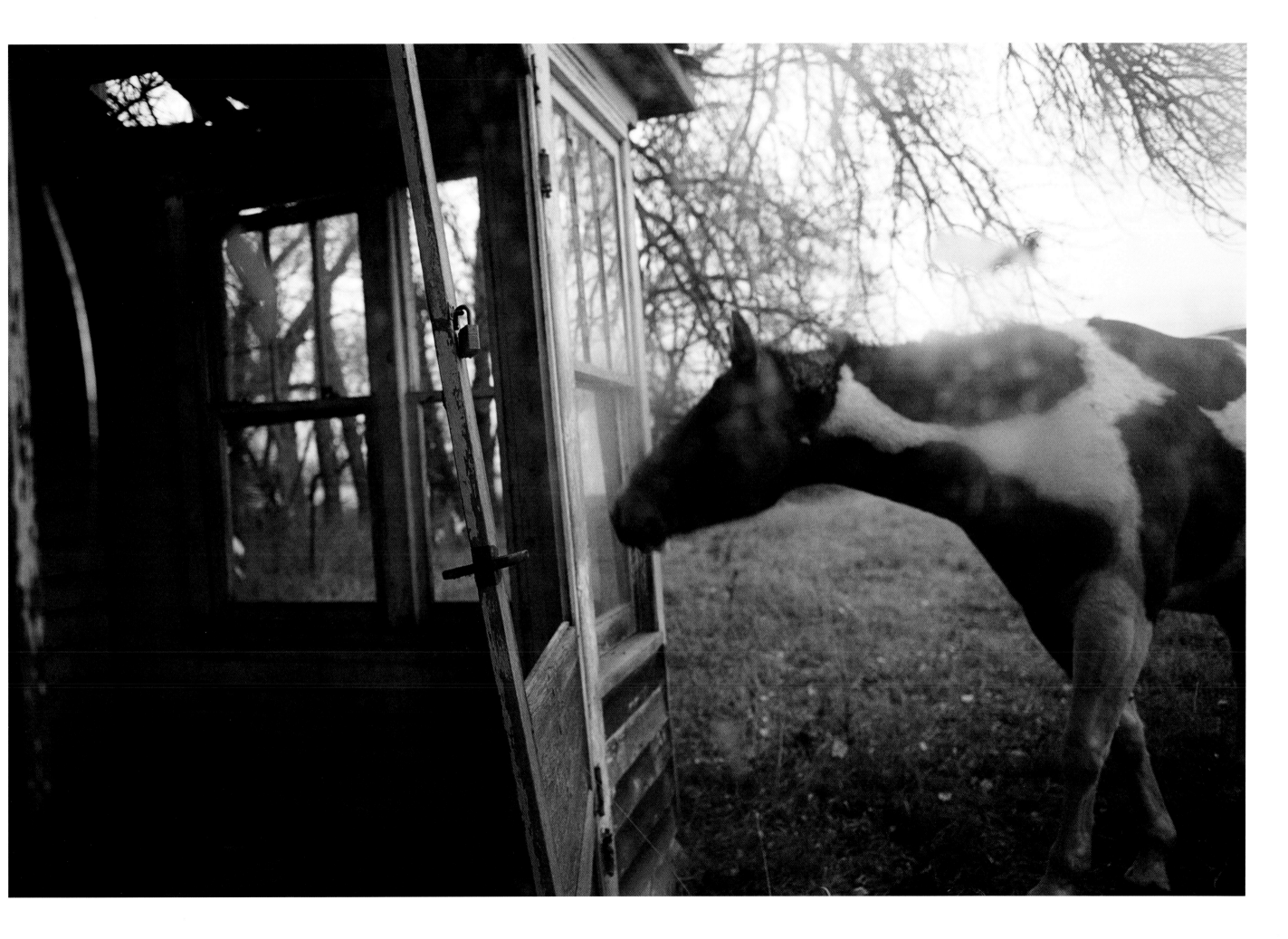

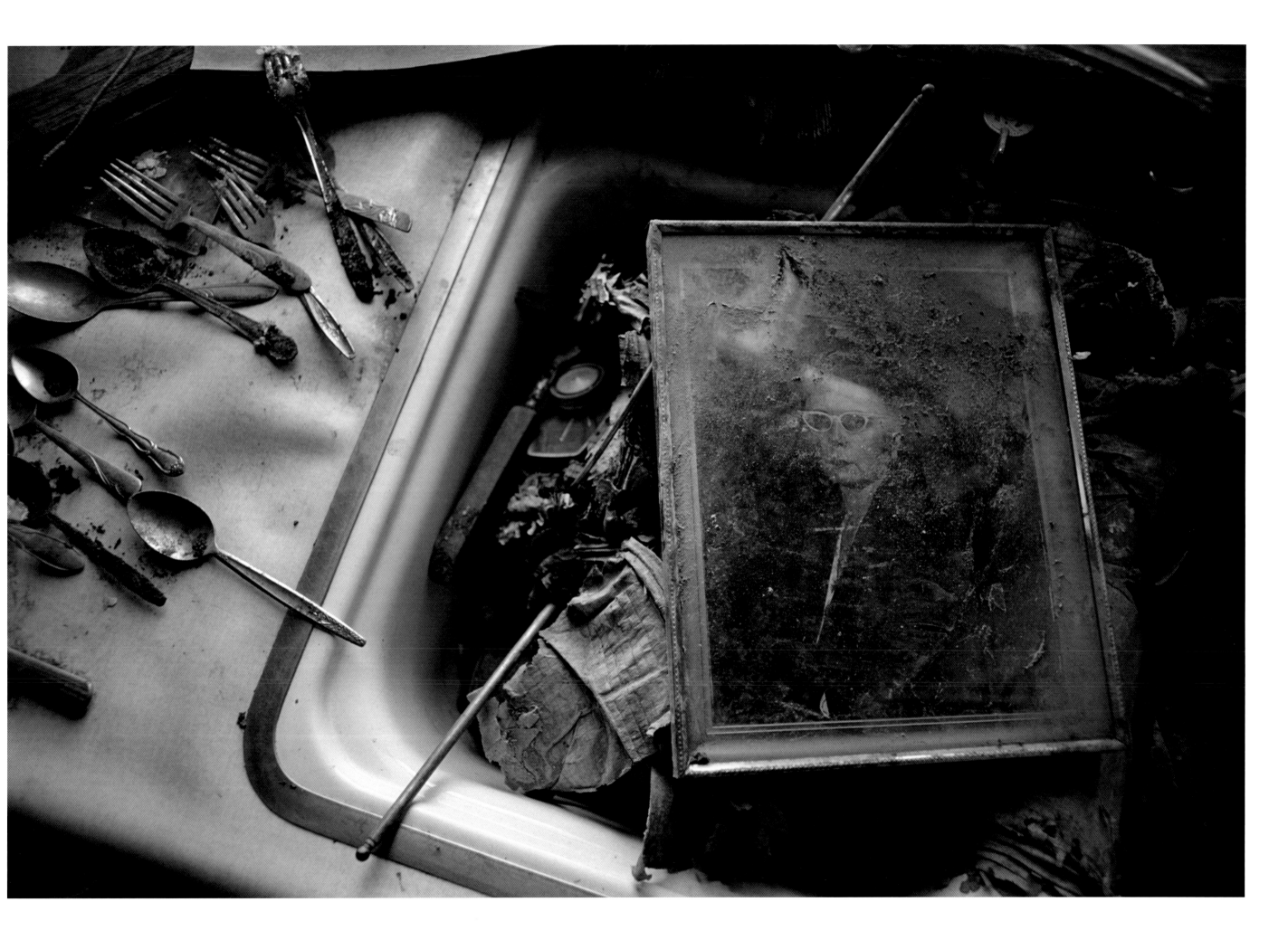

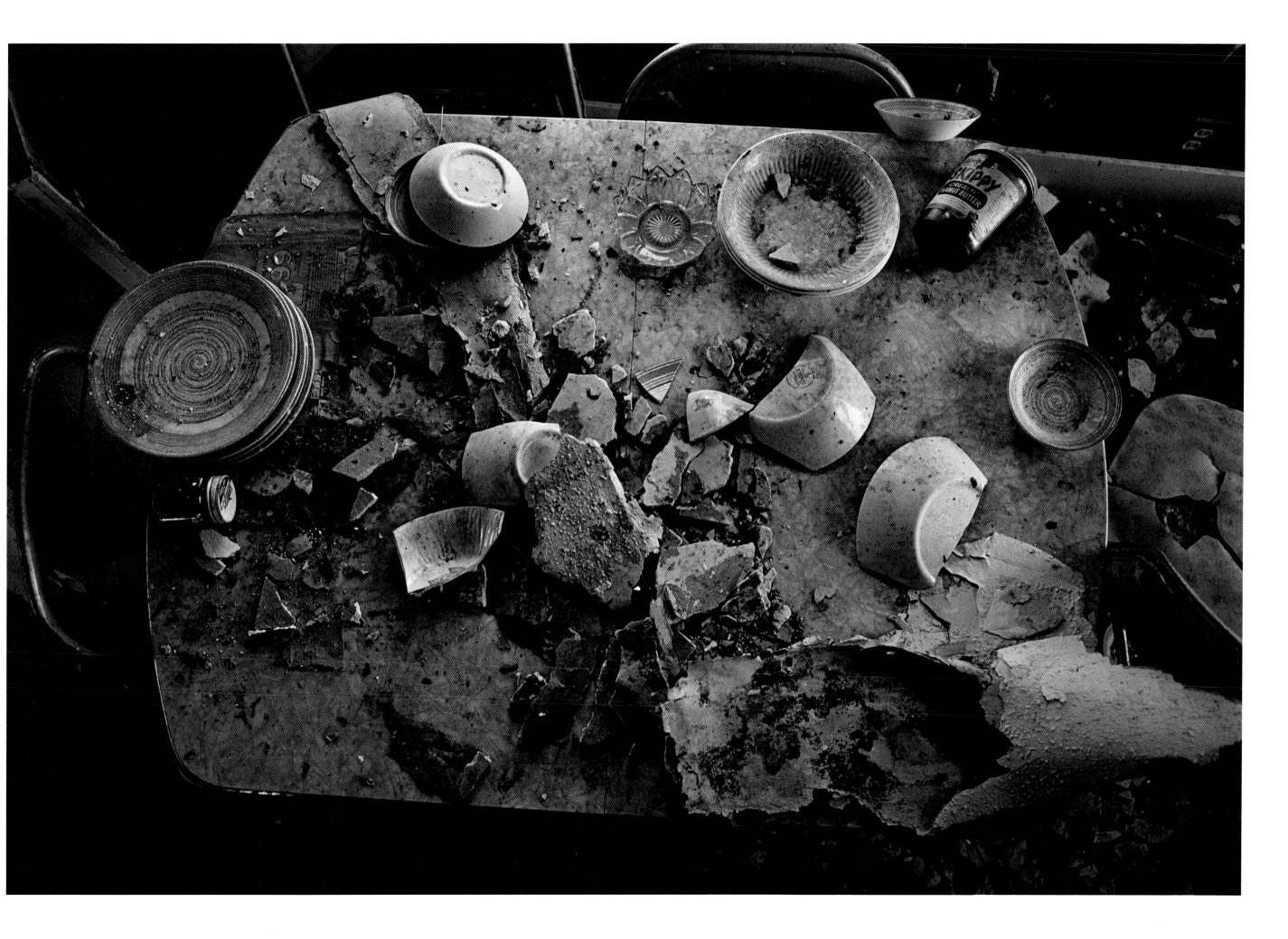

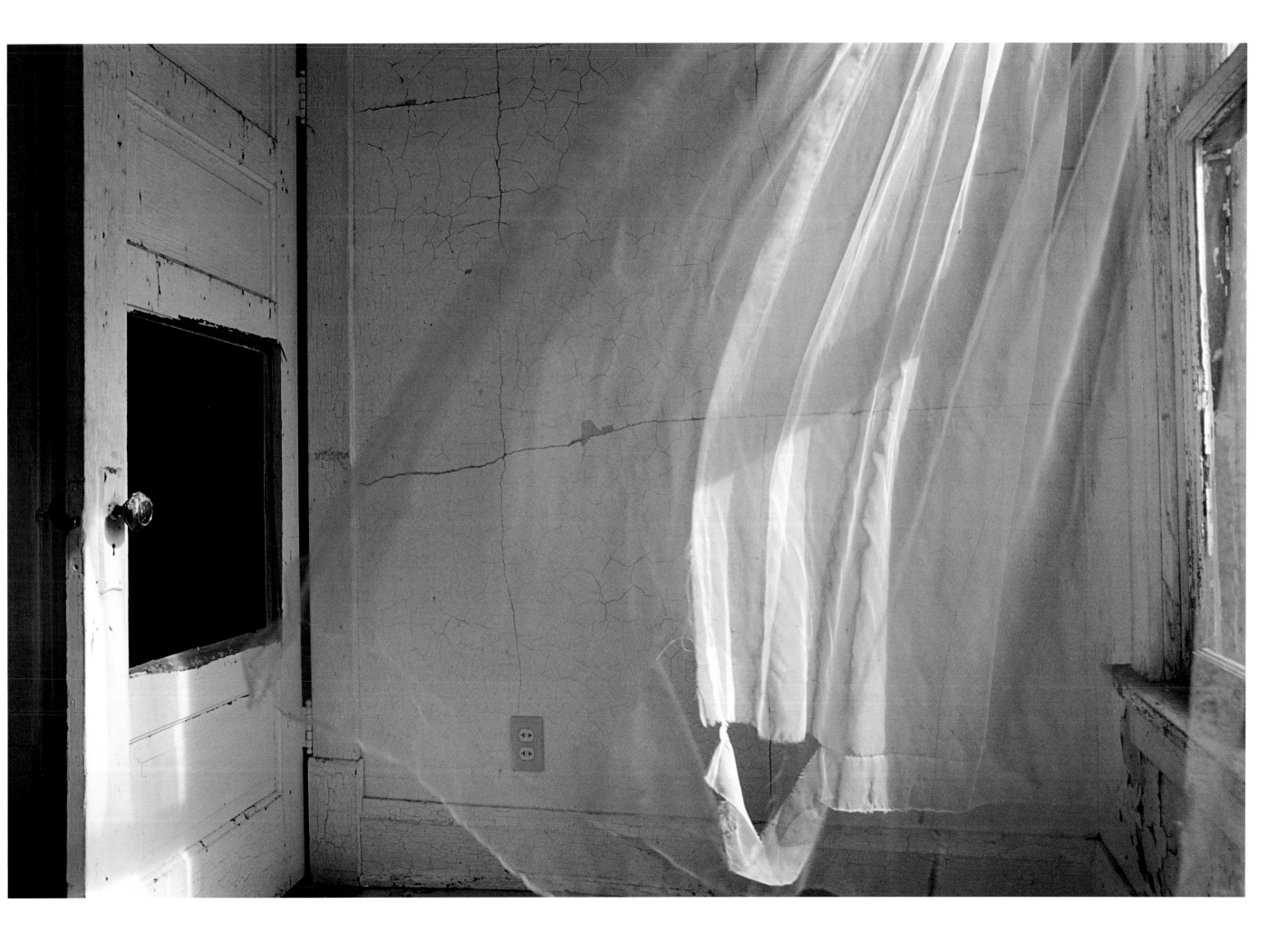

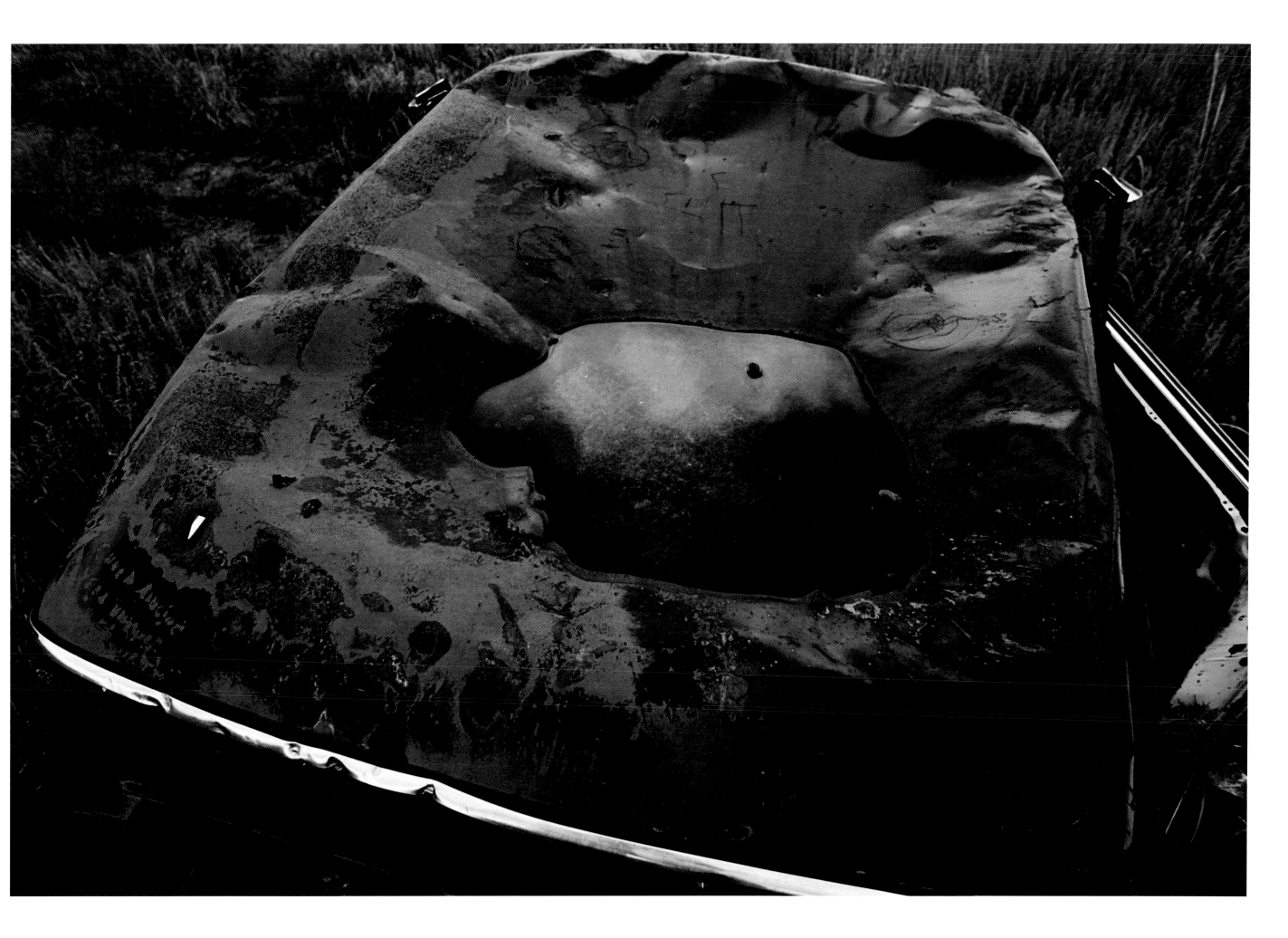

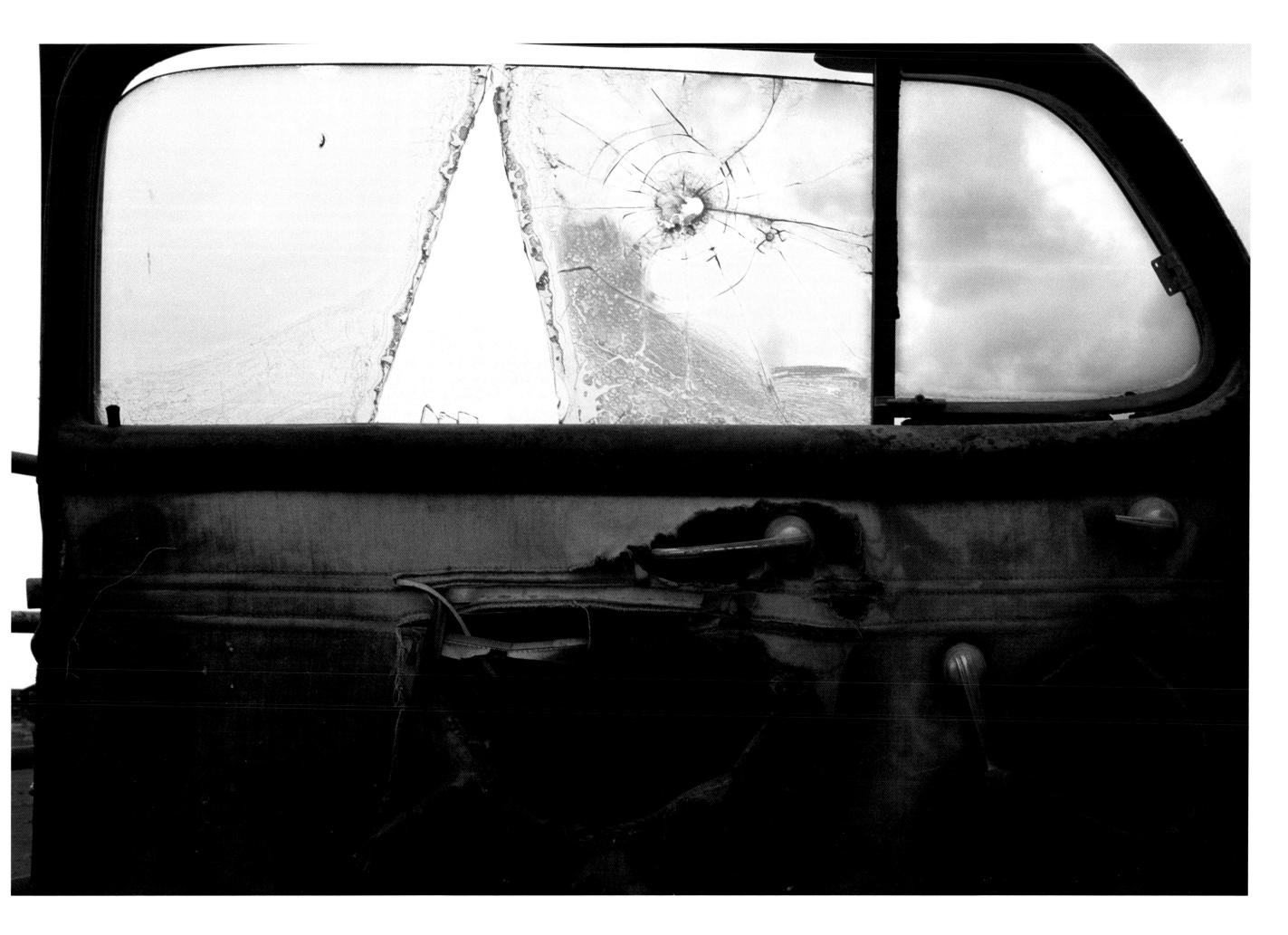

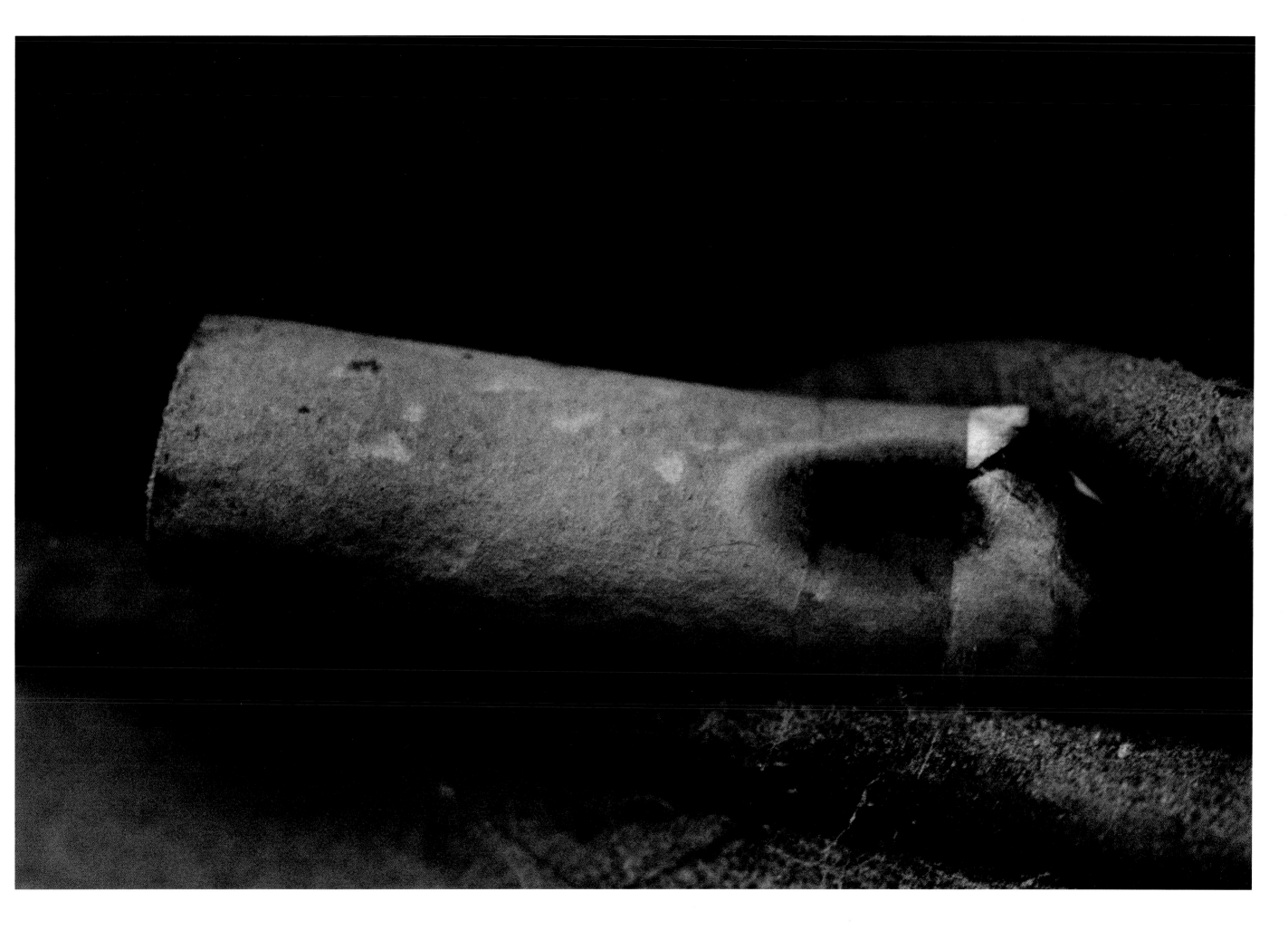

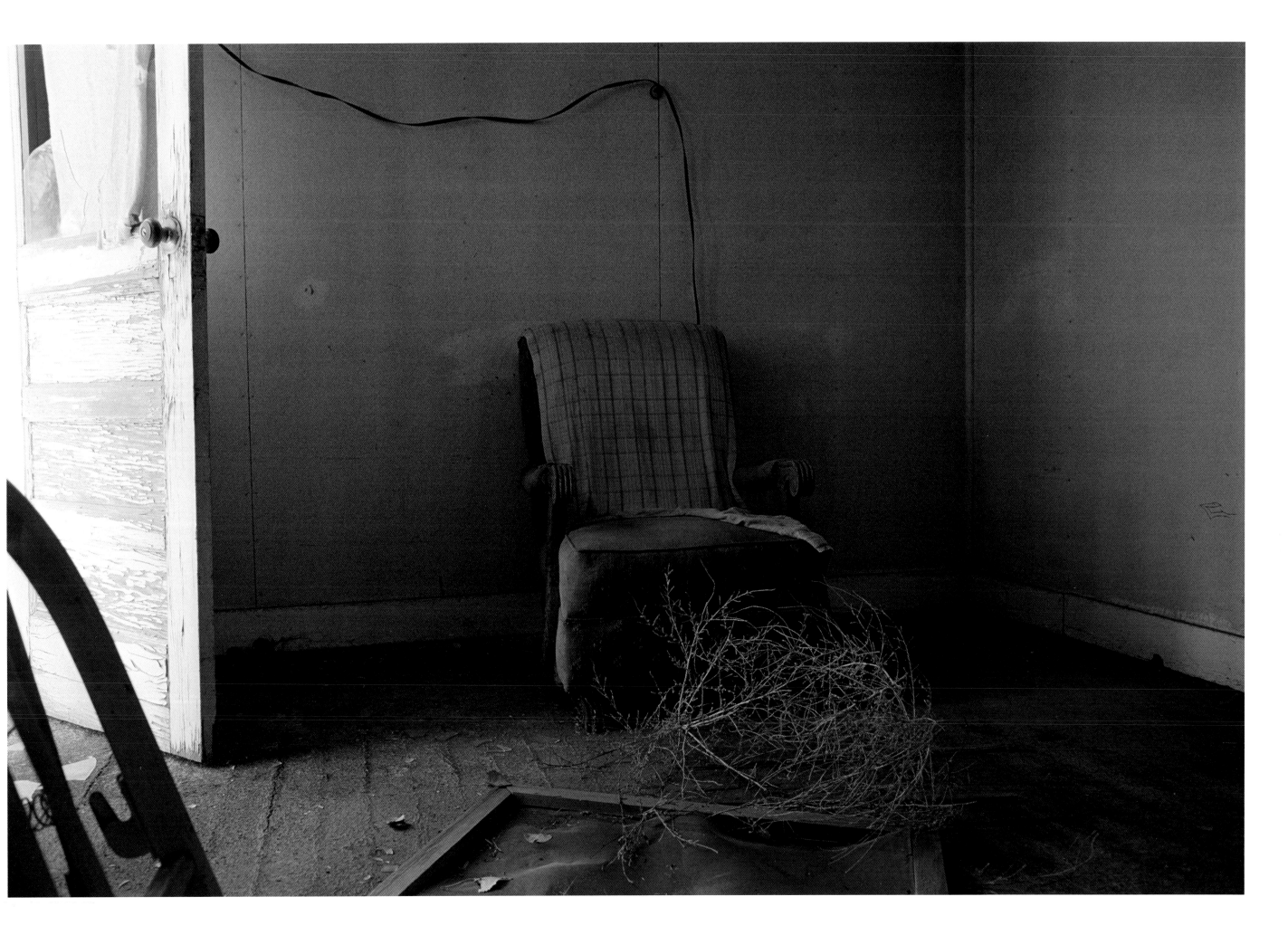

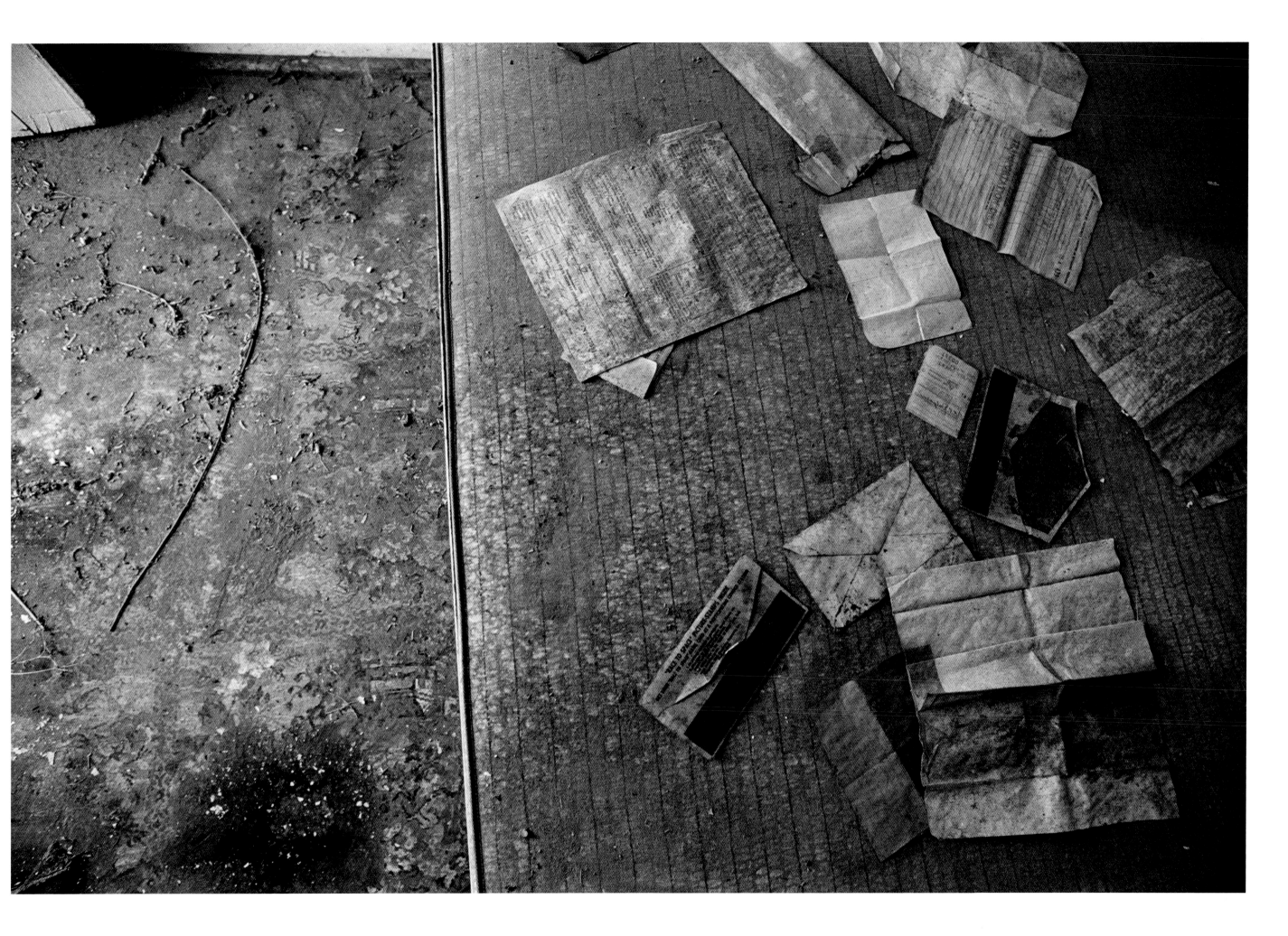

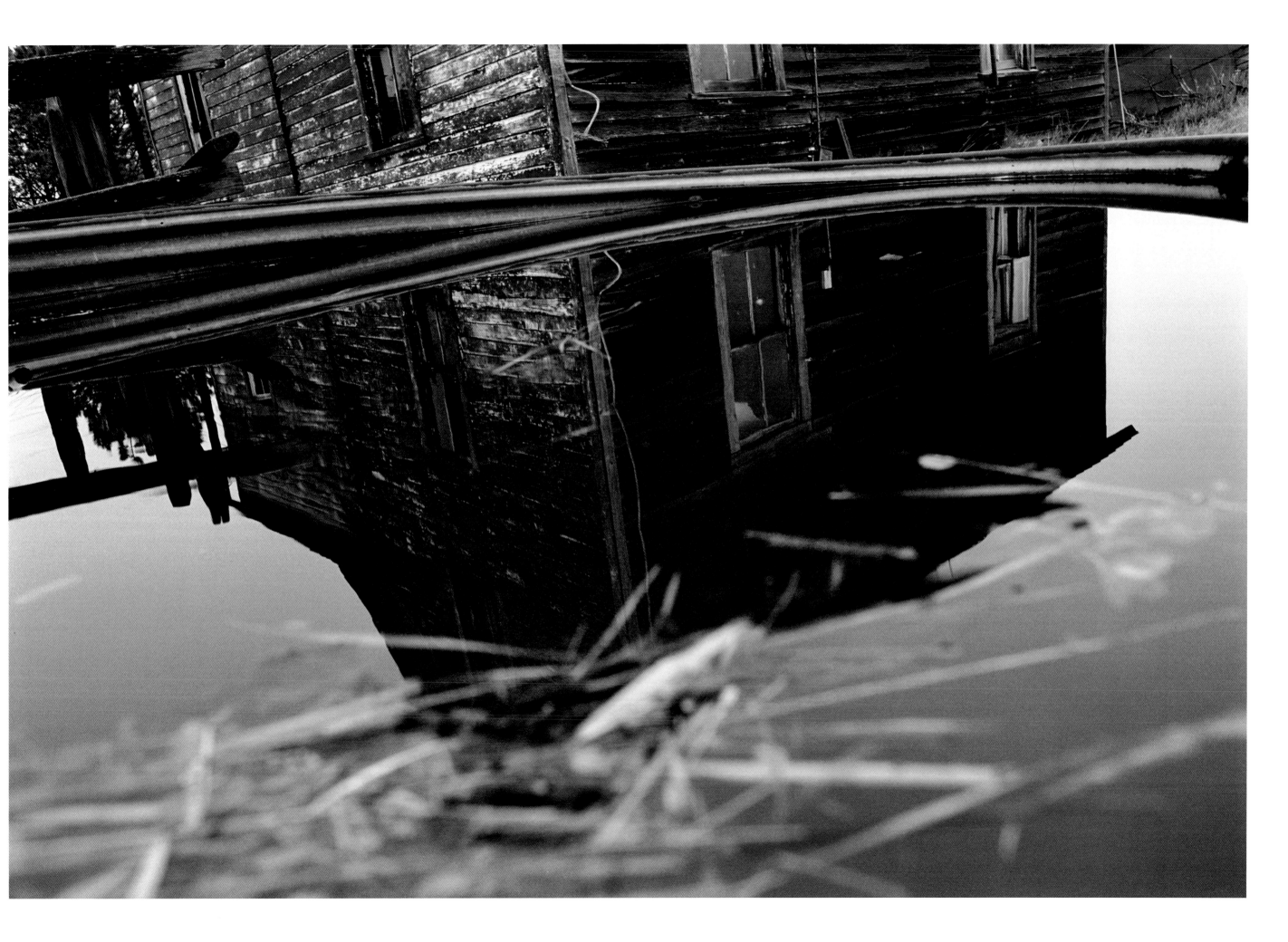

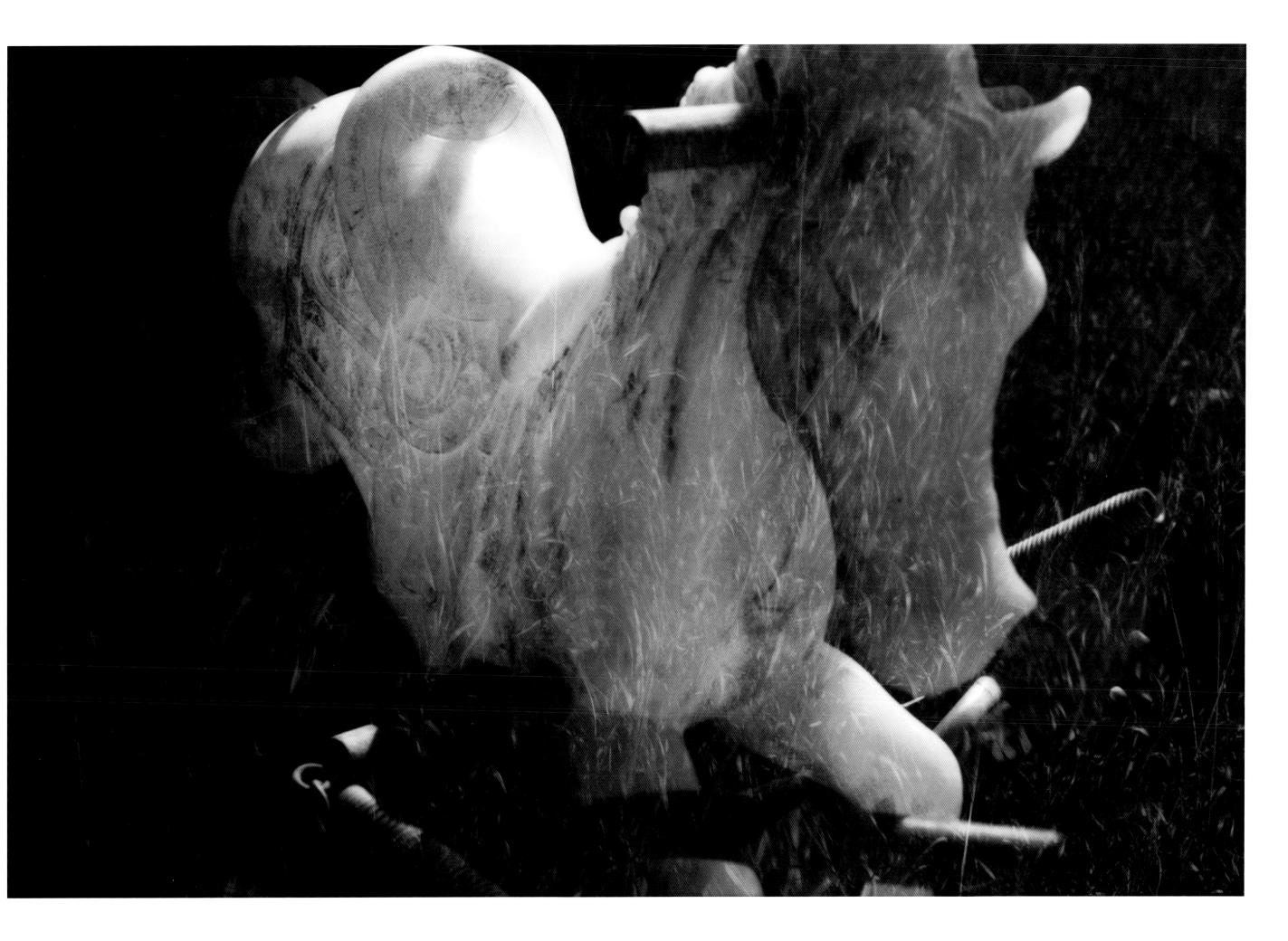

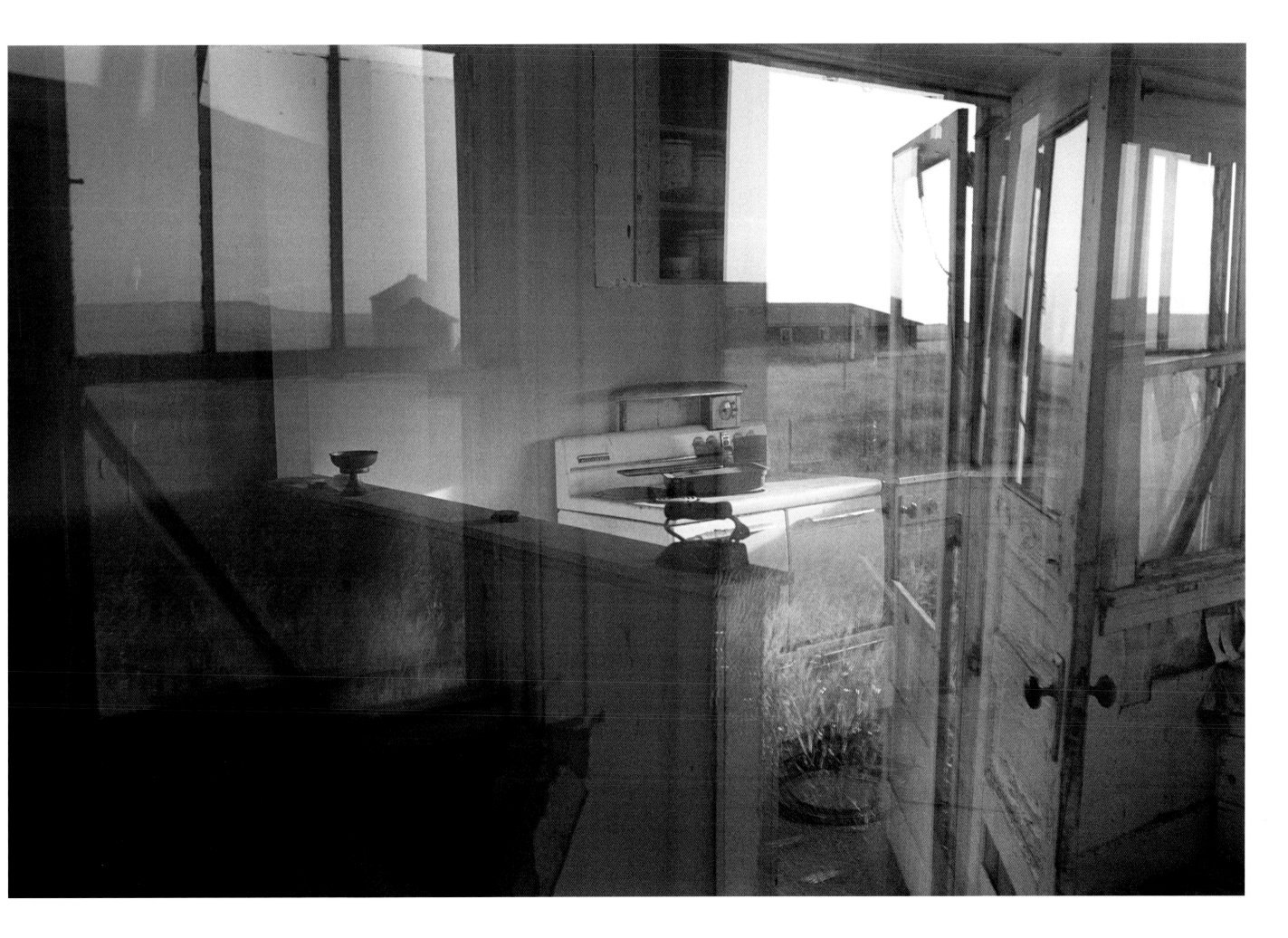

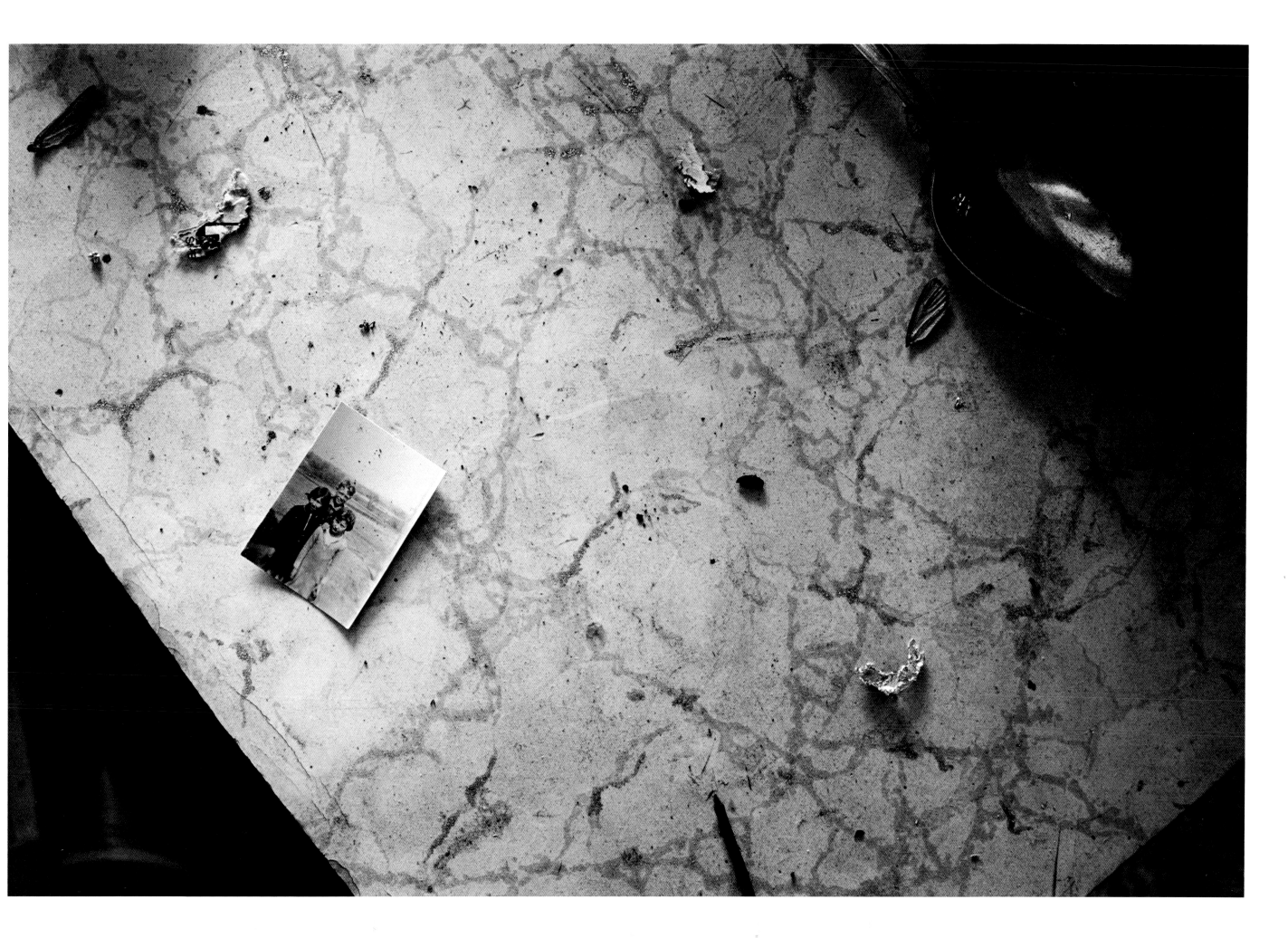

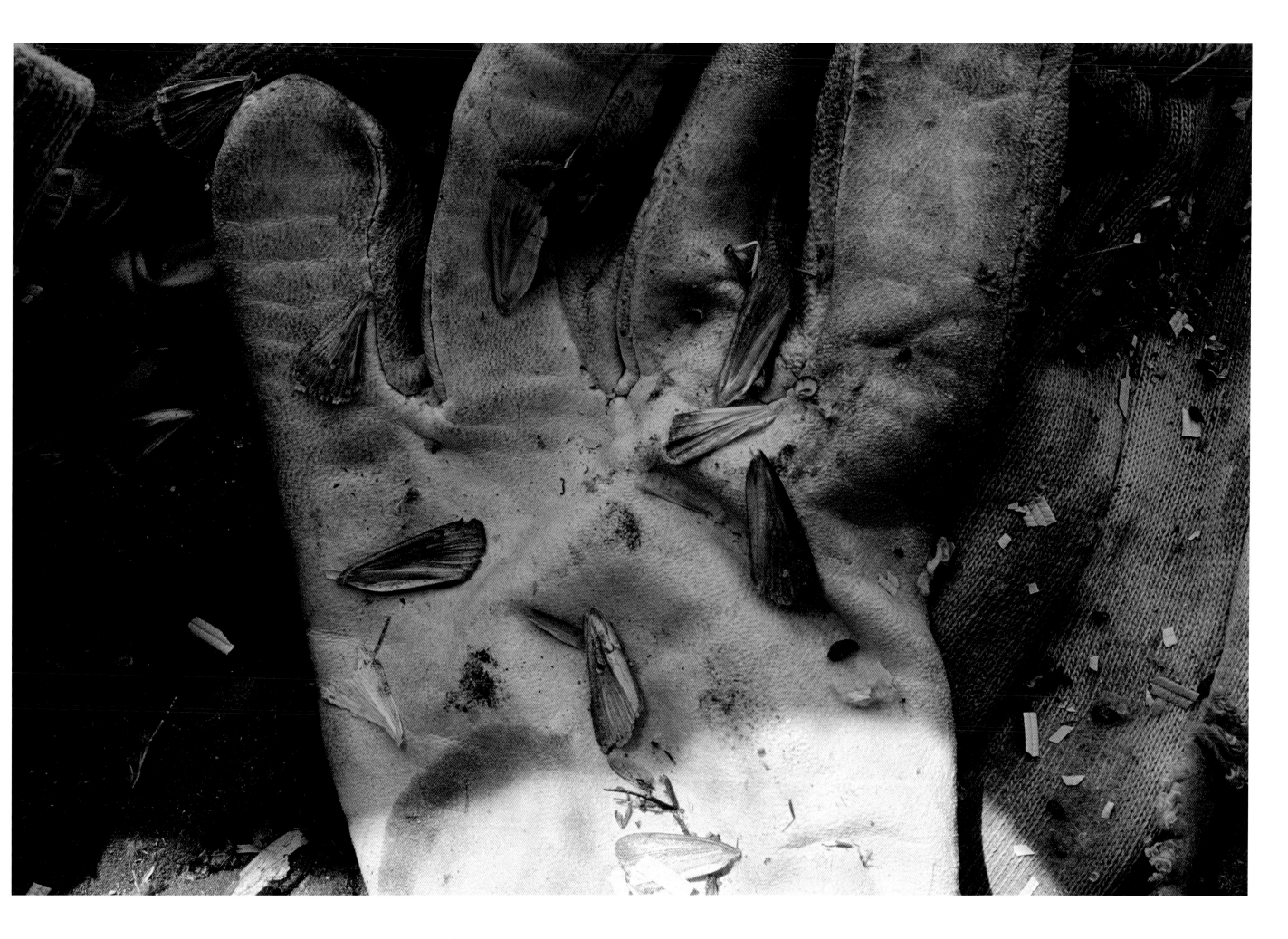

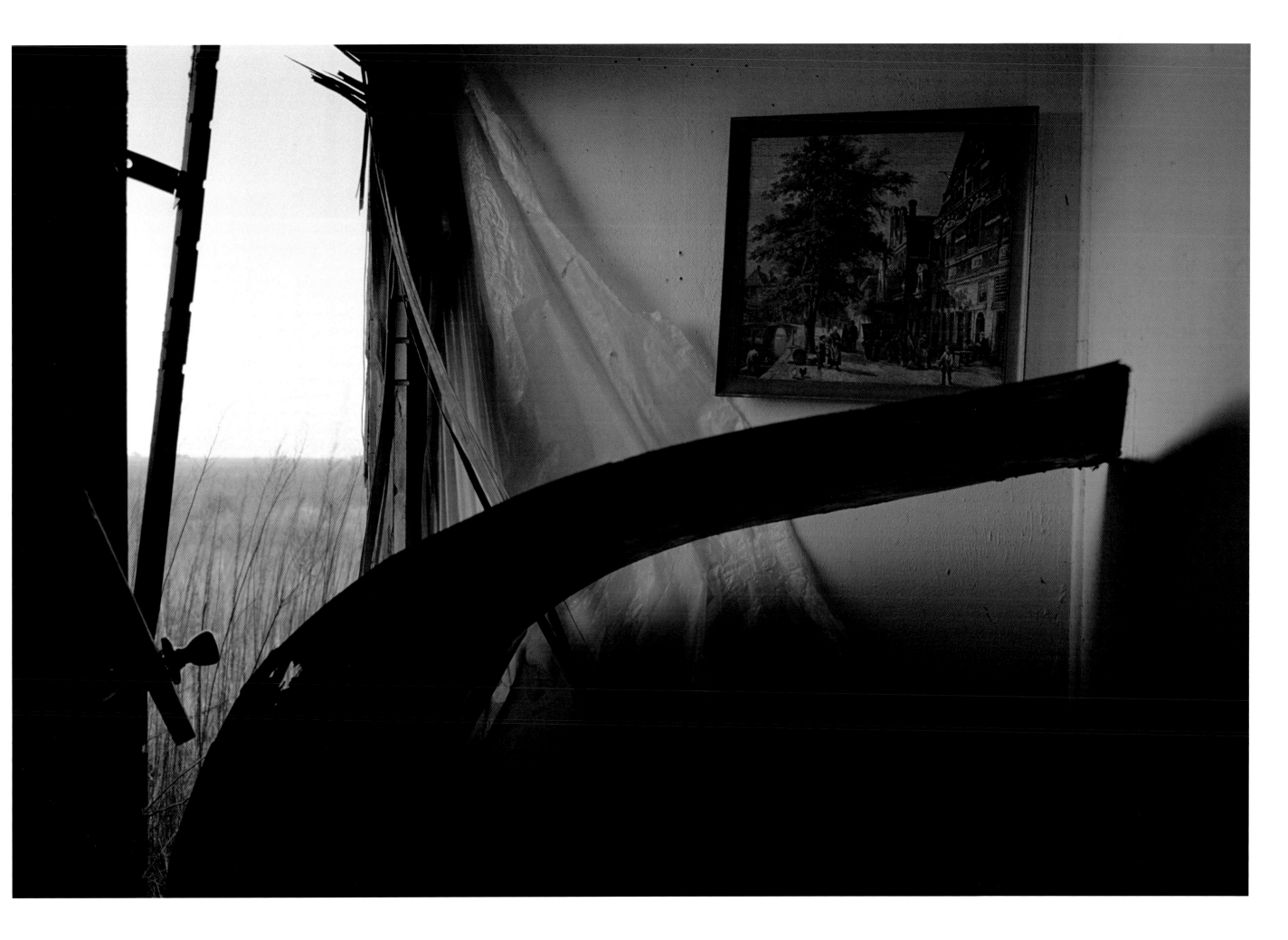

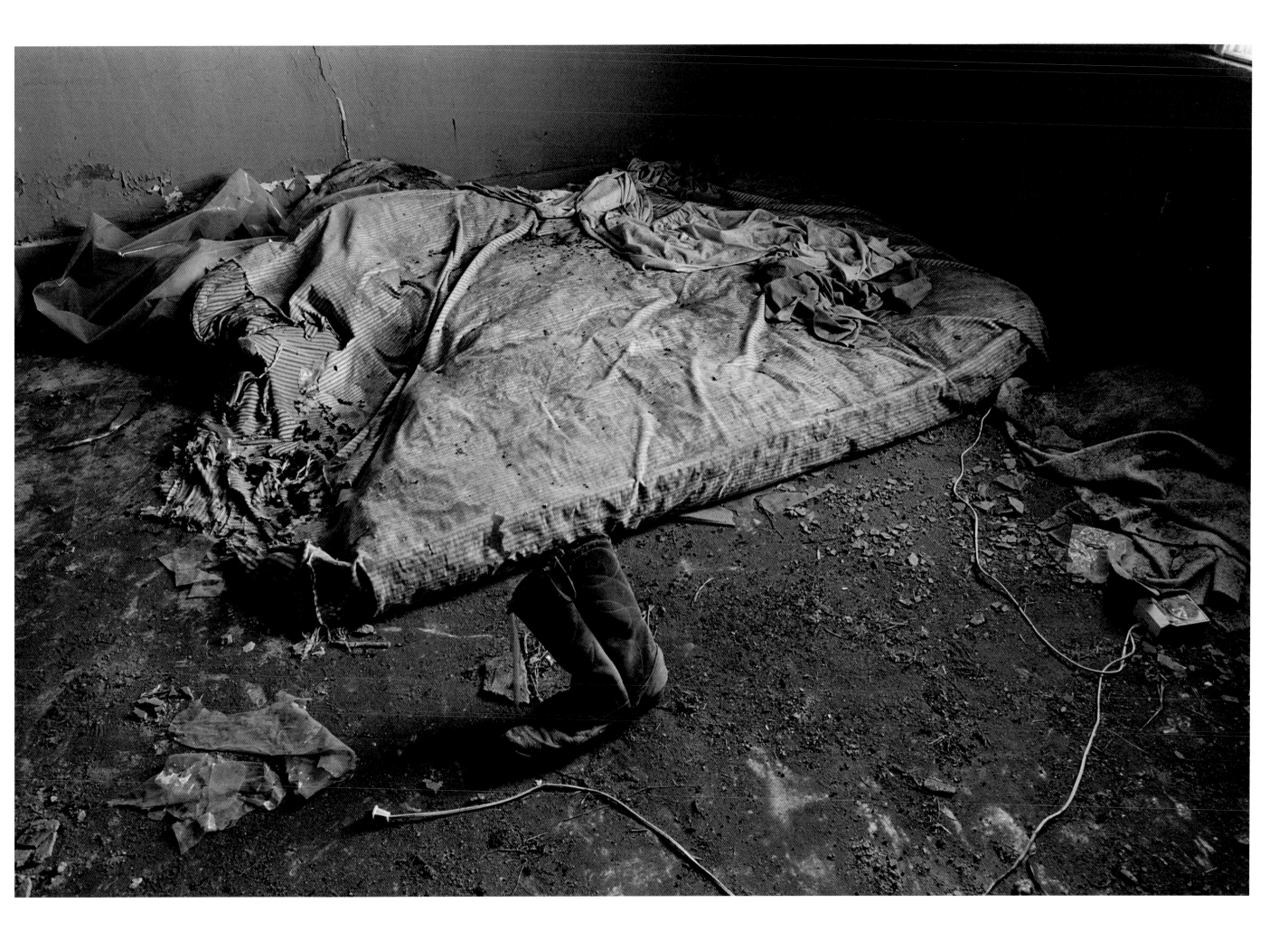

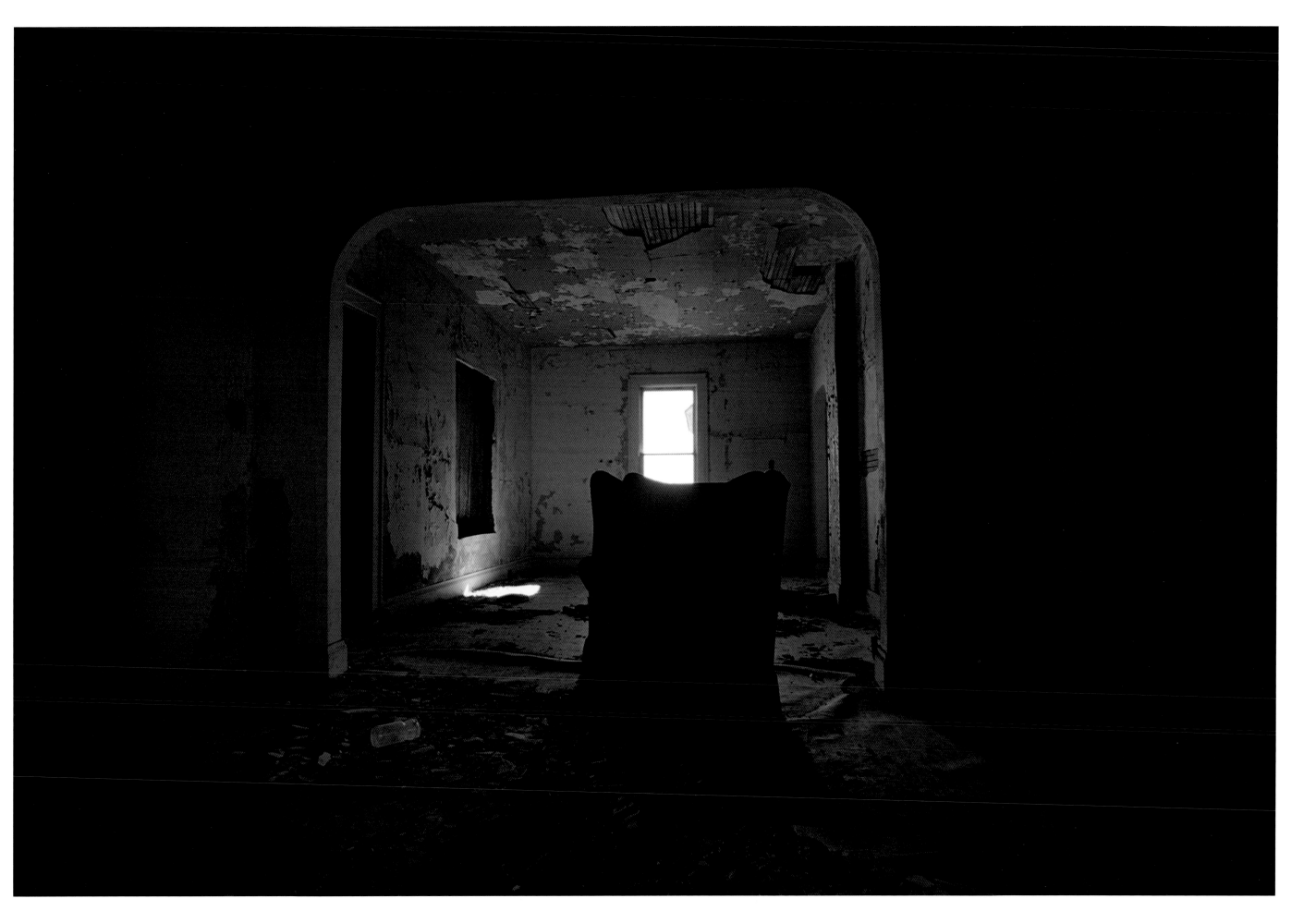

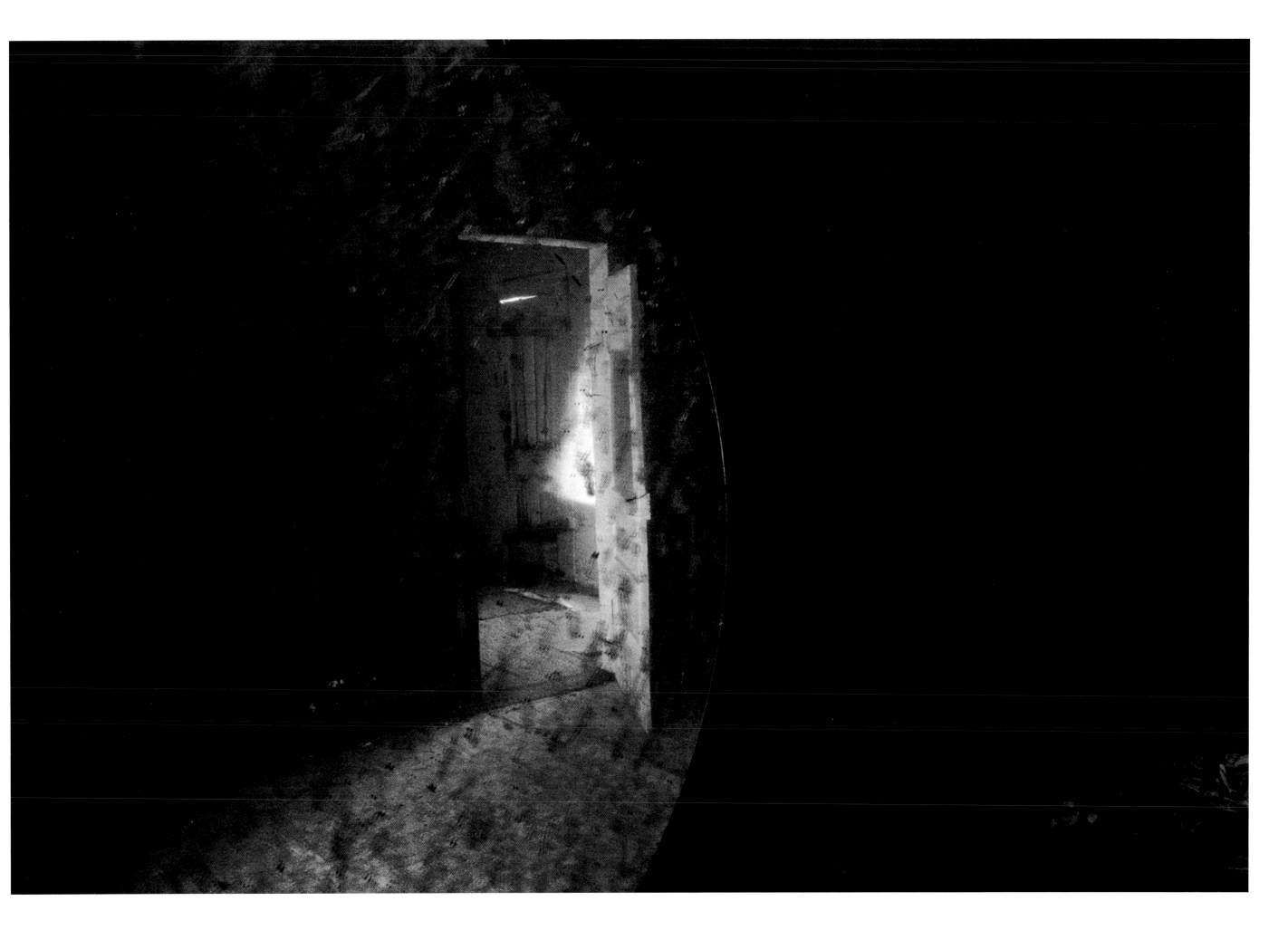

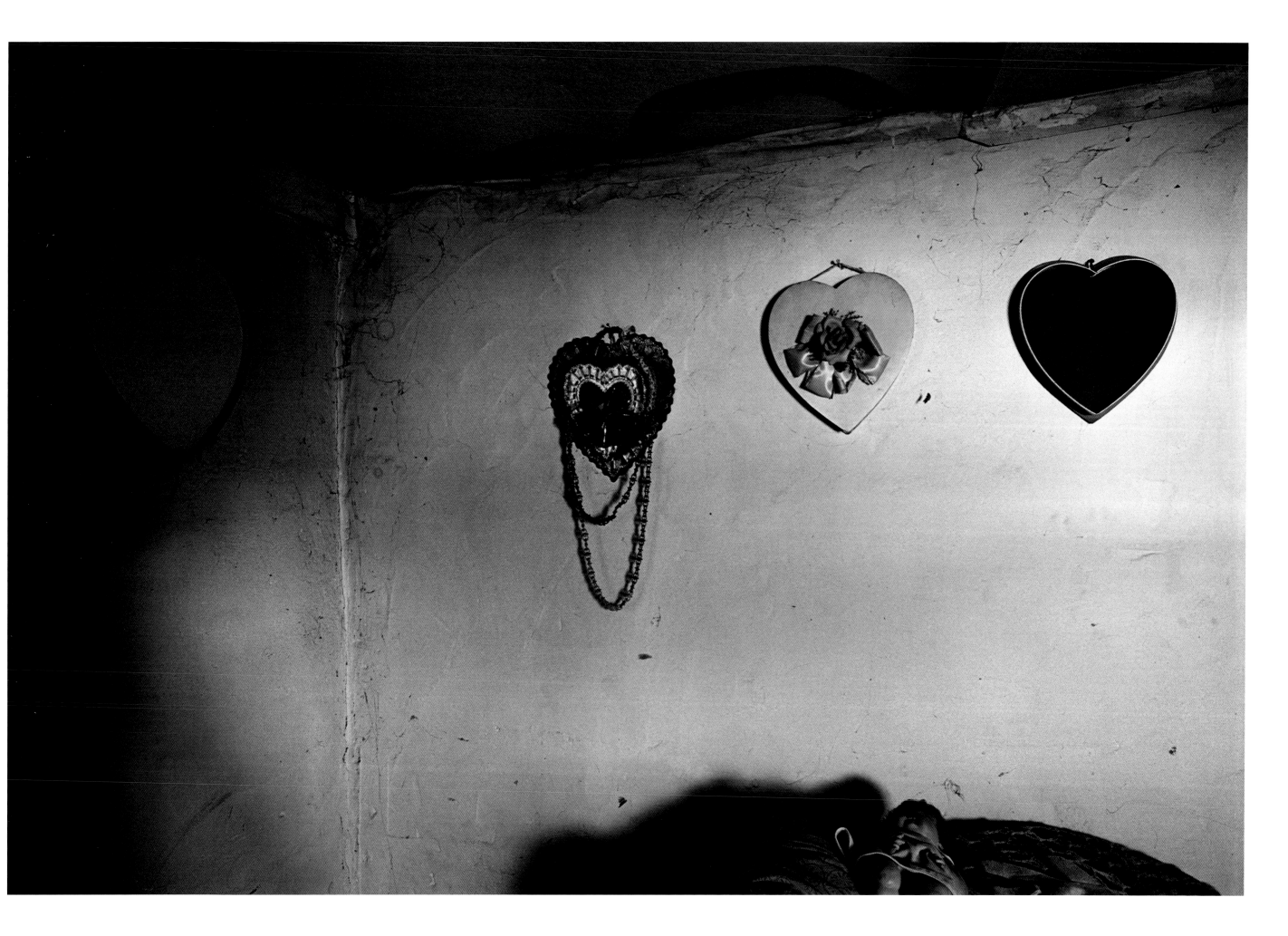

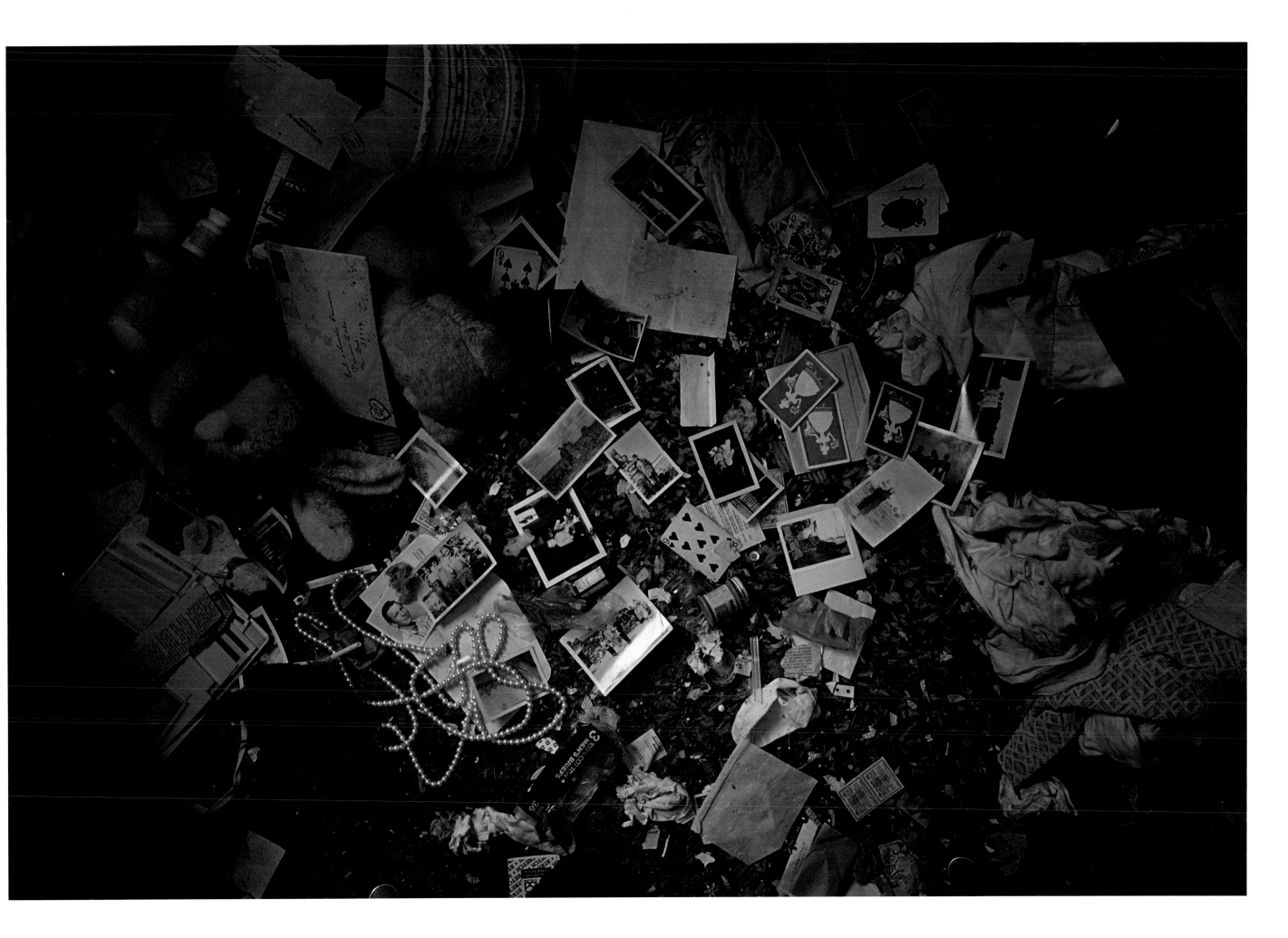

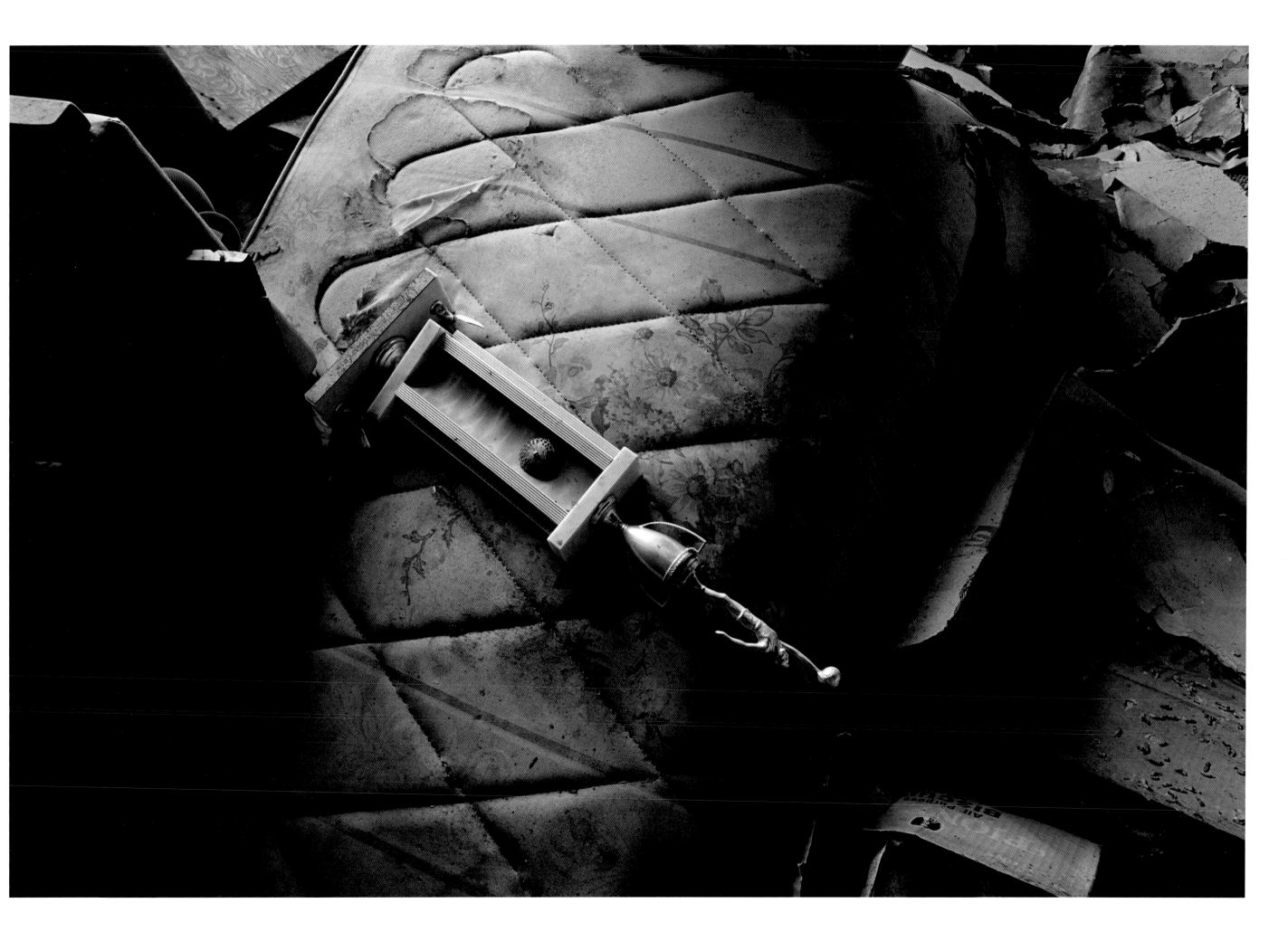

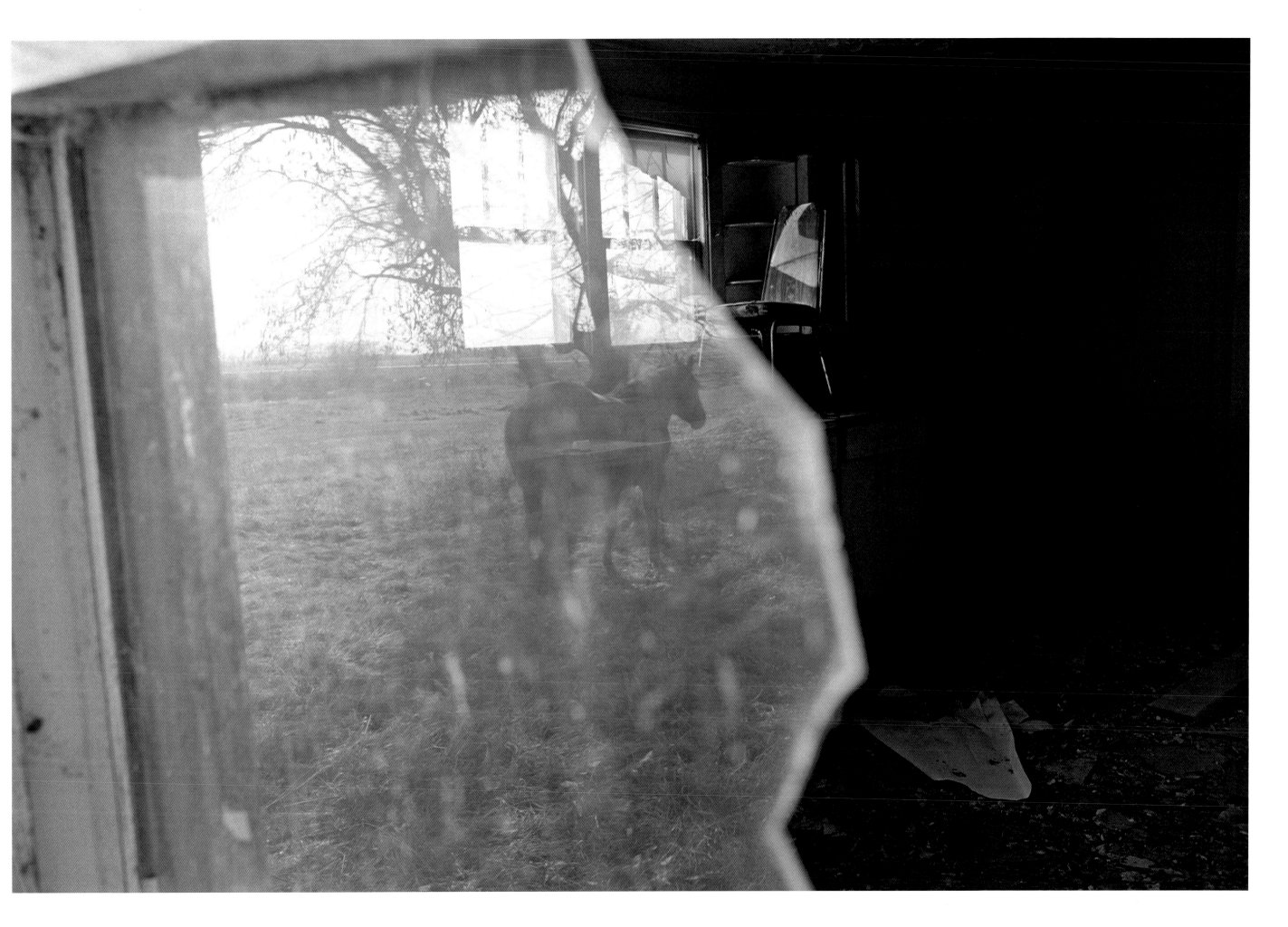

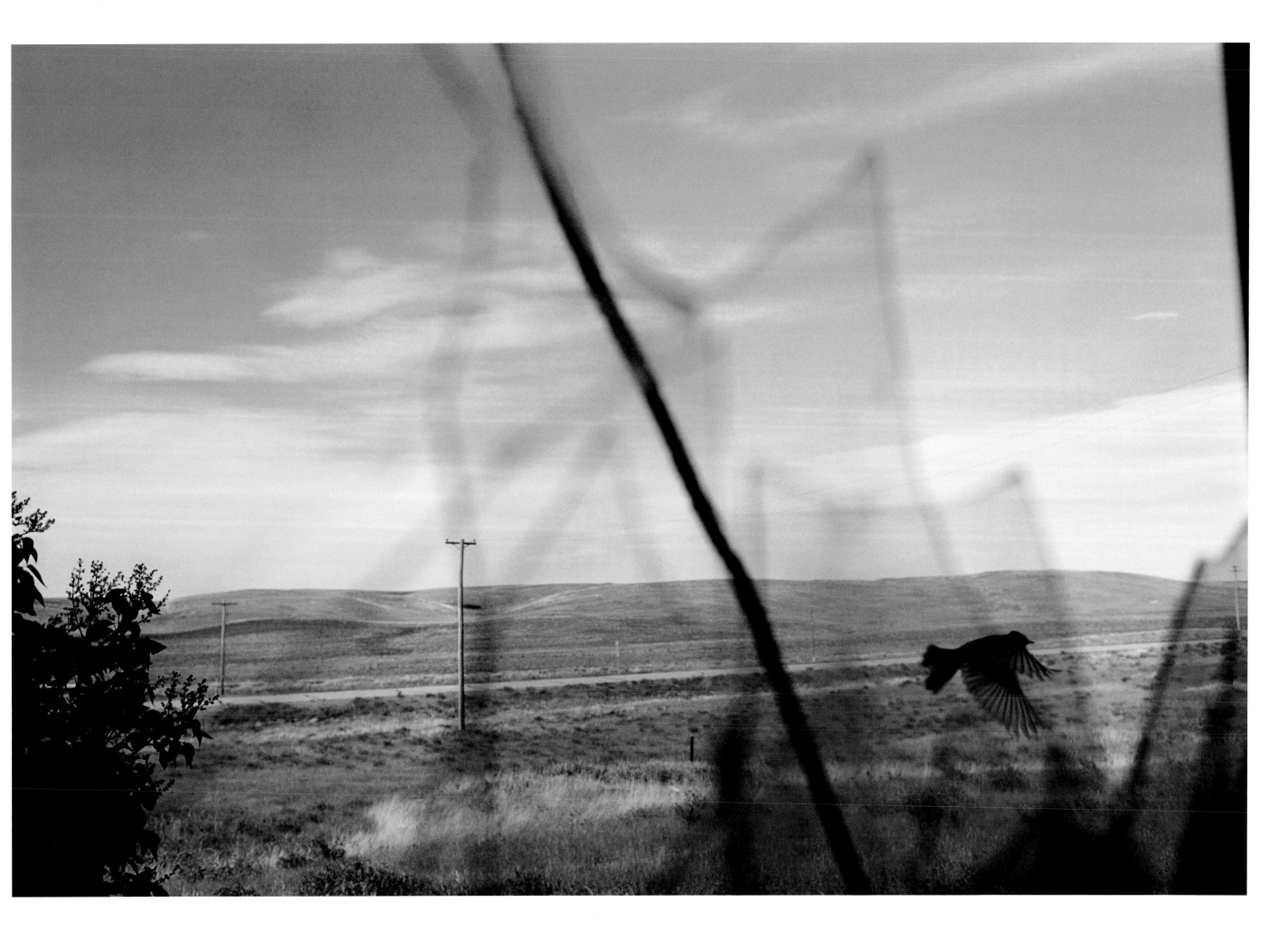

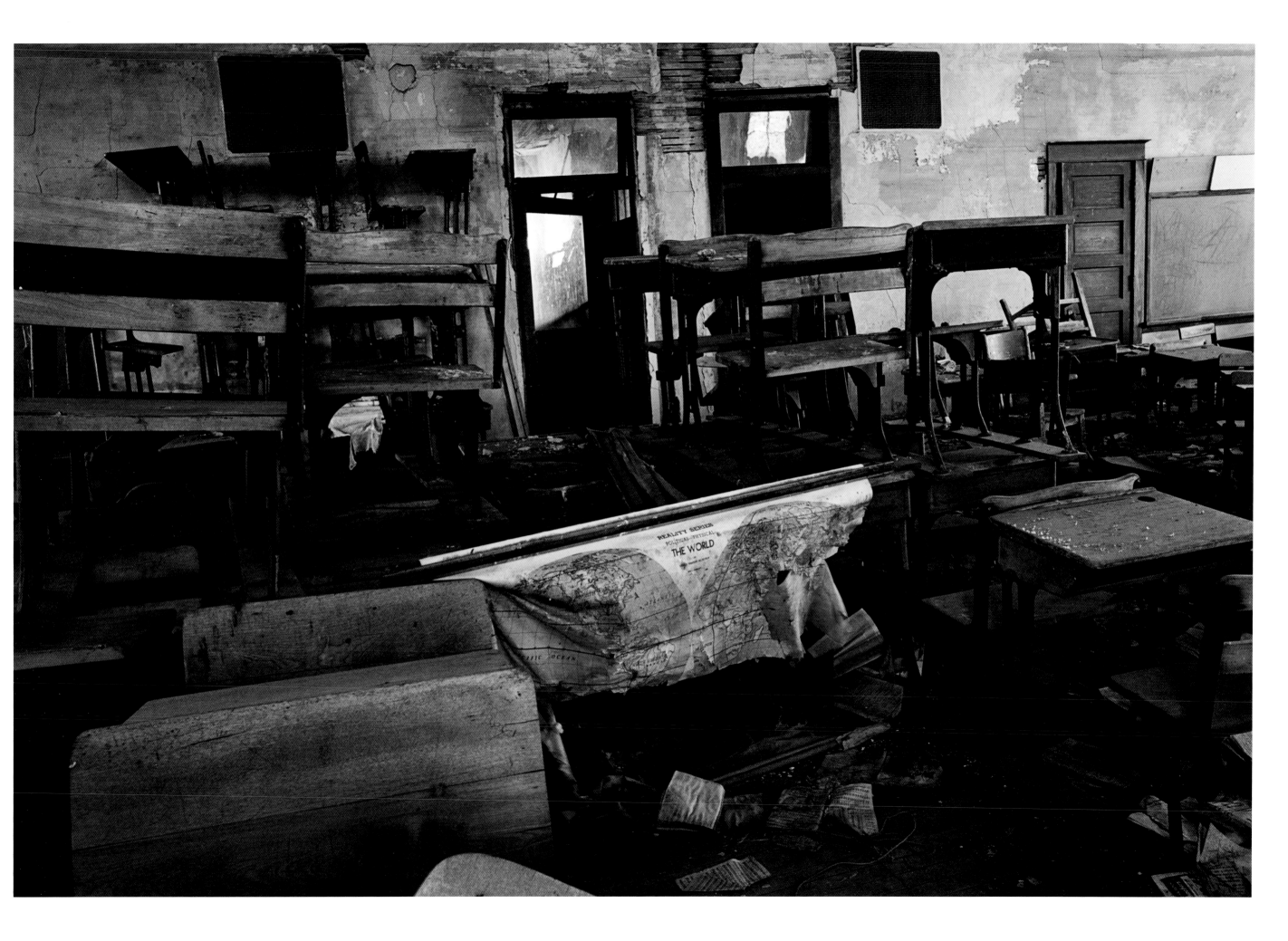

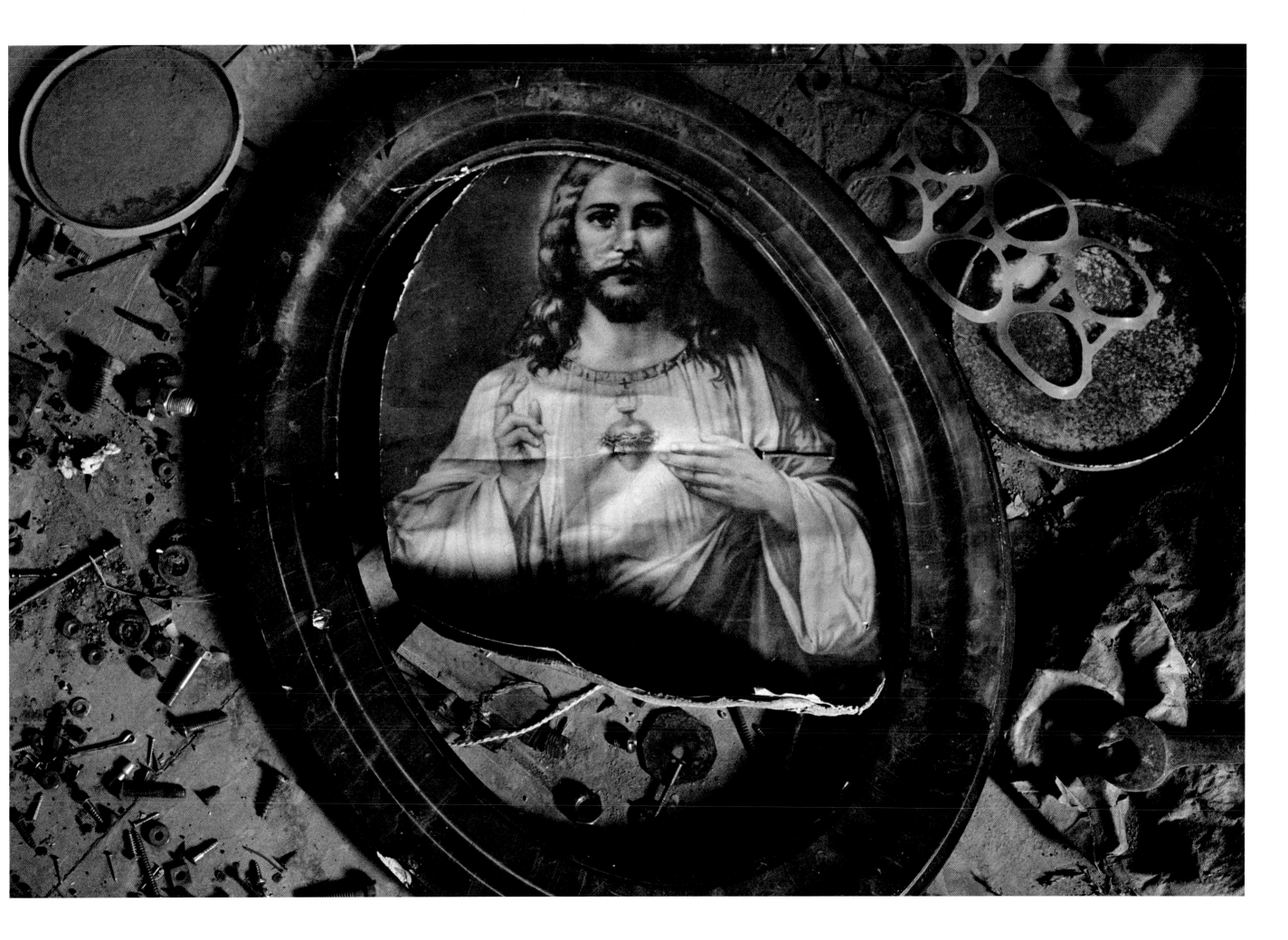

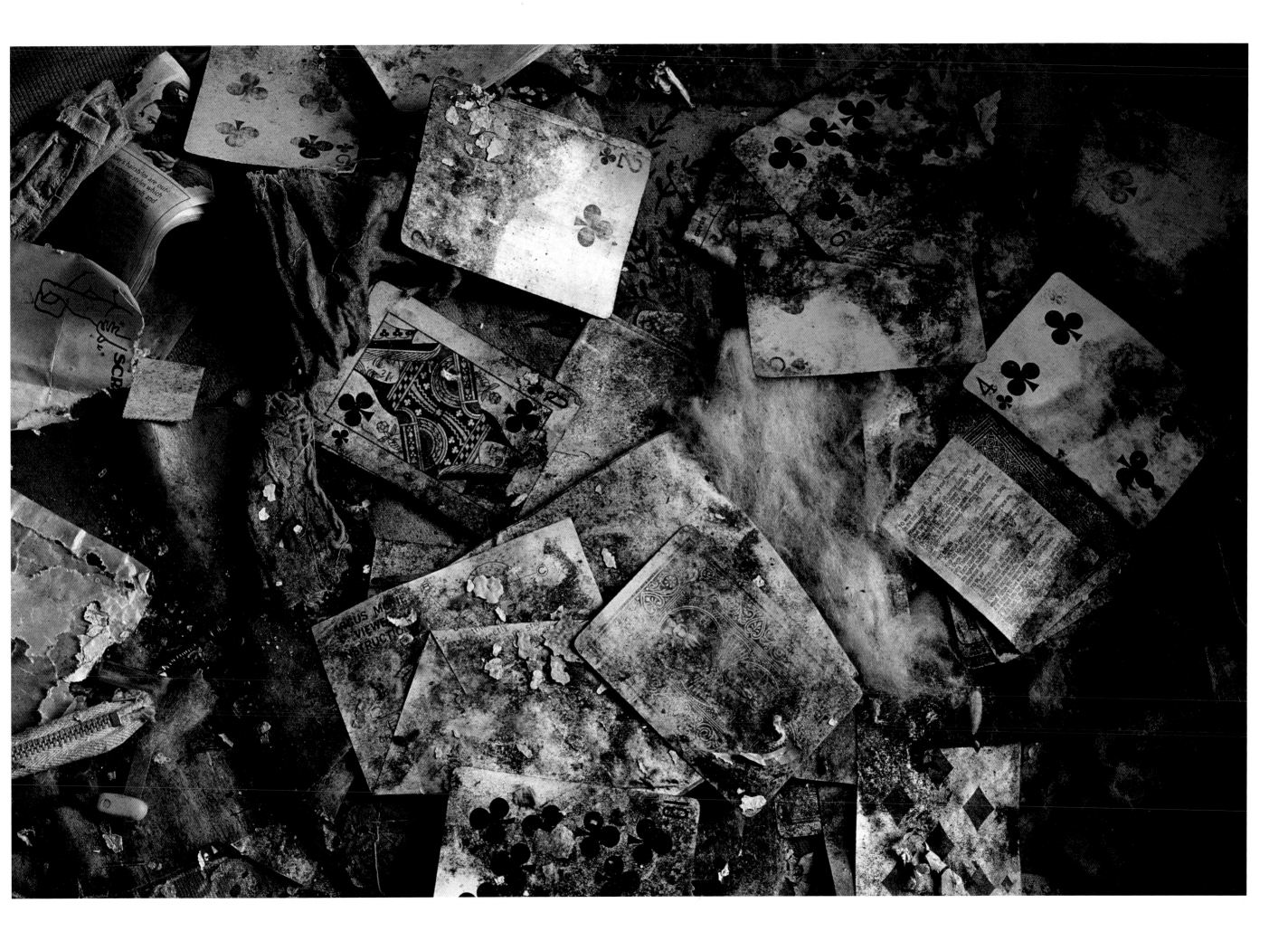

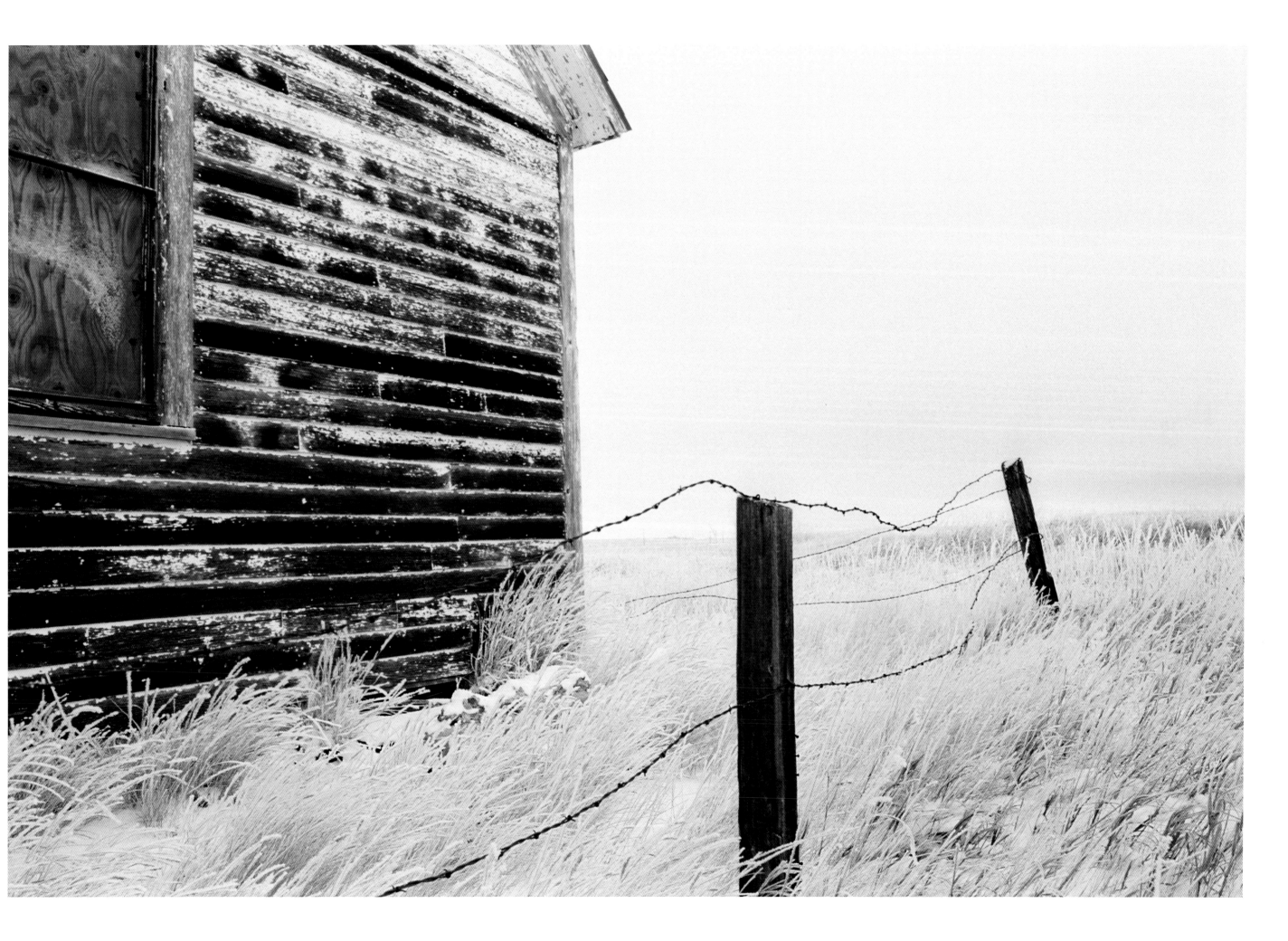

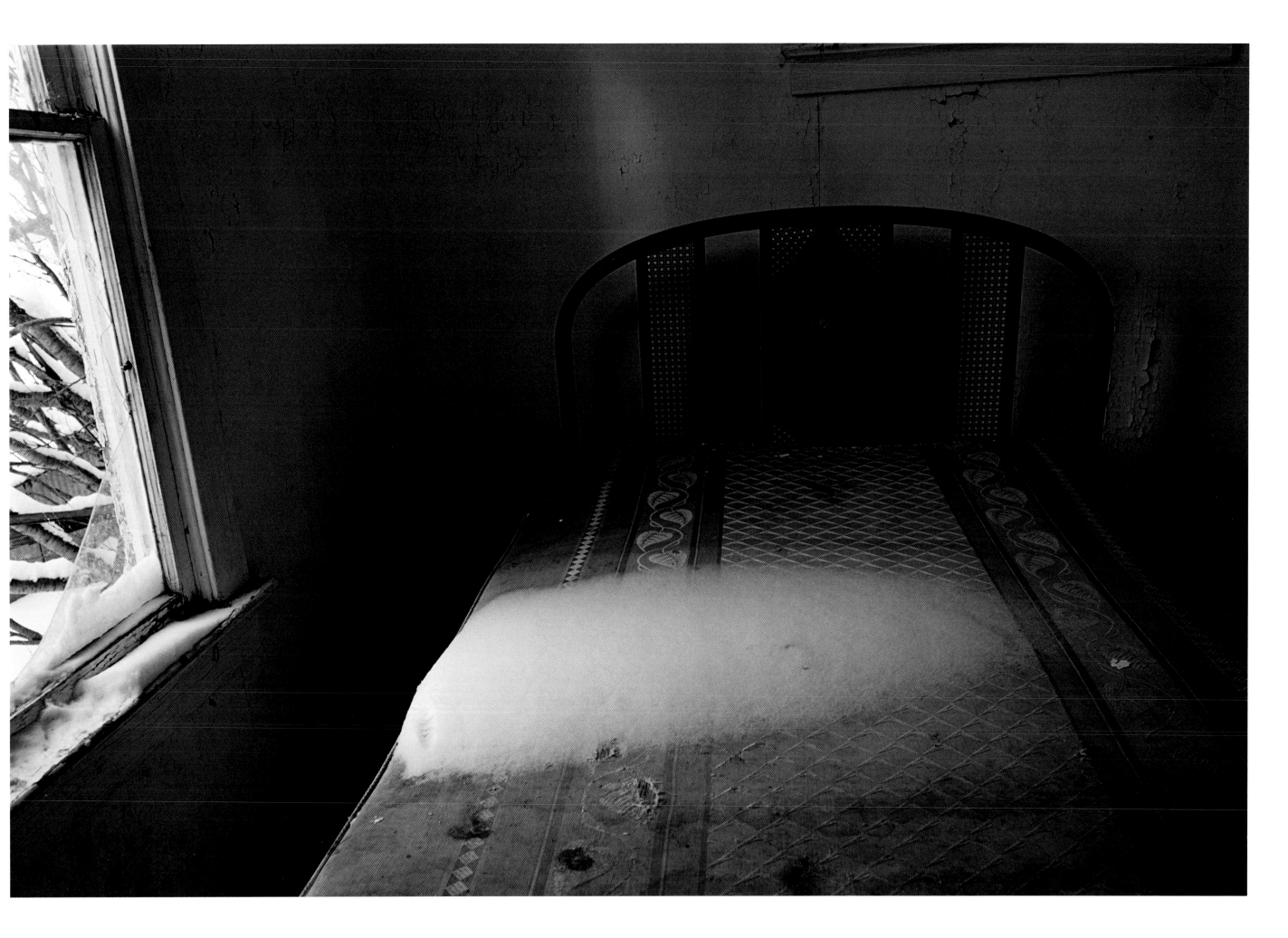

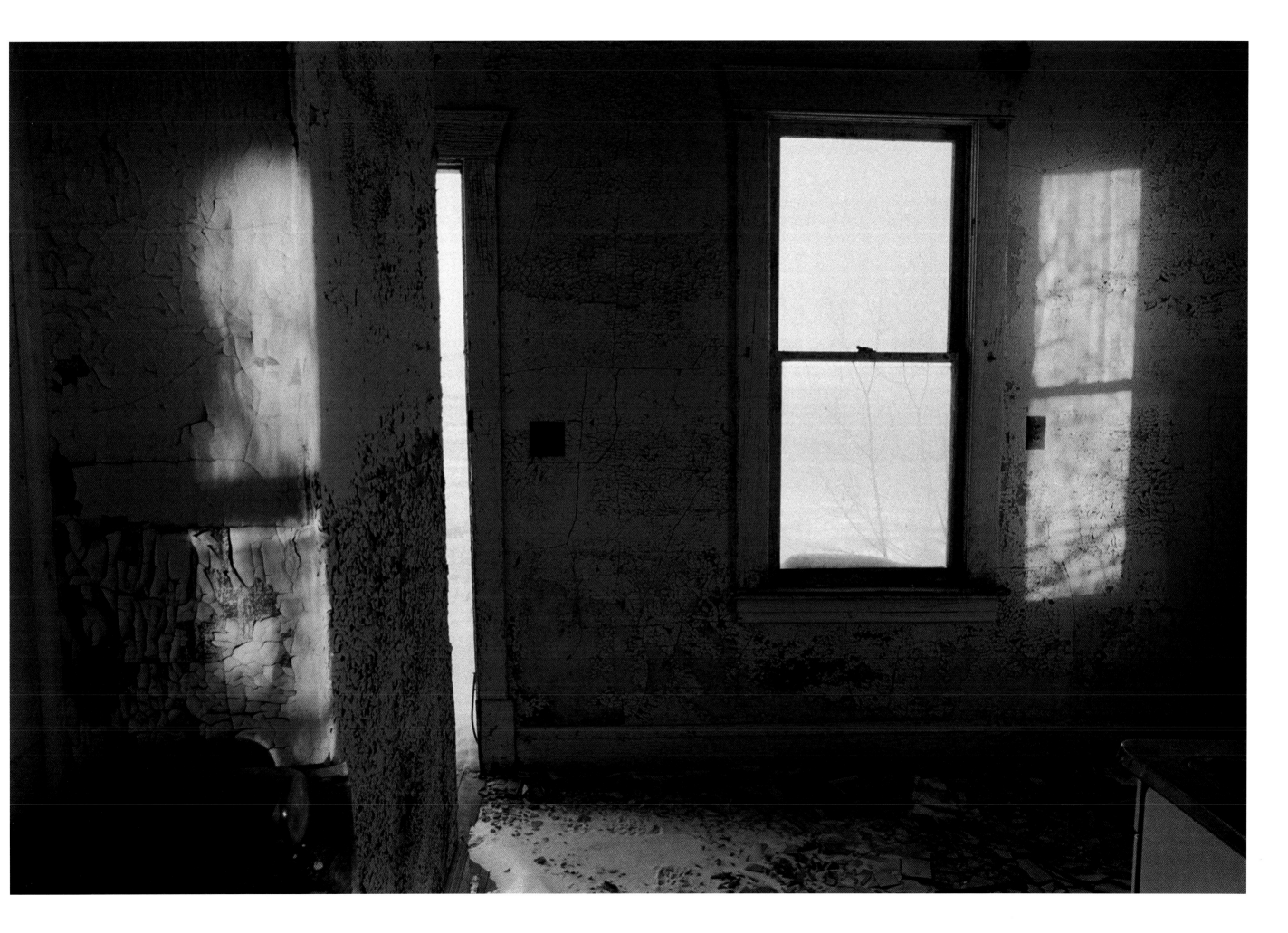

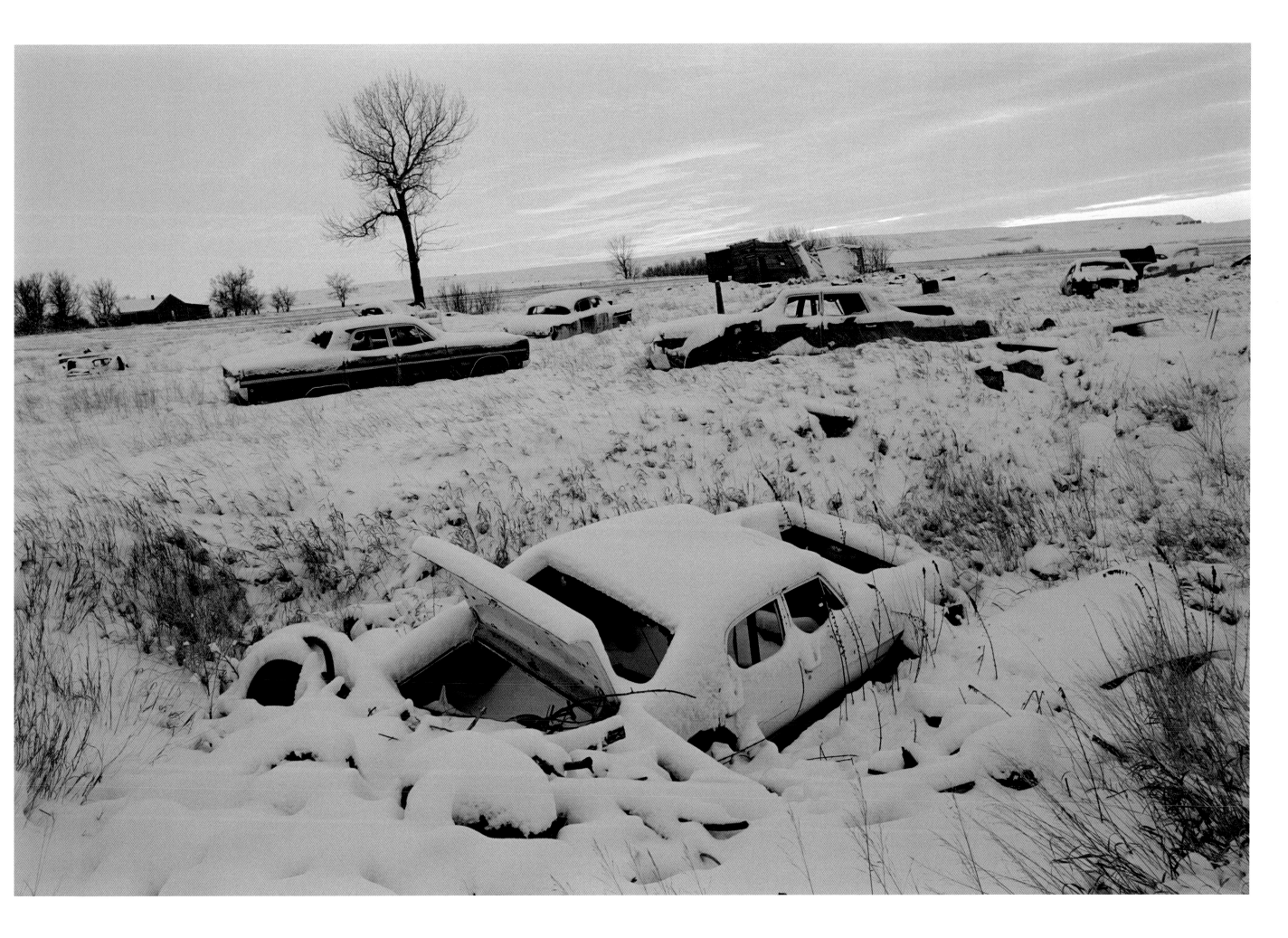

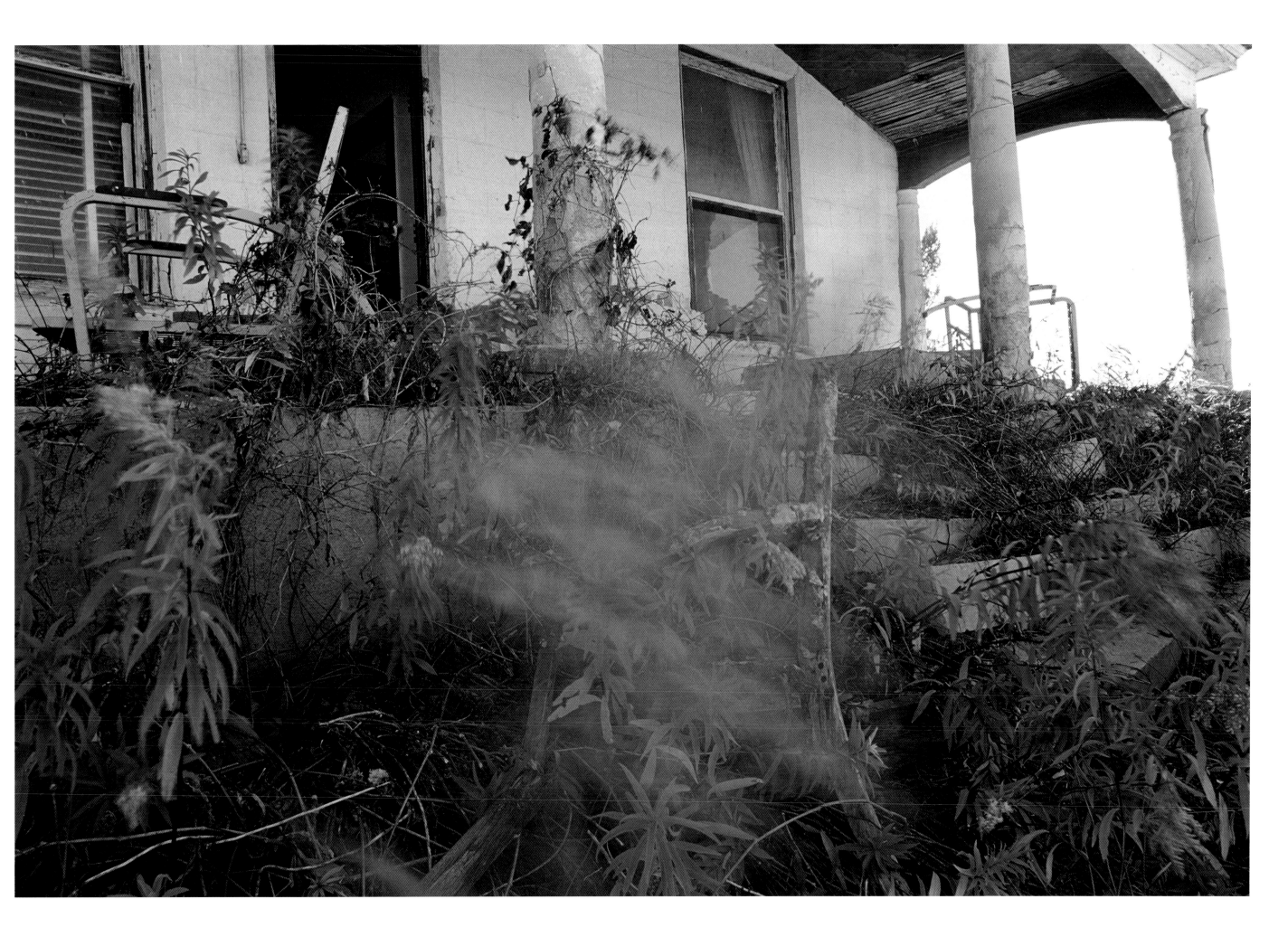

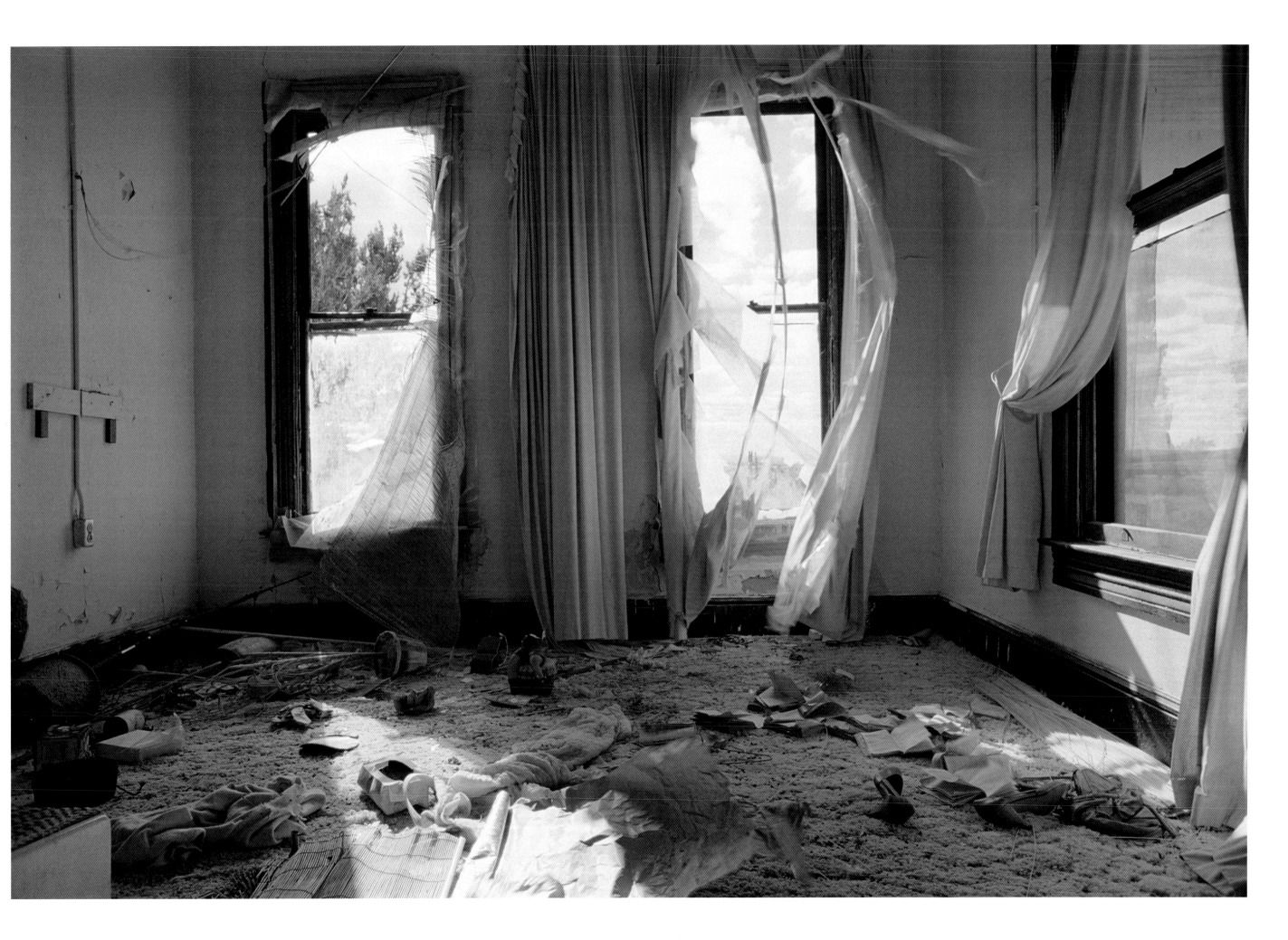

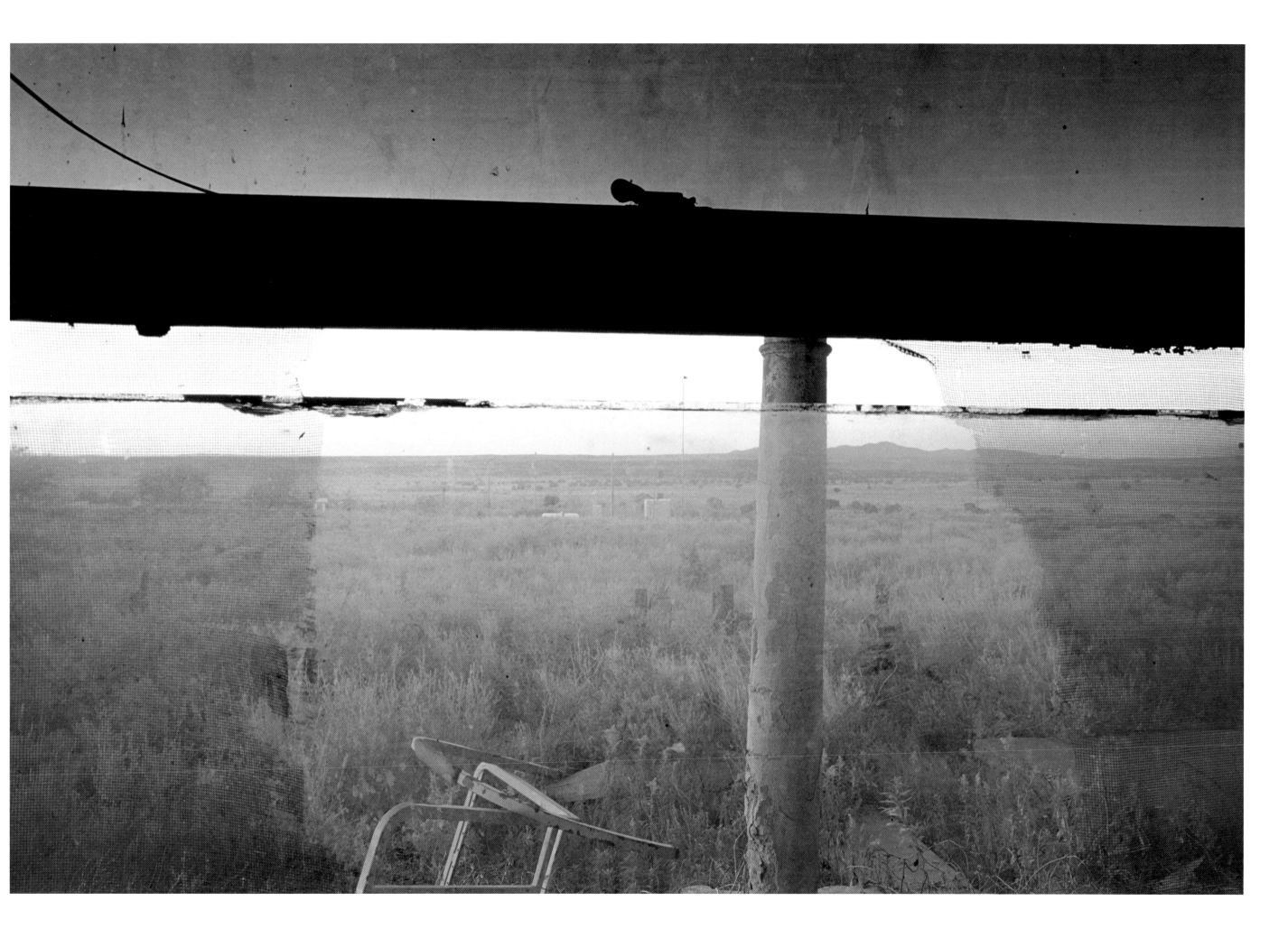

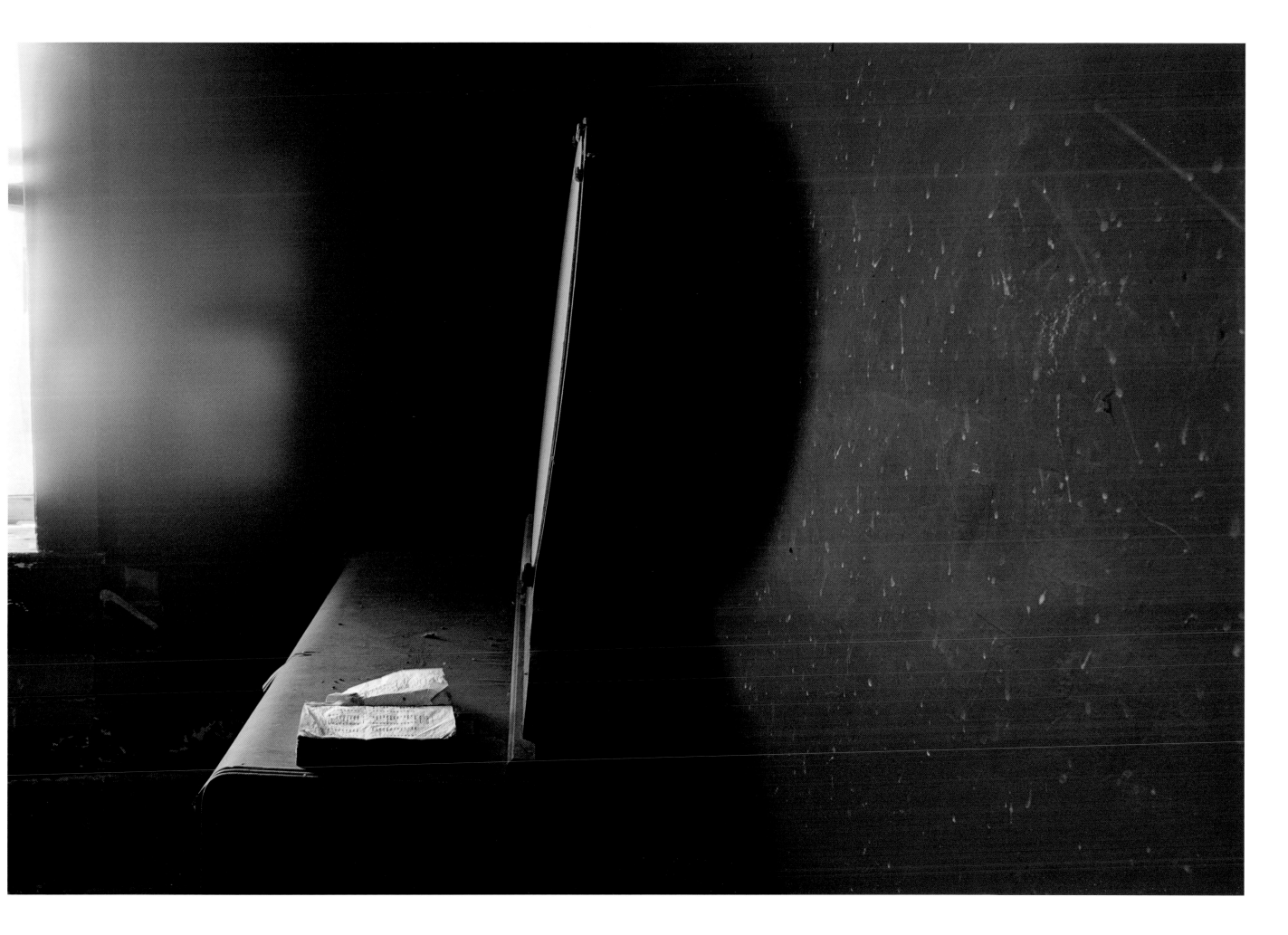

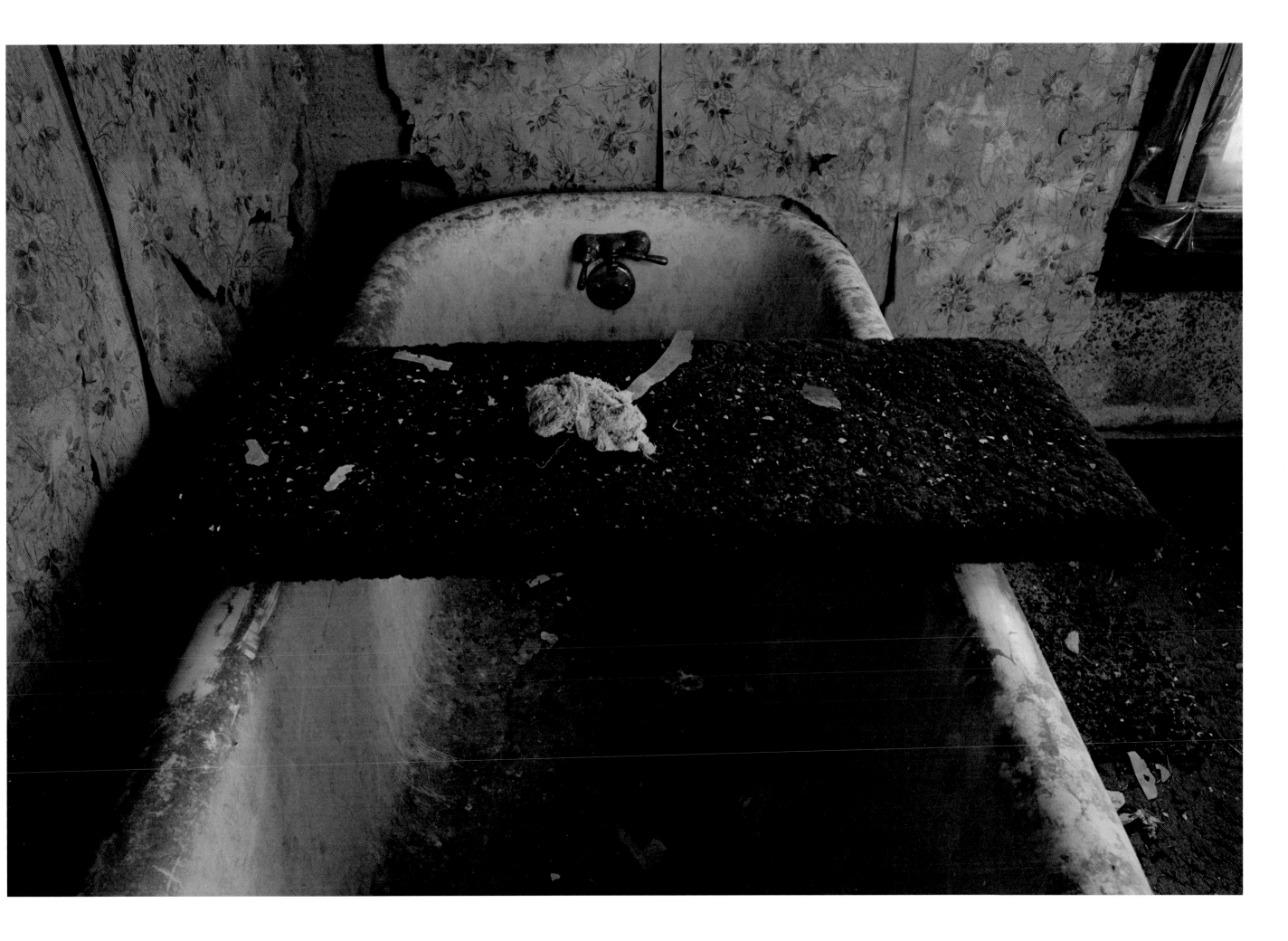

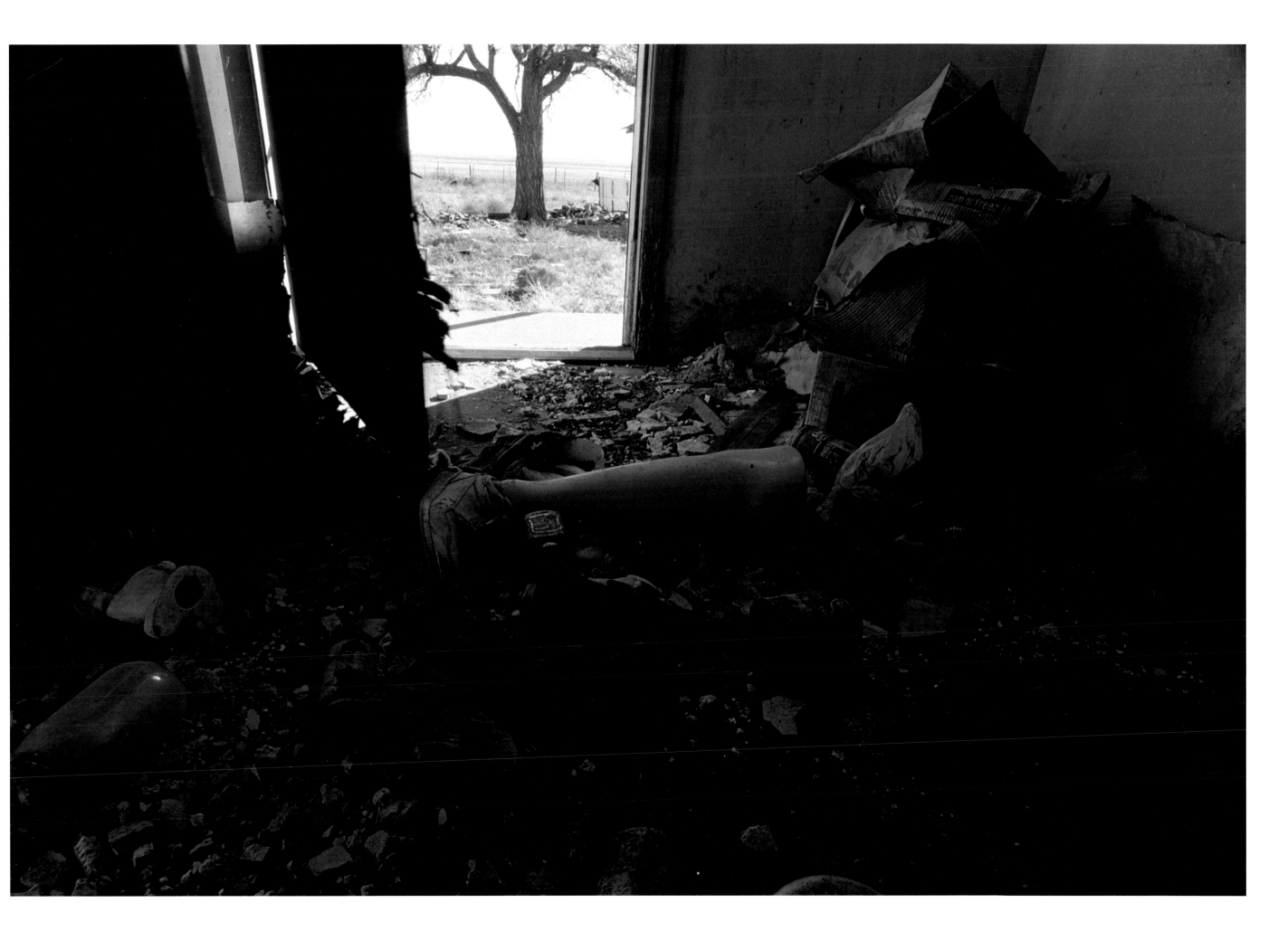

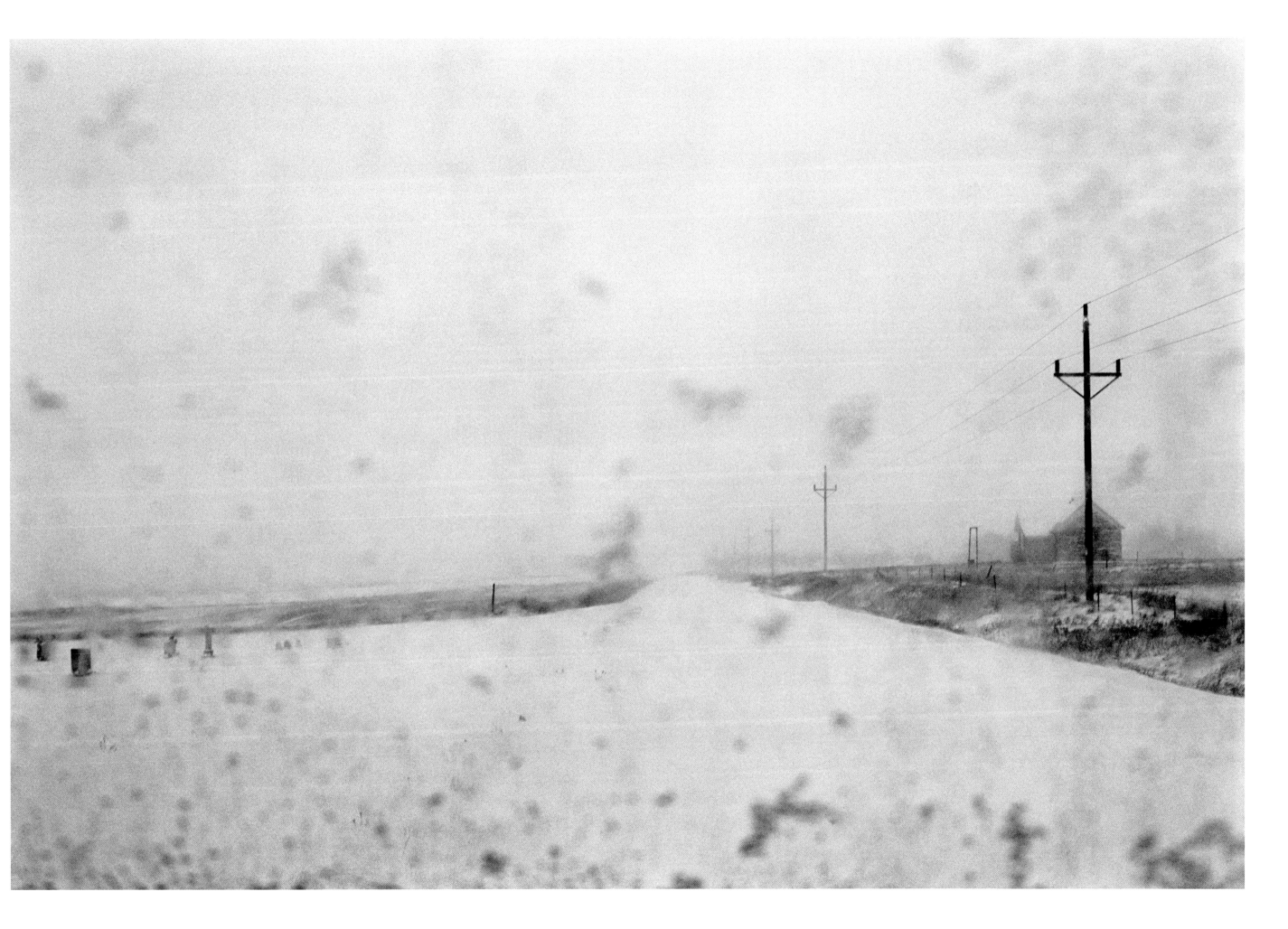

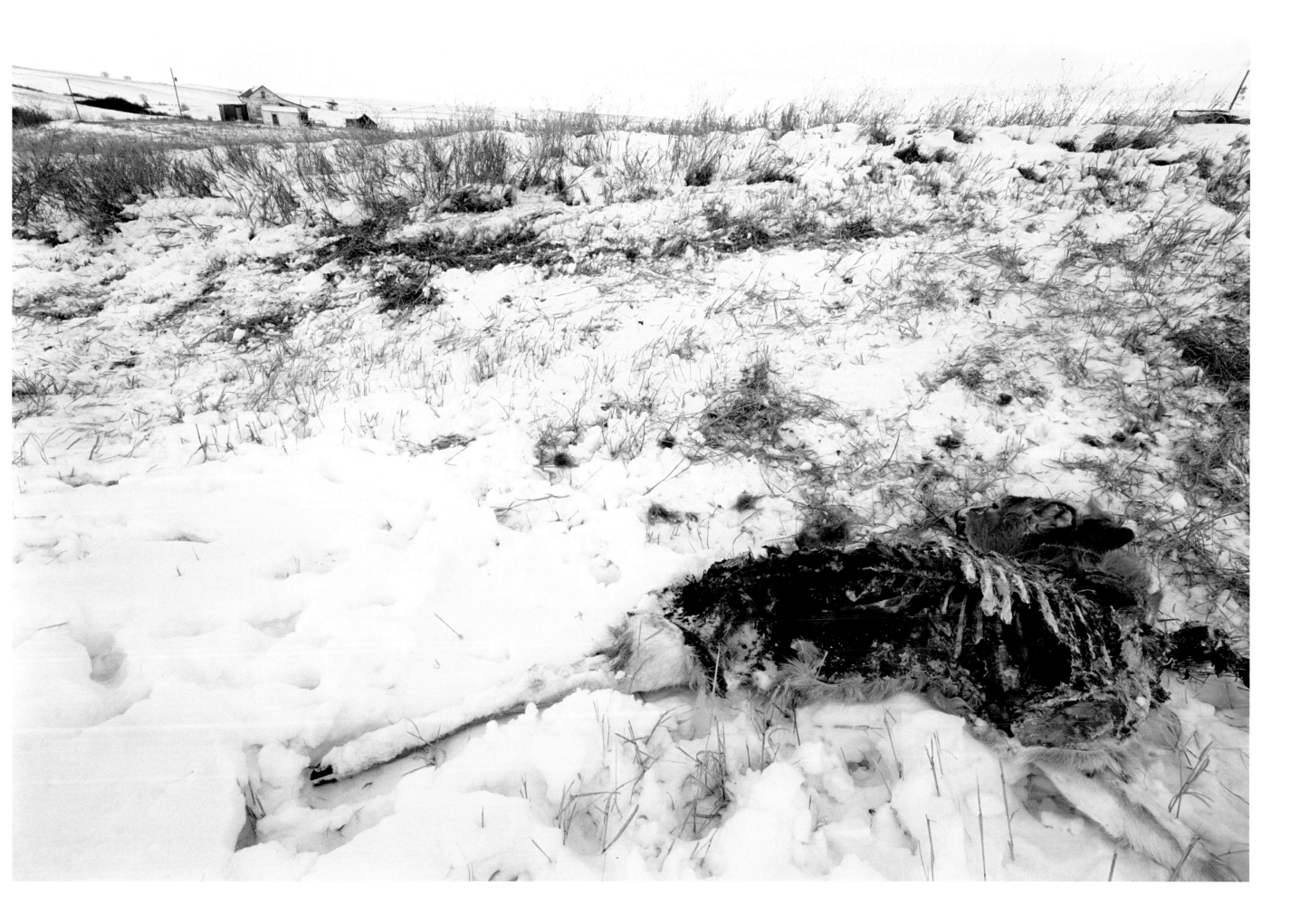

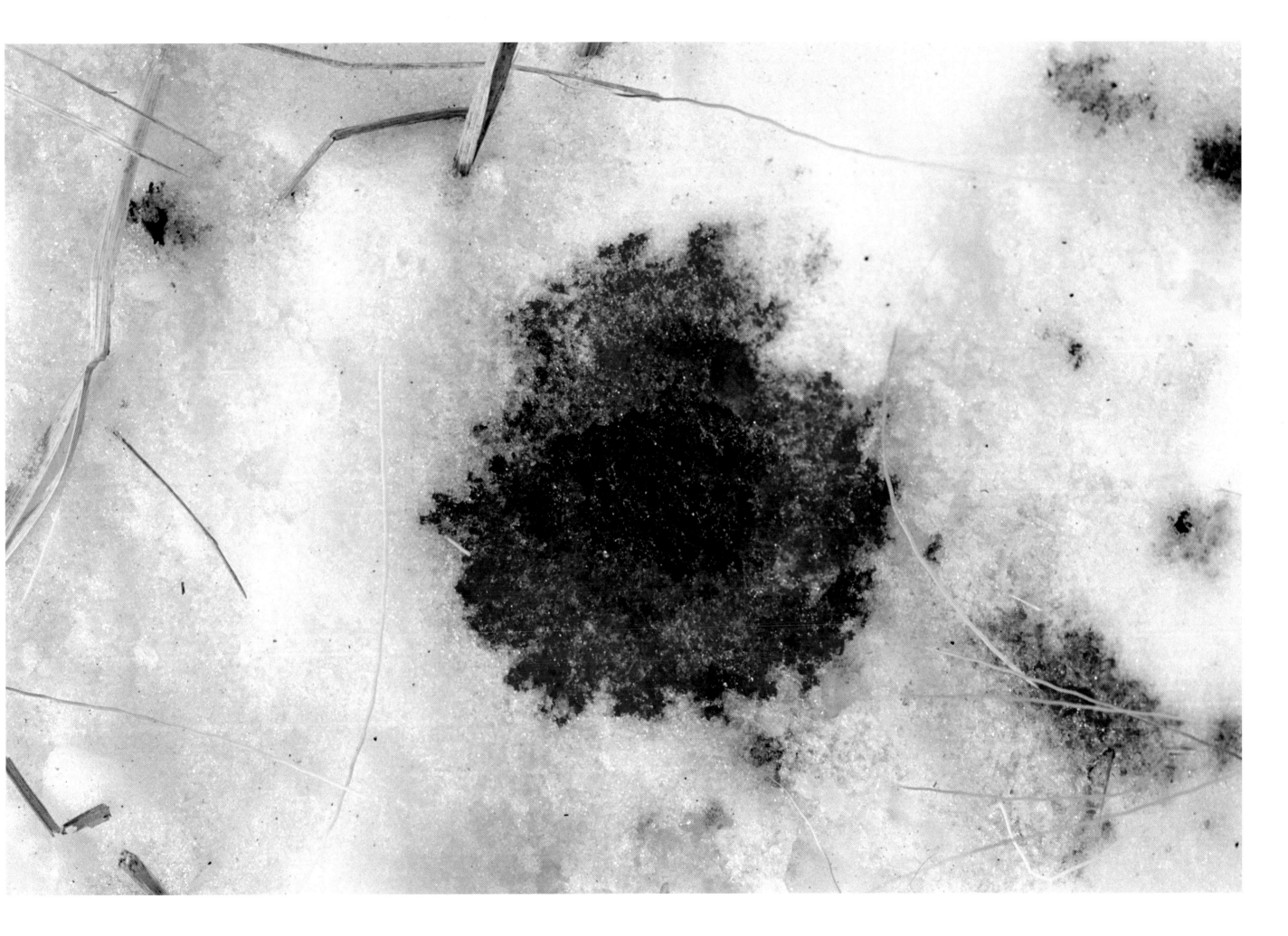

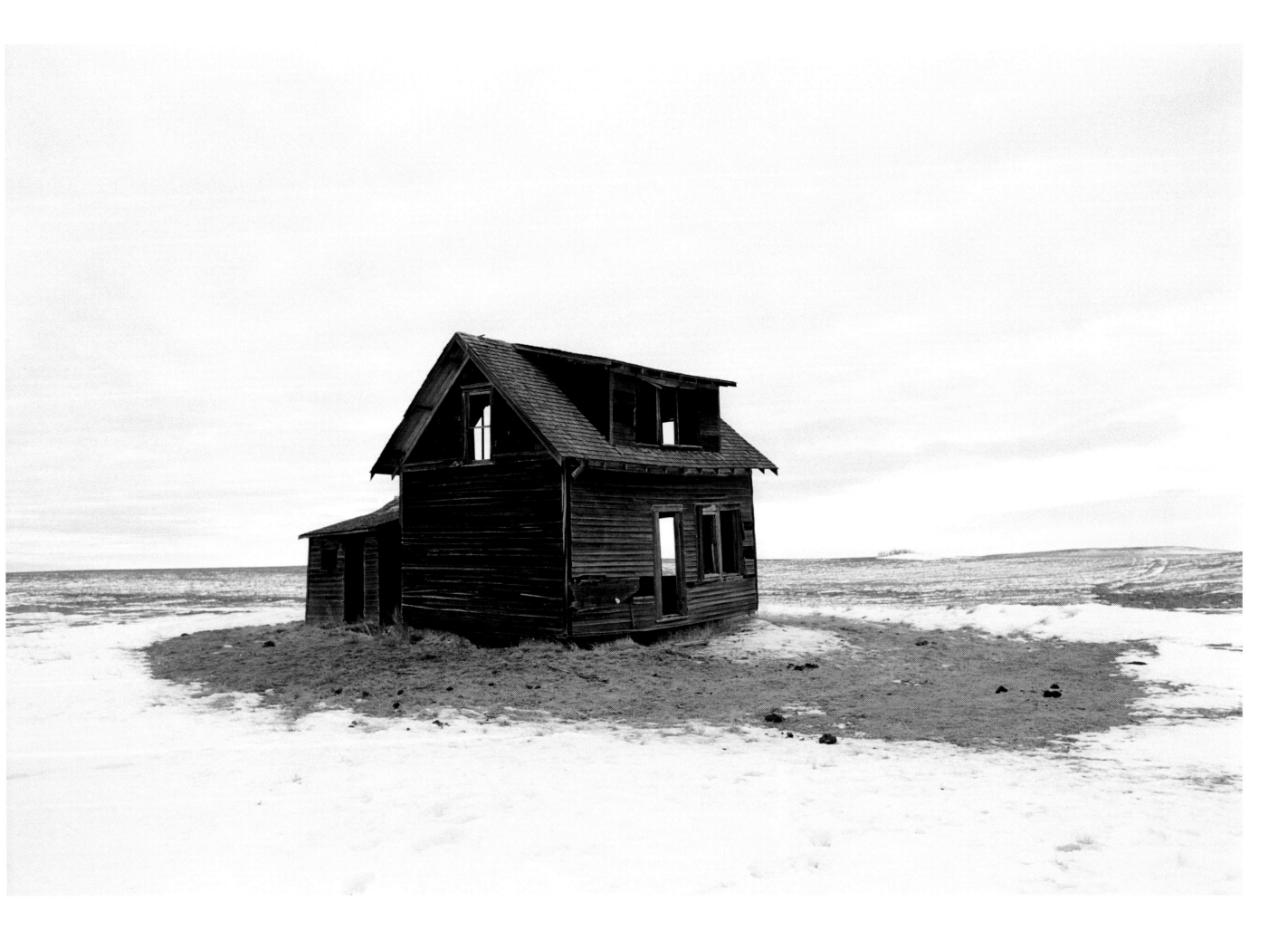

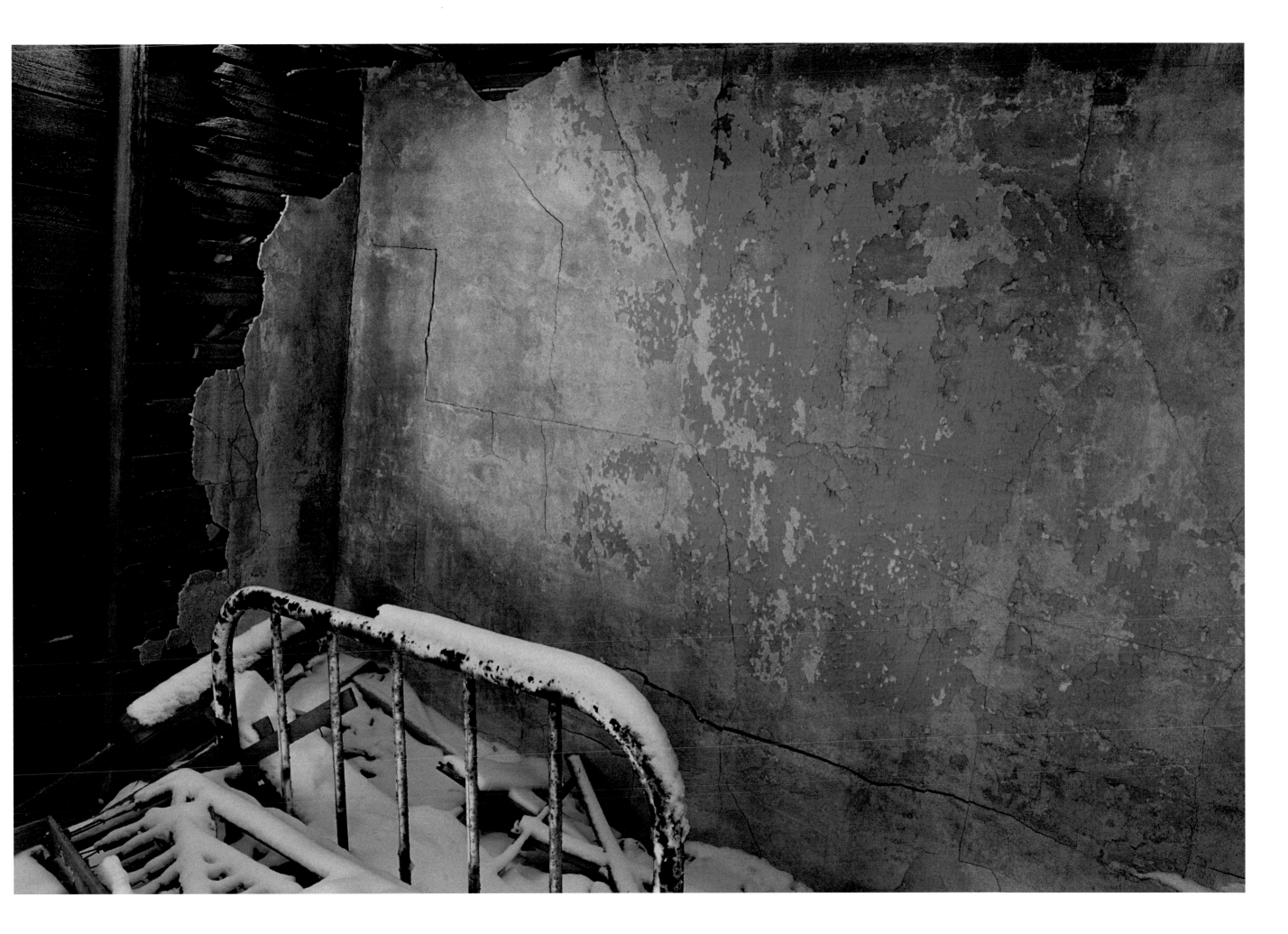

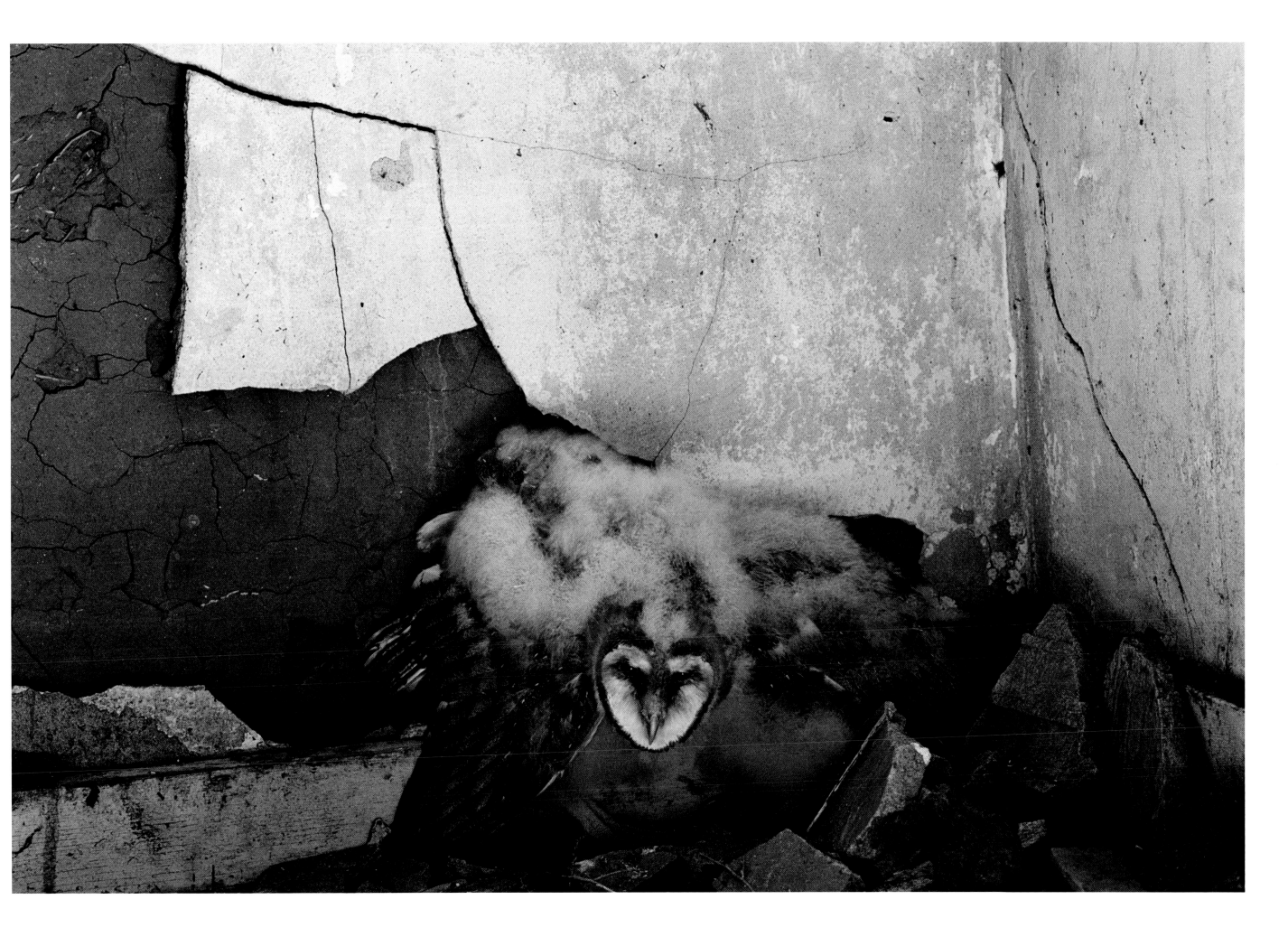

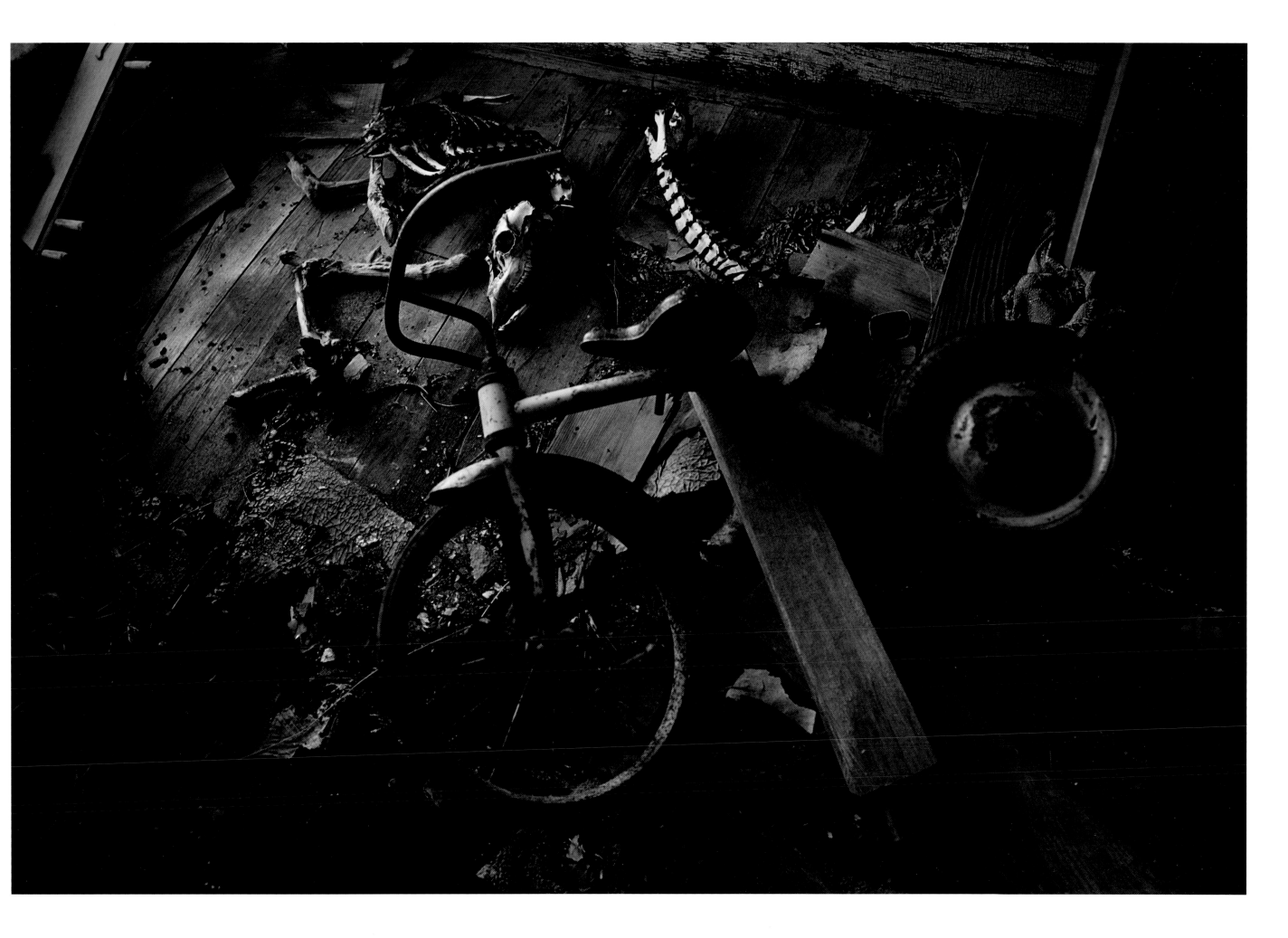

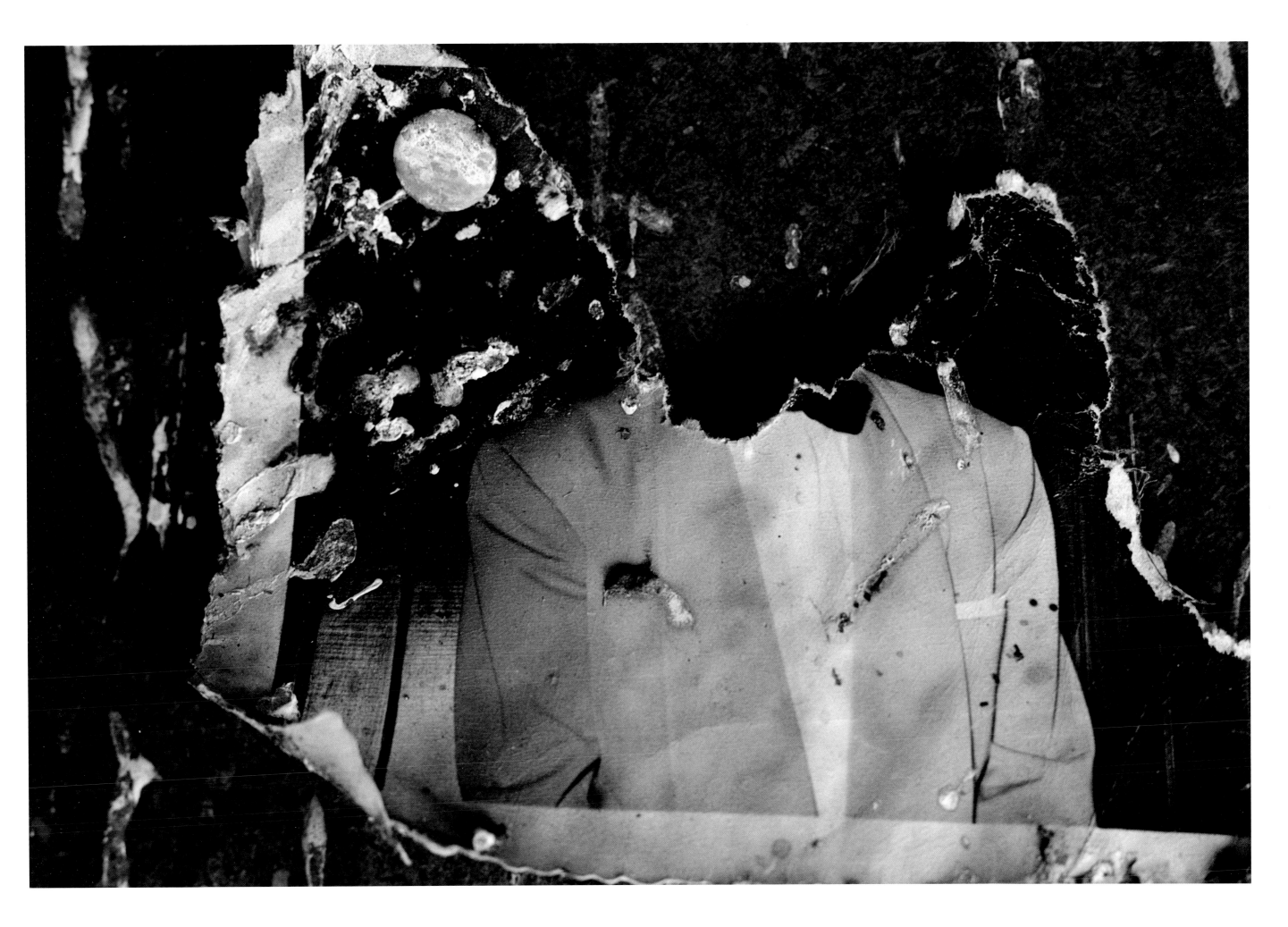

Working Notes

Rawlinson, Arkansas. The sun wasn't up and there was a thick layer of fog over the cotton fields, so no one could see me. I crouched down and began feeling around under the soaking wet plants for the remains of Corrine McGowan's house. The house had been a tiny, box-like sharecroppers' shack that she'd flush out every other day with buckets of water. Mrs. McGowan was in her mid-forties back when I knew her, hair in corn rows, wide face, shiny, unlined skin, blind (as were her two sons), right eye staring straight ahead, the left turning inward as if she were looking inside herself. It was when I passed through the Delta in '86 that I learned that Mrs. McGowan's first-born son, Willy, had died, as had her husband, Will, and best friend, Mrs. Brown, and that she'd moved away to somewhere up north, maybe Chicago, where she'd died. But the shack was still there, painted bone-white, raised up on concrete blocks, with a rusted-out washing machine and childrens' playthings scattered about. So I spent the whole of that first night back in the Delta wrapped up tight in a blanket in a motel, dreaming of the dead. And now all these years later I was back again, on my knees in a muddy cotton field searching for what had once been, with no real understanding of why I was doing this, no clear reason for doing it, except that in growing older I'd taken to remembering much too much about the past one day, nothing at all the next.

Howe, Nebraska. I was thinking about how Clarence Keyser had seen it all—unending drought, his crops gone to the wind, his wives dying—not about where I was going. After driving up the wrong road and speeding up another not far enough, I finally found his house and was standing in front of it, staring at it, when a farmer named Jim Finley pulled up. Leaning out of his pickup, Jim said that he wanted me to know that he still thinks about the day they carried Clarence up to the nursing home with "a failing heart." I asked Jim if he knew how Clarence's daughter, Donna, was doing—"She's through with rehab," he said—then asked about Donna's husband, Roger, who was always begging Clarence to let him repair the crumbling old place. And as suddenly as Jim had started talking he stopped, seeing no reason to tell someone who hadn't come around in years that Roger had taken his own life. Putting his truck in gear, he pointed to the house. He said it didn't look it, but it was unlocked. I could go inside if I wished.

Route 38, two miles west of Hughes, Arkansas, a tenant farmer's shack in tatters, porch door hanging off, red ball of a sun slipping down, red doors in the kitchen, curtains trimmed in red.

Powers Lake, North Dakota. The floors and walls were moist, soft, clingy; flies were hitting against the windows, wanting to get out. Five rooms, the last one I went into painted the same blue as the sky outside. Had to have been an elderly person's room. I found a twin-sized bed (the mattress had been yanked off it), something like fifty half-empty orange plastic vials of pills, mouse droppings, strings of Christmas lights, a plastic urinal, broken pencils, bottle caps, a key chain, playing cards (still so brightly colored that they read like omens), a Mass card (I forgot to write down the name), lengths of twine, clumps of wool from a sweater, and pictures--black-and-white ones, color ones, family ones, photo booth ones--scuffed and melted into the rug.

Des Moines, New Mexico. We followed a faint track, then had to sit in the car until the lightning storm was over. The house, on a remote piece of high desert, was one of the boarded-up ones that'd been breached, had a hole punched into the back door, the locks ripped off. I squeezed inside, knowing to lower my head as the dirt and insects rained down, then started inching away from the light and out of sight of the road, all the while listening for snakes and stomping on the floor to be sure it would hold the weight.

Corinth, North Dakota. I caught a glimpse through the falling snow of a church, a grain elevator, wooden houses--plain and gray as stones. I'd read that back in the early 1900s Corinth was known as "the Queen City of Williams County," with thirty businesses, two banks, and a population of three hundred. In amongst the shadowy buildings that make up the downtown were the remains of a general store, its display window full of clutter. I pushed inside, stumbled around in the dark. Way in the back was a door, warped, off its hinges. It opened up into what turned out to be a tiny bedroom. The floor was undependable, sinking down toward the far wall. The window was broken. Snow had blown in across the iron-framed bed.

Ancho, New Mexico. Some months back, I pointed to an abandoned house far out in a field and asked the rancher I'd just met if he knew where the people who'd lived in it had gone. "They're not moving away," he answered without emotion, "They're going to the cemetery." Maybe that explains what happened in Ancho. Whoever had lived in the big pink and green stucco house by the railroad tracks appeared to have left suddenly, taking few, if any of their belongings. Now it sits vacant. Nothing moves inside but the curtains in the parlor when the wind stirs them. There's an ominous stillness to the place, and a different sense of what memory is. I pick up a doll's head and have this dim recollection of my sister playing with it. I walk into the wallpapered room where there's an old claw-foot tub and remember bathing my elderly father in it. I look out the floor-to-ceiling windows and see myself as a young child running around in the sunburnt fields. But the memories aren't my memories, and they're not the memories of the people who once lived here.

Lostwood, North Dakota. The farmhouse must have stood empty for seventy, maybe ninety years.
You could see its metamorphosis (all of the doors and windows were missing), and hear it
(the swallows were swooping and tumbling in from the fields, screeching at me to get out).
Water had seeped into the walls. They were green with lichen, swollen, crumbling. Floors
were strewn with plaster, branches, leaves, the husks of insects, broken glass, feathers,
the shriveled corpses of small animals. On a window sill in the last of the daylight lay wasps
stunned by the cold, struggling to get up, spinning in circles.

Froid, Montana. I came upon the old cement-walled house at the end of the day and was
photographing what remained of an upright piano when I heard a panicked flapping of wings
in a back room, a body thumping against the wall. A fledgling owl, close to full-grown but
not yet able to fly, leapt out of a broken window into the high grass, then began backing
away--past some rusted-out cars, past the ruins of a barn--never taking its eyes off me.

Langdon, North Dakota. What I think of as the wedding-dress house is off a gravel road
north of the town. It's a white, two-story, wood-framed house with a white picket fence
that appeared in okay condition, except that the door was broken-in. There were dozens of
cardboard boxes strewn around the first floor. At least one of them contained an infant's
clothing. Stored away in a clear plastic container were mementos from a wedding: a garter
trimmed with beads, a tiara, his-and-her champagne glasses. The full-length wedding gown
was hanging--radiant, like a silent bride--from a door in the upstairs hallway outside an
emptied-out room, as if someone had meant to come back for it, but didn't.

Sioux Pass, Montana. The stairs leading up to the second floor shuddered and groaned as
I went up them. They had to have been brutally steep for someone elderly to climb. In a
bedroom dusty with junk I found a woman's long, thick, woolen coat that I thought was
a body when I first stepped on it, and a man's work boot, all scuffed and worn. There'd
been children; I knew this because they'd scratched their initials into the woodwork back
when they were young, or maybe after they were grown and had cause to move away.

Wheelock, North Dakota. I stood up on a crate to try to see in. The windows were cracked
and smeared with dust and reflections. Crossing the road, I knocked on a door and an elderly
woman peeked out. "No, I pay no attention at all to it," she said, "if it's that old place
you're talking about. But maybe my husband can tell you how old it is." I heard whispering
behind the door. "Well, I asked him and no, he can't. Anyway, isn't it too late to be
worrying about what went on all those years ago? Isn't it? Well, it is. What's out there is
finished. It's over. Done."

The Photographs

For my son, Sam

I wish to thank Richard Schlagman, Denise Wolff, Nerissa Vales, Sue Medlicott, Makiko Katoh, Samantha Woods, and Amanda Renshaw of Phaidon for their belief in this book; Les Clark, Tracy Clark, Chuck Bowden, Hamilton Fish, John Morgan, Melvin and Morrene Wisdahl, Debra Quarne, Galen Bellet, Robb Kerr, and Donna Killion for their friendship and help; Shamus Clisset and Philippe Laumont for their craftsmanship in producing the book scans and match prints; Chris Johns, Susan Welchman, and David Griffin of National Geographic Magazine and Kathy Ryan and Joanna Milter of The New York Times Magazine for meaningful assignments that enhanced this project; and Sam Richards and Erica Murray for their suggestions and technical assistance. Deepest gratitude to Janine Altongy, whose patience, criticism, and caring made this work possible.

Phaidon Press Limited
Regent's Wharf
All Saints Street
London N1 9PA

Phaidon Press Inc.
180 Varick Street
New York NY 10014

www.phaidon.com

First published 2008
© 2008 Phaidon Press Limited

ISBN: 978 0 7148 4832 7

Designed by Eugene Richards
Printed in China